Envisioning Science

THE DESIGN AND CRAFT
OF THE SCIENCE IMAGE

Felice Frankel

THE MIT PRESS

CAMBRIDGE, MASSACHUSETTS
LONDON, ENGLAND

This material is based upon work supported by the National Science Foundation under Grant No. 9652950

This book was set in Trade Gothic and Sabon and was printed and bound in the United States of America.

Library of Congress Cataloging-in-Publication Data

Frankel, Felice.
 Envisioning science: the design and craft of the science image / Felice Frankel.
 p. cm.
 ISBN 0-262-06225-9 (alk. paper)
 1. Photography—Scientific applications. 1. Title

 TR692.F73 2002
 778.9'95—dc21

for Ken

Contents

3 / Images in Science: A Gallery of the Past

4 / Basics of Picture Making

5 / Photographing Small Things

6 / Photographing through a Stereomicroscope

7 / Photographing through a Compound Microscope

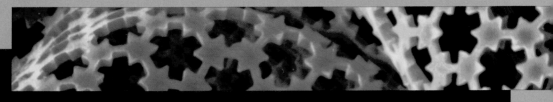

8 / Presenting Your Pictures

1 / Envisioning Science

Why This Book?

This is a book about a new kind of science image, an image
that communicates your work more effectively to both colleagues
and the general public. *Envisioning Science, the Design and
Craft of the Science Image* intends to encourage you—the
researcher and student—to find a place in your research for a
new way of seeing and presenting your work and to provide
you with the tools to do so.

Until now, it is likely that the images you have made for your
laboratory notebooks, journal submissions, and presentations
have had a particular "look," a look that is quite related to
their purpose: communicating your observations and processes
to your colleagues. Only on a few occasions have you had
reason to work on an image to make it more compelling. Many
of you have not seen the potential of using your images to
communicate to those outside the research community, nor have
you made the connection between making science images
and thinking about science.

What Is the Difference?

The science pictures you see here have an additional purpose
to those in your notebooks. Although often used for presentations
and submissions to the professional, they also communicate
science to the general public and thus capture the attention of
those unfamiliar with the subject. They have a component
that is sometimes called "artful," a word I, like you, should be
wary of using. They might appear as personal interpretations
but they are not. They are honest documents of scientific inves-
tigation. However, they have one additional quality not usually

present in science images—they somehow include the marvel of whatever phenomena I intend to capture. That "somehow" is the subject of this book.

You and I share a love for science, but I have an advantage of not being fully trained as a scientist and encouraged to hide my infatuation with the subject. I am not embarrassed to show the wonder I see in the science I portray, and that could define the difference between these images and yours. In this book I share my experiences photographing science and engineering to encourage you to practice the process for yourself. As a result, you will develop your own techniques in creating arresting images of your work for these good reasons:

➤ As research becomes more interdisciplinary, illuminating and intelligent images of your research will become more useful in communicating to those scientists outside your field of expertise.

➤ Using compelling and accessible pictures is a powerful way to draw the public's interest to the world of research. When the public develops a more intimate association with science the results will be both a richer society and one supporting the important efforts in scientific investigation.

➤ As you spend more time making these new images of your research to communicate to a larger community, you will see your work differently; you will expand the way you think about your work and therefore the way you envision it.

Taking You through the Process

Envisioning Science describes how I use the same principles
all skilled photographers use to create images. There are no
secrets. Light, composition, and focus, for example, used with a
photographer's eye, will provide your starting point. But only
a starting point. This book urges you not to stop with your first
picture but to study and adjust those elements over which
you have control—moving you toward an image that is more
than "good enough."

I began the book without a preexisting structure. By going
through the thousands of images I have made over the
years, including the not-so-successful ones, I discovered my
approach—the "lesser" photographs would be the core
of this volume. I would fashion the narrative of *Envisioning
Science* to show comparisons, some obvious, some subtle.
You would look at the images, side by side with small differ-
ences between them, with one picture as a "draft" for the
other, much like a writer's first version followed by the edited
piece of prose. You would begin to understand how subtle
changes in the photographic process would result in a signifi-
cantly different photograph. You would train yourself, just
as I did, to see differently as you study the pictures.

This book on how to make good pictures of good science would
thus become both a practical guide to science photography
and a metaphor for the scientific process.

With this insight, the project became an extraordinary exercise
for me. I had to figure out how I did what I did. I would then

communicate as much as I could to you with the hope that
you would be drawn to the challenge of visually capturing and
communicating sometimes staggeringly beautiful phenomena.

I wrote the book with the assumption that you have a basic
knowledge of photography. I have included specific issues about
film that you might consider irrelevant to your work if you use
a digital camera, but you can and should extrapolate this dis-
cussion and make it relevant to digital capture. Most practition-
ers of digital photography, for example, don't bother to bracket
exposures; they think the camera will automatically take care
of everything. The exercise in bracketing exposures in chapter 4
will teach you about gaining control and controlling the process.
Whatever camera you use, this is the first step to making sig-
nificant images. With every adjustment, you will see something
you hadn't seen before.

Acknowledgments

Phylis Morrison accepted my invitation to write a brief his-
torical perspective. We both agreed it was important for you to
recognize that making pictures to visually record and commu-
nicate ideas and images about our world started long before the
camera. Matthew Footer contributed a separate discussion
on fluorescence microscopy, found in chapter 7. I feel fortunate
that such a superb photographer agreed to share his expertise.

With a few exceptions, most of the pictures in the book are
mine and I credit those that are not. Please take note of
those important contributions. When I use imaging equipment

1 / Envisioning Science

about which I have more limited knowledge, like a scanning electron microscope, I work with others with more experience. I am very grateful to those who shared their knowledge in areas beyond my own realm of expertise and I mention them in each chapter.

My gratitude also goes to the National Science Foundation's Directorate for Human Resources, Division of Undergraduate Education for support of the project and specifically to my program officer, Herb Levitan, who at an early stage understood its significance. Profound thanks go to my colleagues at MIT, at all levels, and especially to Moungi Bawendi, Paul Gray, Tom Greytak, Klavs Jensen, Alan Lightman, Paul Penfield, and Elizabeth Thomson who were among the first to champion my efforts. I am privileged to be part of MIT's rich intellectual environment where one is encouraged to run with her idea if it appears to be a good one. I also thank MIT's Edgerton Center staff and especially Kim Vandiver, its Director.

Ken, Matthew and Laura, and Michael, my wonderful family, have always understood and supported my enthusiasms and are owed my loving appreciation. My deepest gratitude, too, to Mary Cattani, my friend and occasional unofficial editor, who tweaked and nudged some of the text, taught me so much about writing, and most important gave me the confidence to write. My heartfelt thanks go to Sandra Minkkinen at the MIT Press who clarified the larger body of text with great intelligence. I am grateful, too, to my editor, Tom Stone, who inspired my think-

ing, kept me calm, and shepherded the book to the end. Thanks again to Michael Frankel, this time for the grueling task of finding and organizing the bits and pieces for the visual index.

To Stuart McKee, as both a book designer and a collaborator, I offer special appreciation for his intelligent insights and impeccable taste, bringing this book to a place I could never have imagined.

My thanks, too, to my students working at various times during the project: Marianna Shnayderman, Justin Ging, David Hamby, and Esther Fong, for collecting, scanning, organizing, and delving with me.

I am fortunate to have Phylis and Phil Morrison as my friends and advisors, who have encouraged me along the way and continue to keep me honest.

I am grateful to those in the remarkable science and engineering community who welcomed me into their labs. Finally, I am forever indebted to George Whitesides, whose imagination fired my own and whose elegant approach to science compelled me to find the images to match. From the beginning, he urged me to "stay with it."

As I did and continue, so I hope will you.

Now, let's get to work.

2 / How to Use This Book

Your First Glance

As you initially flip through these pages, you will immediately
see the emphasis on images—no surprise for a guide to
photographing science material. In a literal sense the pictures
in this book are its substance.

Read the images as if you were reading text.

Study them and discover how they relate to the specifics
described in the narrative and how they relate to each other.
Each image is numbered and appears almost always on the
page with its relevant text.

As you scan the text, you will notice highlighted sentences.
Some of these might seem obvious, and you might wonder why
I stress their ideas. My experience has been that most
researchers take the obvious for granted when making pictures.

This book is about making science pictures, not making science.
Therefore, I haven't expanded the scientific content in the
narrative. But because the science in the pictures drives the
thinking behind making the images, you will find relevant
data in the back of the book in the visual index. You should also
note that most of the images in the book have been minimally
"cleaned," digitally, and a few have been resized to fit the
page proportions. My belief is that the integrity of the images
has not been compromised with these adjustments.

THE BOOK RELIES ON THE FOLLOWING ASSUMPTIONS:

> You have a basic knowledge of photography.

> You have or will read the manuals for your equipment and will familiarize yourself with important technical issues pertinent to that equipment.

> You will extrapolate the discussions in the various chapters and see the relevancy to whatever imaging equipment you use.

The Chapters

Chapters 1 and 2 are introductions to acquaint you with the voice and structure of the book. Because it was important for you to hear from me, and to take you through my experiences, I write in the first person as if we were face-to-face. My approach to photographing science will not necessarily be that of other photographers, and perhaps ultimately not even yours, but it will be a good place for you to begin.

Chapter 3, written by Phylis Morrison, provides a brief historical perspective on how visual techniques in the past were used to successfully communicate ideas. There is something comforting to know we are all part of a continuum.

Chapter 4, The Basics of Picture Making, introduces you to what I consider the very fundamentals of making satisfying pictures when one is already familiar with the basics of photography.

Chapters 5, 6, and 7, respectively, take you from things you can see with your eye and a camera and lens, to the stereomicroscope, and then to the compound microscope. Note the chapter openers. They are all of the same computer core memory from the mid-sixties, which now seems ancient. I shot each version

7

HOW TO USE
THIS BOOK

with the relevant equipment for the following chapters. Even if your specific needs do not require all of the particular imaging techniques in the book, I encourage you to investigate the possibilities presented in each chapter.

This book is intended to teach you to see.

Chapter 8 includes a brief discussion on scanning and storing images and gives a few ideas on how to present your pictures. The latter subject, alone, could fill a separate volume. The discussion is only a starting point and in it, I raise some important questions concerning the appropriateness of various digital manipulations.

To supplement the information provided in the chapters, I constructed a few exercises to help you practice the techniques. They are in the back section, and I encourage you to try them.

The book designer, Stuart McKee, and I worked only through e-mail messages with file attachments and phone conversations. We never met during the two years of the project. I would first send Stuart the edited text and low res images on a Zip disc, with suggestions on which images I would prefer large. He would then send me potential page designs as PDF attachments. We would discuss various issues and agree to each page layout on the phone as we looked at our respective computer screens, thousands of miles apart.

2 / How to Use This Book:

From the Designer's Perspective

Stuart McKee

From the Beginning

The design of this book began at least a year before I received any initial manuscript. Felice proposed that we work on it simultaneously as a collaborative effort. The book would begin with my design, informed only by Felice's description of what she imagined along with my knowledge of her photographs.

I immediately realized how unique this project would be, and that no single model existed that could help me to design it. From the beginning, I knew that it would be at least five different books joined together within a single binding. The most difficult part of designing it was deciding how to make all five feel like one.

This book would be first and foremost a workbook, designed to be propped up or opened flat within the laboratory or workstation and read as a sequence of technical recipes. It would function as a reference text as well, providing access to a specialized array of photographic facts, methods, and resources. Obviously, it would also be a book of arresting images, and I would need to retain its educational value despite the many pleasures within the photographs. There would even be a storybook here, each chapter relating to personal experiences behind the making of the pictures. And finally, perhaps most excitingly, it would be a guidebook, a sightseeing adventure into the colorful realm of science.

The design of *Envisioning Science* utilizes its beginning, middle, and ending as distinctly separate sections. The introductory section, which announces the book's intentions and discusses how to use it, is designated by colored pages.

2 / How to Use This Book:

From the Designer's Perspective

DESIGN NOTES

A Closer Look

The main body of the book, chapters 4 through 7, constitutes the book's "white pages," the photographic lessons that are its substance. The chapters in this section follow a simple pattern: as the text introduces a photographic lesson, an accompanying image (or set of images) illustrates it, as shown in

EXAMPLE 2.1

example 2.1. The images are labeled with identification numbers, which also reappear in the margin next to where the image is first mentioned.

The book closes with a second reference section including exercises, a visual index, a bibliography of suggested readings, and an index, again set off in color. The visual index reproduces the book's complete set of images along with source notes.

EXAMPLE 2.2

Example 2.2 shows how the visual index functions as a reference resource. Each linear entry within the index represents a two-page spread from the book, featuring the images from that spread, along with the images' identification numbers, page numbers, and section headings. The source notes (which appear in white) and photographic credits are included in case you'd like to learn more about the science behind the images and the scientists making it happen.

If you are unfamiliar with the book and need a quick lesson in a particular technique, you can browse the visual index to quickly find the information you need to get started. You can also use this section to help you relocate an image or lesson that you forgot to bookmark.

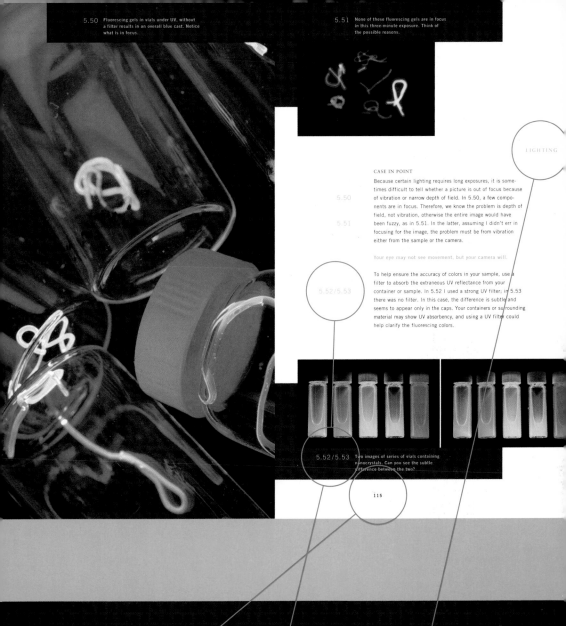

5.50 Fluorescing gels in vials under UV, without a filter results in an overall blue cast. Notice what is in focus.

5.51 None of these fluorescing gels are in focus in this three-minute exposure. Think of the possible reasons.

LIGHTING

CASE IN POINT

5.50

5.51

Because certain lighting requires long exposures, it is sometimes difficult to tell whether a picture is out of focus because of vibration or narrow depth of field. In 5.50, a few components are in focus. Therefore, we know the problem is depth of field, not vibration, otherwise the entire image would have been fuzzy, as in 5.51. In the latter, assuming I didn't err in focusing for the image, the problem must be from vibration either from the sample or the camera.

Your eye may not see movement, but your camera will.

5.52/5.53

To help ensure the accuracy of colors in your sample, use a filter to absorb the extraneous UV reflectance from your container or sample. In 5.52 I used a strong UV filter; in 5.53 there was no filter. In this case, the difference is subtle and seems to appear only in the caps. Your containers or surrounding material may show UV absorbency, and using a UV filter could help clarify the fluorescing colors.

5.52/5.53 Two images of series of vials containing nanocrystals. Can you see the subtle difference between the two?

115

EXAMPLE 2.2 The Visual Index: images appear again with
scientific references.

pp 114–115

5.50

5.51

5.52/5.53

Lighting

5.50/5.51 Polyacrylamide Tubular Gels
See 5.48

5.52/5.53 Vials of CdSe Nanocrystals
Moungi Bawendi's Lab, MIT.
Bawendi, M. G. et al. "(CdSe)ZnS
Core-Shell Quantum Dots: Synthesis and
Characterization of a Size Series of
Highly Luminescent Nanocrystallites."
J. Phys. Chem. B 101, 1997.

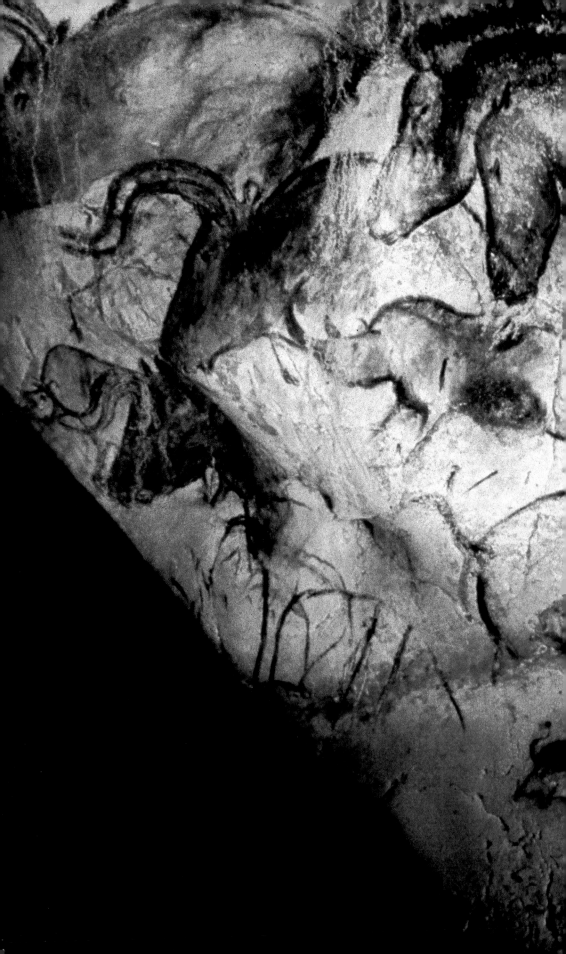

3 / Images in Science: A Gallery of the Past

Phylis Morrison

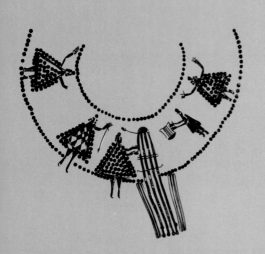

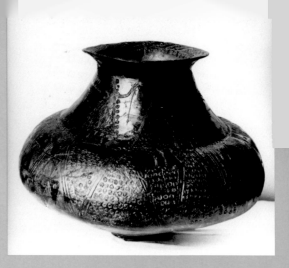

Visual communication is growing increasingly important, and we have more use for images than ever before. The proliferation of films, television, videos, the Web, video games, electronic billboards, books, magazines, and catalogs makes this clear; it is especially true of images for scientific purposes. Not only are the images of science used everywhere, but we also have more accessible ways of making and presenting them, and we "read" them with better understanding. The greater ease in making pictures and in placing them before wider audiences means more people are producing what so many see. This book will give you tools to make better photographic images of your own work, work whose meaning and communicative intent you know better than anyone.

3.1 **Chauvet**

Here you can see a bit of visual history, some of the most influential pictures of the world from the past. The oldest fully developed paintings I know come from a cave named Chauvet, in the south of France, near the valley of the Rhone river (see previous page). Thirty thousand years ago one of our ancestors working in the dim light of an oil lamp painted this group of aurochs, horses, and a rhinoceros. Is it a "scientific" image? Not in our modern sense, but it does show that the painter had observed and could reproduce telling details of the anatomy of familiar animals, showing form both by outline and by shading, as well as indicating depth as one beast eclipsed another. The naturalistic rendering from so far in the past is astonishing,

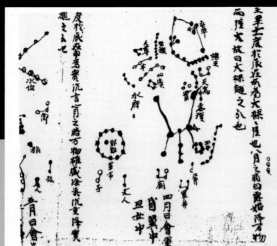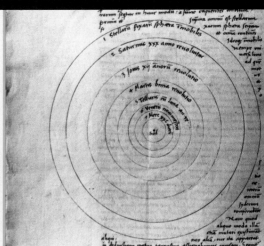

clear evidence of a rich and subtle relationship between that
artist and his world so long ago.

3.2 / 3.3 Halstatt Vase

Some decorated objects present evidence of mastery of early
technologies and of aspects of daily living as well. The drawings
on this vase from 500 B.C.E. in Hungary display technical
details of Neolithic spinning and weaving at a warp-weighted
loom. They suggest that music was performed for the working
women. Can that striped rectangle held by one of these
personages be a harp? Its strings might belong to a small loom,
but then why are the final two figures dancing?

3.4 The Constellation of Orion, Tunhuang Sky Map

An ancient map of the stars, from China a thousand years ago,
is based on even older maps only partially preserved. The
constancy of the form of the constellation Orion since the pic-
ture was made is remarkable.

3.5 Copernicus's World System

Copernicus's drawing, from the start of the sixteenth century,
of the new idea that broke the "crystal" spheres enfolding
a motionless earth. Here the earth moves with all the other plan-
ets around our shared sun. Not only was this concept a revolu-
tion in thought, but it was also the harbinger of a new way
of doing science, opening all that one saw to possible question.

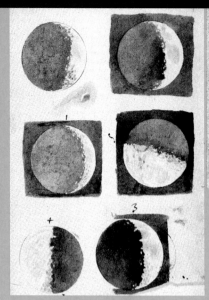
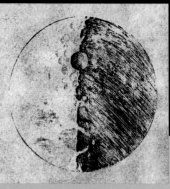

3.6/3.7 **Galileo's Moon Drawings**

Something entirely new: these are Galileo's own skilled water-
colors of the moon, probably made as he looked through
his telescope. (Did the paint freeze on a cold night?) These
images open the line of evidence that finally led to the consen-
sus that Copernicus's ideas about the solar system's geometry
had been right. Moreover, some things that were heavenly
were visibly made of the same sort of matter we call earthly,
held by the same web of laws. We see also one of Galileo's
moon images as it appeared in print in 1610, image 3.7, repro-
duced from a woodcut. We have come a long way since in the
technologies of image presentation.

The enlarged image of the moon in the telescope offered Galileo
details never before seen. He reported, "just as the shadows
and hollows on the earth diminish in size as the sun rises
higher, so these spots on the moon lose their blackness, as
the illuminated region grows larger and larger." And speaking
of a certain mountain-rimmed crater, he described it thus:
"As to light and shade, it offers the same appearance as would
a region like Bohemia, if that were enclosed on all sides
by lofty mountains arranged exactly in a circle." That remark
was a daring leap in uniting the earthly and the heavenly,
and doubtless influenced Galileo's downfall among the clergy.

3.8 **Jupiter's Moons**

More evidence? He turned his telescope on bright Jupiter and
noticed that it was dogged by a small group of tiny lights
that were never far from it, yet moved from hour to hour and

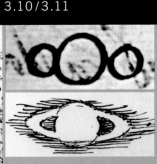

night by night. By recording their positions over several months, he came to realize that they were moons to Jupiter as our moon is to us. He could follow the path of each bright point, moving away and then toward the great planet, then passing behind, in front or very near, then receding from it on the other side. They were circular paths seen from the side. Jupiter and its companions were like a little solar system within our own! Even today his style of drawing of this dance in vertical strips is copied to show our predictions of where the moons will appear.

The Phases of Venus

And more: Venus, whose orbit is always within our own, shows a pattern of movements around the sun resembling the dance of Jupiter's moons. First seen on one side of the sun, then moving to the other, but never too far away from the great sun, surely again a circular path seen from the side. If that were so, Venus would appear either very large or very small when seeming near the sun, depending on whether it was near or far from us on earth; it would always shine by light reflected from our bright sun, as our own moon does, so it should show the figures of crescent, half, and full circle in turn. When Galileo looked, he found that very effect, here informally reported by a quick sketch in a letter.

Two Ideas about Saturn

His telescope failed him in grasping the form of that strangest of all our planets, ringed Saturn. He could not quite make

out what was to be understood there and drew three disks.
Fifty years later, Dutch astronomer Christiaan Huygens got it
right. Sometimes astronomers first have the picture and only
later work out their understanding from it.

3.12 Robert Hooke's View of Cork

As the telescope opened the skies, so its complementary
optical invention, the microscope, gave us access to the minia-
ture world. In London in 1662 Robert Hooke published a
book, *Micrographia,* brimming with pictures of things never
before seen, the harvest of a weekly session he had chaired
at the Royal Society. He placed many materials—mostly ordinary
things newly disclosing detail—on the stage of his instrument;
he described the image of a printed period "like a great
splatch of London dirt." This master observer cut a piece of
cork, such as you find closing a bottle of wine, into thin slices,
both lengthwise and crosswise. He called the little pores
cells, probably thinking of the cubicles of monks—to me they
seem like an endless series of motel rooms—and his term
stuck. We find and name cells in all living things.

3.13 The Head of a Fly

Hooke also gave us the great frontal image of "The Eyes and
Head of a Grey drone-Fly," and reported in detail how he
went about observing it—surely a part of your task as you make
photographs of your own research. Of the detailed image
showing a score of the simple eyes of that fly, he noted, "Then
examining it according to my usual manner, by varying the

Fig. 3

degrees of light, and altering its position to each kind of light,
I drew that representation ... the surface of each of which
was ... shap'd into a multitude of small hemispheres ... the bot-
toms of every which, were perfectly intire and not at all per-
forated or drill'd through which I most certainly was assured of,
by the regularly reflected Image of certain Objects."

3.14 A Detail of a Fly's Eye

He went on to describe how he set up his workspace, facing
a window a few feet away. "In each of these hemispheres
I have been able to discover a landscape of those things which
lay before my window." And indeed, we do see in the little
image the reflection of the two windows of Hooke's workroom.
In an earlier passage he recorded his confusion in looking at
another such object, noting that it can be very difficult to ascer-
tain whether the hemispheres before him are mounds or cups.

Hooke spoke convincingly about the great need for self-honesty
in the presentation of science: "I hope that my Indeavors ... may
be in some measure useful to the main Design of a reformation
in Philosophy, if it be only by shewing, that there is not so
much requir'd towards it, any strength of Imagination, or exact-
ness of Method ... as a sincere Hand, and a faithful Eye, to
examine, and to record, the things themselves as they appear."

THE ADVENT OF PHOTOGRAPHY

Experiments with silver chemistry sensitive to light led to
the beginnings of photography in the 1830s, both with

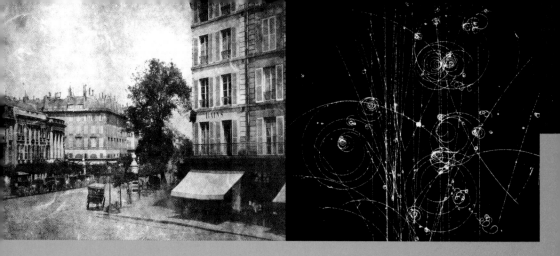

Louis-Jacques-Mandé Daguerre's unique images on silver metal
and William Henry Fox Talbot's silver-salt-coated paper negatives
and the positives made from them.

3.15 **Paris Cityscape**

It was a powerful and direct new way to record reality. In
describing his cityscapes of Paris, Fox Talbot says that photog-
raphy "chronicles whatever it sees," noting the complex and
jumbled array of chimney pots and lightning rods. He was very
sensitive to what the light was up to: we see the lit awning of
the shop and the dark shadow under it, as well as the shadows
under the nearby carriage and the sapling tree next to it. Yet no
people appear—perhaps they were there, but had not lingered
long enough for their images to be recorded on Fox Talbot's slow
paper. By 1900 the dependable transfer of photographs to the
printed page by the halftone process was available for use in both
elegant books and on coarse newsprint almost everywhere.

FIVE STRANGE IMAGES

We are now in a new era, and images are called upon to do
a new kind of work. Visually oriented creatures, we use our eyes
now to view images made by instrumentation—the progeny
of the telescope and microscope of the seventeenth century and
of the Victorian view camera—in amazing variety: the cell or
the sun in detail, processes exceedingly slow or explosively fast,
the hidden brain within the skull or the embryo moving within
the womb, often displayed under once-invisible sorts of light, all
of it tumbled before us any day at every scale, as from a horn

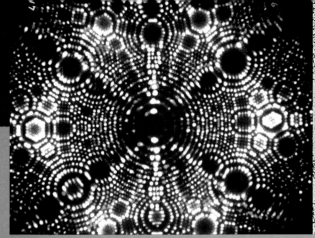
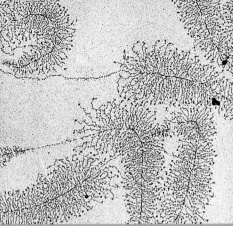

of unending plenty. This set of pictures represent the unending array of modalities opening in our time for science to explore, explain, and share.

3.16 **Bubble Chamber, Pair Formation**

These trails are of charged atomic particles moving through liquid hydrogen in a bubble chamber. Tiny bubbles mark the paths the particles have taken. Much can be read from such an image: look for the conspicuous "V" near the center— some stealthy uncharged particle has transformed into two charged ones that become visible in the process. You can see their fast motion, slightly curved by the magnetic field in the chamber, if you look down their tracks from a steep slant. The slightness of that curve tells you these two particles were moving very fast.

3.17 **Field Ion Microscope Image**

This dotted image displays the metal atoms in a slender, highly charged tungsten needlepoint, projecting their field strength onto the screen surface to be viewed in this odd kind of micro-scope, giving a first view of the atomic array on the surface of the crystalline needle. The symmetries are made especially clear.

3.18 **DNA Unfolding**

DNA unfolding and transcribing into feathery fronds of RNA, under biochemical manipulation, as seen by an electron microscope.

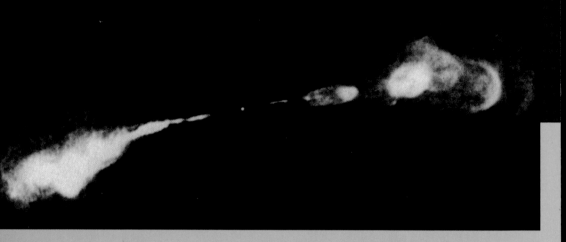

3.19 A Radio Galaxy, Hercules A

From end to end the cloud shapes in this picture are a million
light-years across, far too big for a galaxy of stars. This image
is brought to us by radio waves crossing space, caught in
the net of a couple of dozen big radio dishes in New Mexico.
In fact, the generator of all this radio intensity is an unseen cen-
tral galaxy whose radio-bright core you can make out as a dot
between the two lobes of cloud.

3.20 X-ray of Hand

An early x-ray of the hand of a cadaver. The pathways of blood
through the hand have been injected with a dye that is opaque
to the penetrating radiation.

The variety of such photography stands for the extending of
the senses that has been the hallmark of modern science.
Again and again invisibility has been given a face and form.
X-rays, penetrating usually opaque substances, opened up worlds
to explore. Beyond our examples, the spectrum of light has
become a fingerprint of the atoms that made the glow. The scan-
ning electron microscope shows us tiny scraps of almost-life.
The backward glance that gave us the riveting sight of our
own round blue planet, free in space, changed the whole mean-
ing of living on a planet for many of us. The images of science
enlarge and educate us all.

3.21 Darwin's Tree

These have been examples of public imagery. We have another
role for pictures as well: some arise not from the physical

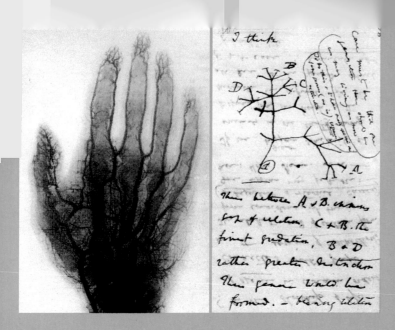

world in its great diversity, but from the inner one within our-
selves. While puzzling out what processes caused change
in living creatures, Charles Darwin drew for himself this sketch
of an irregular branching tree and used the image to further
his thoughts on evolution. Eventually the sketch appeared
as the only drawing in his thick book, *On the Origin of Species
by Means of Natural Selection*.

The images we have been showing you are public; only Darwin's
was made for his self-instruction, a part of his decades of
work in unraveling and documenting the path of life over vast
times. Even that became a special part of his long argument for
a special readership. The samples displayed here are the
result of techniques changing from charcoal rubbed on a damp
cave wall under the flickering light of small flames to the
grayscale of coded radio intensity mapped pixel by pixel by
computer. Those differences in technique are great, yet all the
images share a common purpose: to reveal and to document
meaning for the image maker and for its viewers. Photography is
one powerful tool among many, and it serves the same end,
to advance toward a goal of self-instruction and purposeful,
clear communication of the evidence for and the new results of
any research. Progressing along that path nowadays is as
intrinsic to the work as are the logic and the protocols. Perhaps
even more so, for the symbolic material of text and formulas
may do less than an image to convey the beauty and the wonder
that lie deep in the results of your own efforts.

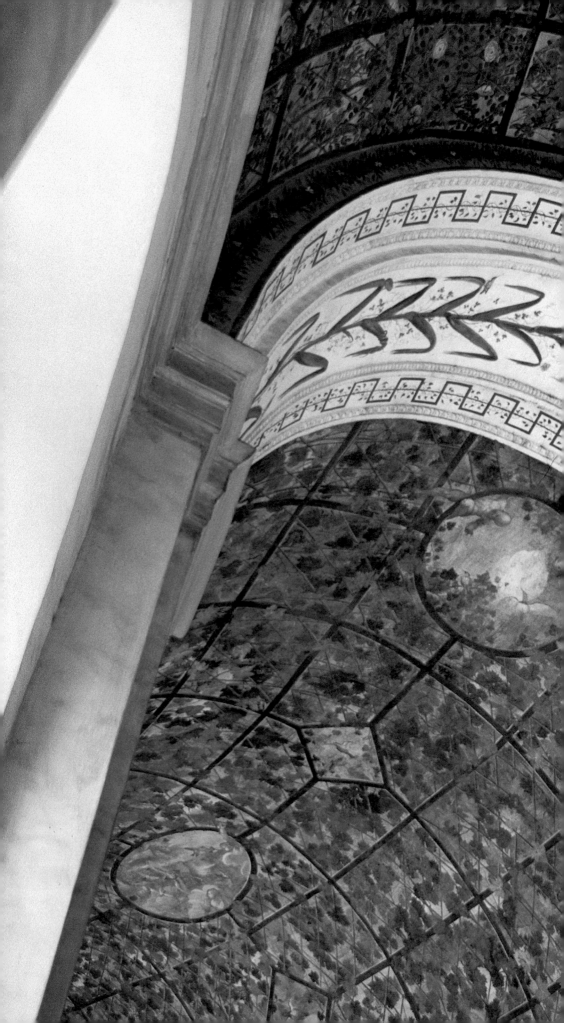

4 / Basics of Picture Making

4 / Basics of
Picture Making

INTRODUCTION

There are a number of photography books that do a fine job of explaining how to create a technically good image, and I encourage you to refer to them. A list of my favorites appears in the Suggested Readings. But because this handbook concentrates on how to make pictures for the purpose of communicating science, not only capturing data, we will look at specific approaches that will help you make your photographs interesting and engaging to both your colleagues and to those unfamiliar with your work.

The basics of picture making are relevant to all kinds of subjects and imaging equipment. Understanding the importance of composition, or insisting on good focus, for example (see page 148), is essential to making any good image whether you are shooting still or moving images, using a digital or film camera, a microscope, or whether your work is biological, material, or both.

While glancing at this chapter, you might wonder if you have picked up the wrong book since I have included some of my photographs from years ago when I photographed the designed landscape and architecture. But in my view, making an image of a landscape designed by Isamu Noguchi (see page 40) is quite similar to making a picture of your own work in science or engineering. Your material *is* a landscape, yet on a different scale, and you must learn to see it as such. As in any photograph, each component in the image is a form and when translated to two dimensions each form becomes just as significant as the next.

UNDERSTANDING THE FLATLAND

It is important to remember what is so obvious it is easy to take for granted:

Images are two-dimensional renditions of three dimensions.

In real space, forms lie in three dimensions. (On page 141 I briefly address the fourth dimension, time.) In pictures of space, these same forms become two-dimensional, that is, flat. As forms flatten to two dimensions, we lose our cues for depth and generally use our experience to determine where forms or shapes lie relative to each other. You, the investigator, know your subject and understand where things are; you have observed the subject of your investigation for many hours, or even years, and now you are photographing it. However, the new viewer, perhaps even your colleague, needs help traveling through the two-dimensional image to "read" it.

I made image 4.1 (see the preceding pages) of a vault at the Villa Giulia in Rome many years ago, and incidentally, with great difficulty. The Italian police quietly "suggested" that I put my tripod away since the Italian government didn't allow tripods in public places. Determined to get the shot, while they were looking the other way, I put my camera on the ground, lens facing up, and triggered the shutter with a cable release, not knowing what I would get in the frame.

At first, it's probably difficult for you to understand what you're looking at. You might not recognize the white curved form on the left because most of the cues for depth are gone. But after a while, as you stay with the picture, you begin making

judgments about depth, where things lie, and what it is you're
seeing. The interesting composition in this image engages
you just enough so that you will try to figure it out. I know that
the curved form is light coming through an arch of the fresco-
covered vault because I made the photograph. However, I
cannot assume that you will immediately understand the image,
just as you cannot assume your photograph will be obvious
to the first-time viewer. You must help her understand where
and how to look and to determine what is essential—to fashion
some order of importance among the image's components.

It is easier to establish order if you begin with as few
elements as possible.

Throughout this handbook you will recognize one repeated
theme applicable to all the images you make: include only the
most essential components. Simply put, simplify your image.

The simpler the image, the more accessible and engaging
it becomes—because there is less to figure out. A simpler image
with the least possible components is easier to comprehend,
and creating order with those elements helps to engage the
viewer, encouraging him to want to look—to stay with the image.

Creating order is the first step in making a successful image.

With careful framing and composition, you will help the viewer
travel through your pictures. First, however, you must decide
exactly what you will be photographing—what particular sam-
ple(s) will be in your image.

PREPARING YOUR SAMPLE

Too often researchers use the original preparation of their in-
vestigation for making their photographs. The samples are
usually worn or scratched. Adding to the problem is that imper-
fections become more apparent as the image becomes more
magnified. You might not notice them because your eye immedi-
ately sees the essential part of the image; you mentally edit
out those distractions.

You know what to look for and what to disregard, but the
first-time viewer sees everything.

If it's possible to prepare more than one sample, do so with one
specifically intended for photography—one that has been
handled less and has fewer imperfections. Just as important,
try to design a preparation specifically to communicate the
science to those unfamiliar with the work. Ask yourself, is there
a clearer way to show a particular phenomenon—to add infor-
mation while at the same time making a more compelling
image? You will see examples of specifically designed samples
on pages 83 and 152.

Just as you design your experiment, design your sample.

4 / Basics of
Picture Making

POINT OF VIEW

POINT OF VIEW

Next, you have to decide from what particular viewpoint you will
make your pictures and at what scale you will be looking.
That will determine what equipment to use. But don't assume,
because you are working at the nanolevel, for example, that
you must only image with electrons or atomic forces. Looking
at some broader view (with an optical microscope, in this case)
could add an interesting component to the beginning of a
presentation, a scientific mise-en-scène. Image 4.2 is an optical
micrograph of nanocrystals, which appears quite different
from the scanning electron micrograph (SEM) recorded by the
researchers, 4.3, yet both images are helpful to visually
describe the material.

4.2

4.3

If the scale of your sample is such that you will produce
an image using a camera and lens, take advantage of the equip-
ment's flexibility and consider a number of viewpoints. In
this close-up image of a bubble-making machine, 4.4, I posi-
tioned the camera so that the machine's large fluorescent

4.4

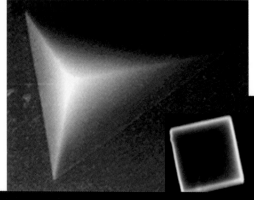

4.3 Scanning electron micrograph (SEM), of a
single nanocrystal.

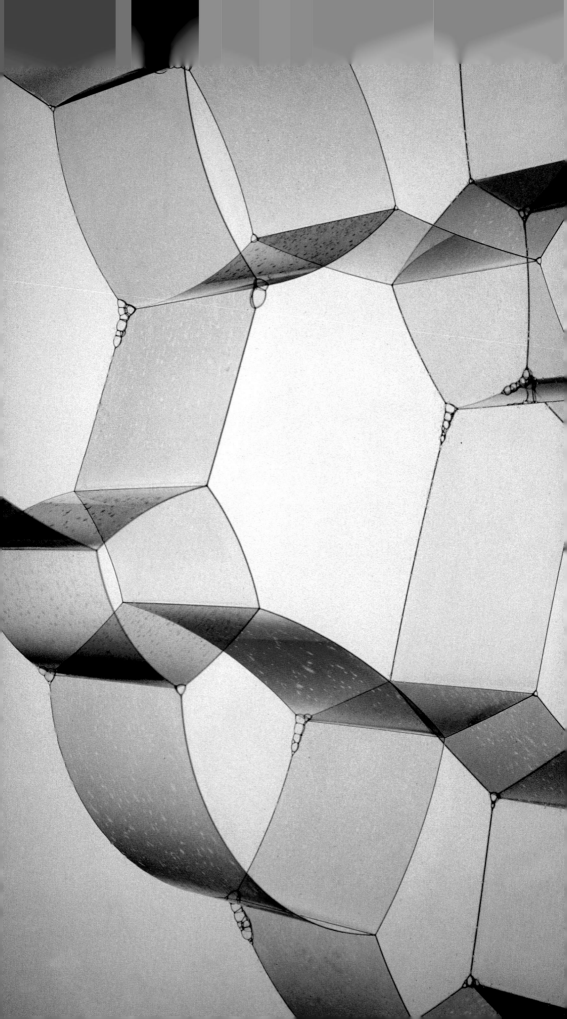

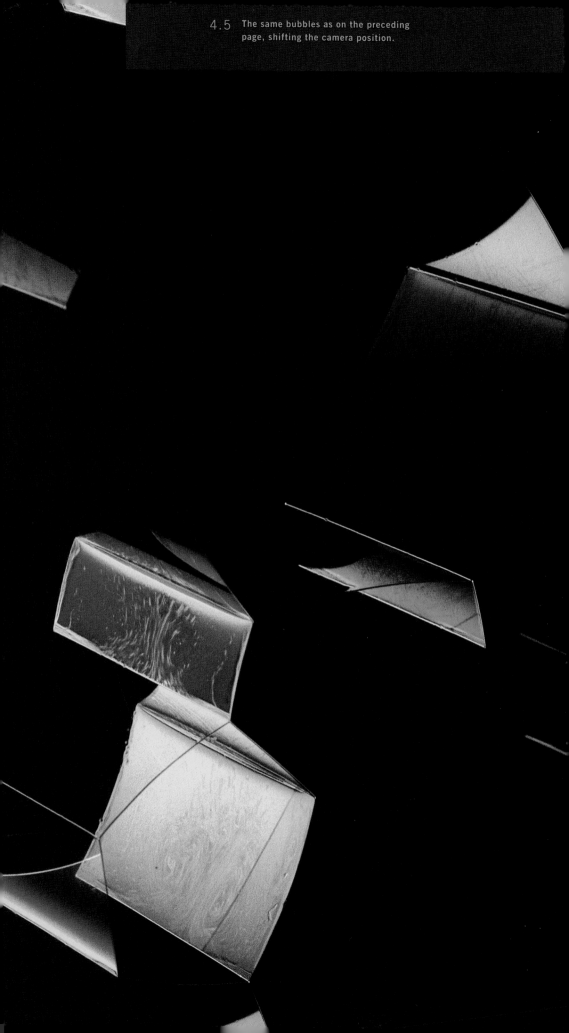

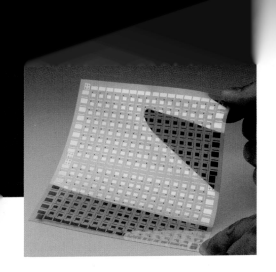

4.5

light source appears as a white background. Image 4.5 is the same bubble detail from another point of view, this time using another part of the apparatus, black felt, as the background. Shifting the camera and the tripod only a few inches resulted in a very different image. You will see in later chapters how your particular point of view has an enormous effect on how and what you see. Although this might seem obvious, my experience is that researchers often get stuck on using one instrument and viewing from a particular angle.

Look Again

4.6

Image 4.6 is a good example of photographing this flexible electronic circuit made of plastic. John Rogers shot the image at Bell Labs showing the material's flexibility. Including hands in the shot gives a sense of scale. The image is certainly successful.

4.7 / 4.8

When John asked me to give it a try, I came up with these two images, 4.7 and 4.8 (see the following pages). First, I used

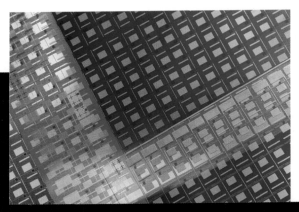

4.7 Another point of view; compare to the above.

33

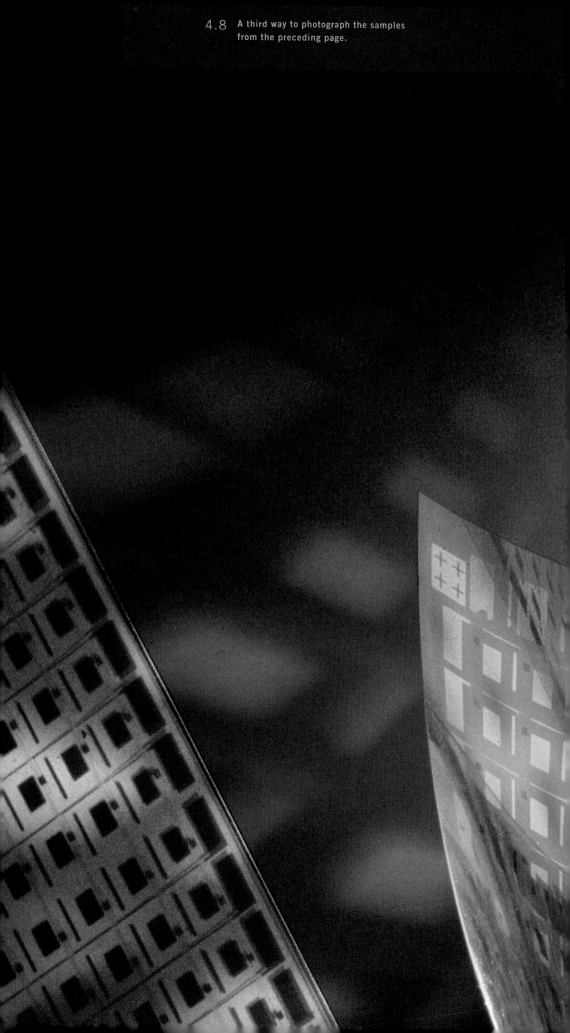

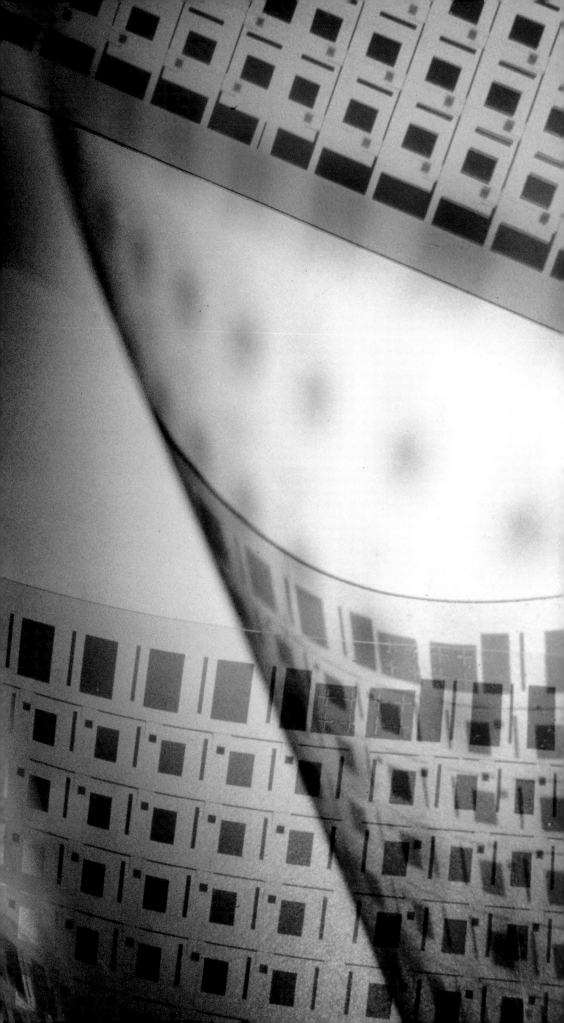

POINT OF VIEW

more than one sample in both images. In the first image, I over-
lapped the samples. Then, while demonstrating the material's
flexibility, as John did, I used light and shadows to emphasize
the sample's transparency.

All three images are successful and useful. The latter two went
beyond the obvious. That's not to say you must always do so,
but it is what this book will try to encourage.

When to Look

Photographing the designed landscape proved a perfect training
ground to understand the extraordinarily temporal nature

4.9/4.10 of all we see. Compare images 4.9 and 4.10, photographs of
a winery in California. I took each from the identical point
of view—one in the winter and one in the summer. A six-month
time span results in completely different images, yet each
describes the place and tells a story. Visually telling stories of
the evolution of your work, over time, is a powerful way to
engage the viewer.

Keep images of earlier versions of your work and include
them in your presentations. (See chapter 8.)

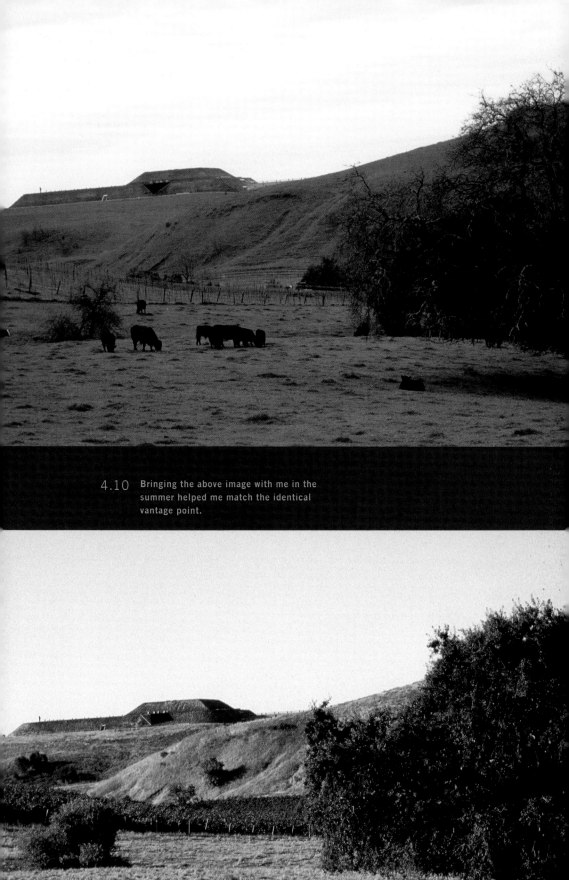

4.10 Bringing the above image with me in the summer helped me match the identical vantage point.

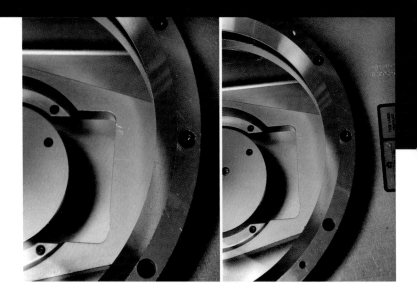

ORGANIZING THE IMAGE: COMPOSITION AND FRAMING

Decide what to include—what is absolutely essential in
the image—then compose the picture with the fewest number
of those elements. Most people generally include too much
in their photographs (and for that matter in their data tables
and graphs). However, the first-time viewer looks at every-
thing, including the unnecessary elements, and for that reason
the eye can be easily distracted. If possible, get closer to
the essential part of the image and crop out of the frame any-
thing that doesn't contribute important information. Look at
the result of a very slight shift in camera position from
4.11 to 4.12, a detail of a wafer chamber. I made the less

4.11/4.12

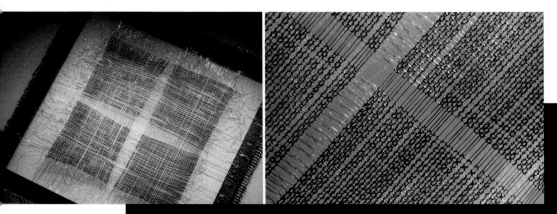

4.13 / 4.14 Getting a "tighter" shot usually gives better
results.

38

distracting photograph, 4.11, by eliminating the unnecessary
label on the right in 4.12.

When I decided to photograph an old computer core memory
at various scales for the chapter openers in this handbook,
4.13 my first attempt was not very successful (image 4.13). I included
too much, and the resulting picture is uninteresting and,
4.14 frankly, a bit boring. 4.14 is one of the more successful images.
It is a closer shot and a simpler view of the same object.
I used it for the chapter 5 opener.

Edit, edit, edit.

4.15 In 4.15, I first tried a random arrangement of laboratory-made
crystals. Your eye doesn't know where to go because it's
not directed anywhere. I made the mistake of trying to show
all the possibilities of colors and shapes: in the end, I
accomplish little because the photograph is uninteresting.
One isn't compelled to stay with it. The more successful image
4.16 is a refined version focusing on fewer samples, image 4.16.

Making a Vertical, Horizontal, or Square Image
Usually, the best choice will depend on how you intend to
use the image. If you are submitting the picture for a journal
cover, study the composition from several previous issues.
Does the journal "bleed" the vertical image, covering the entire
page? If so, make the picture as a vertical. Pay attention to

4 / Basics of
Picture Making

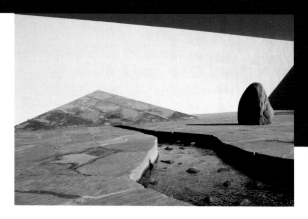

COMPOSITION

where the journal's logo is and where the designer places
type. You might increase your chances of getting a cover shot
(assuming, of course, your article is first accepted) if you
consider the cover's design. What sort of image shape does the
journal use within the issue? Frame your image accordingly.

It's not a good idea to crop the image after you make the
photograph in order to fit a particular layout. Get it right from
the beginning. For that reason, you can cover your bases
by photographing both vertical and horizontal versions. For

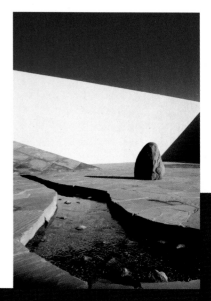

4.18 Changing to a vertical viewpoint. As in
4.17, a special architecture lens allowed up
and down shifting for better composition.

4.17/4.18

example, images 4.17 and 4.18 are of Isamu Noguchi's sculpture garden in California. Although 4.17, the horizontally oriented image, was the more obvious composition, I also composed it vertically in 4.18, framing the sky to leave space for a publication's logo. The image appeared on the cover of a landscape journal.

Centering and Symmetry

4.19

If you choose to compose a symmetrical shot, it must be absolutely symmetrical and centered. If it isn't perfect, it looks sloppy and somehow seems "wrong," as in 4.19. The inexactness raises a red flag. It's worth taking the time to get the lines straight on the vertical and horizontal.

Most of the time, you will not be photographing a perfectly symmetrical sample, and you will need to compose the image to bring attention to the essential element or idea. The most common mistake I see is thinking that the key element should be in the center.

Do not center the important element in your photograph; it makes for an uninteresting image.

4.20/4.21

Look at the following two spreads, images 4.20 and 4.21. They were both cropped to fit the dimensions of this book but are still balanced. If you study all of the images in this book, you'll probably find your own compositional eye.

I believe a good sense of composition is innate. However, with time you will become better at framing the elements in your picture and, just as importantly, you will have a better understanding of what doesn't work.

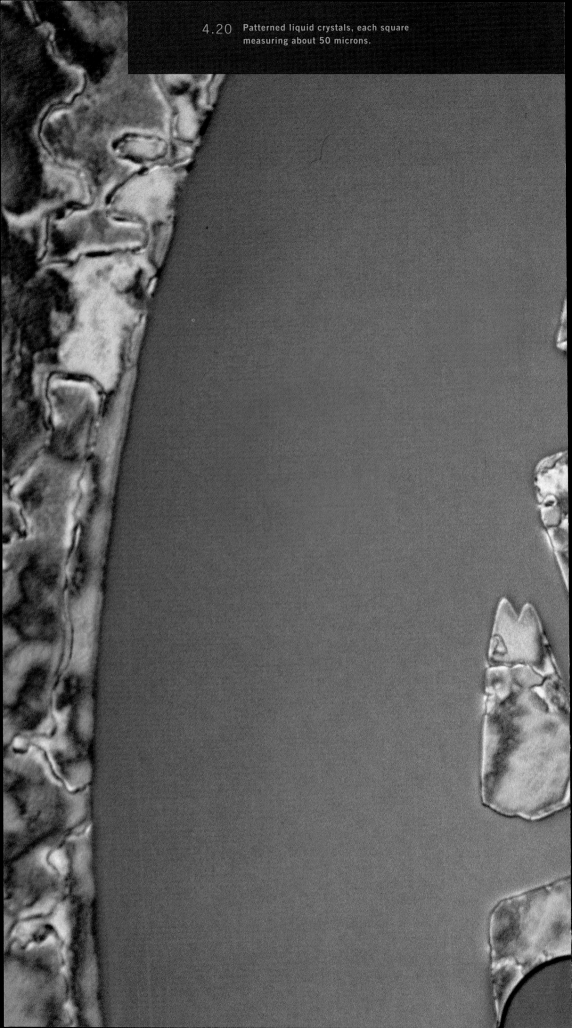

4.20 Patterned liquid crystals, each square measuring about 50 microns.

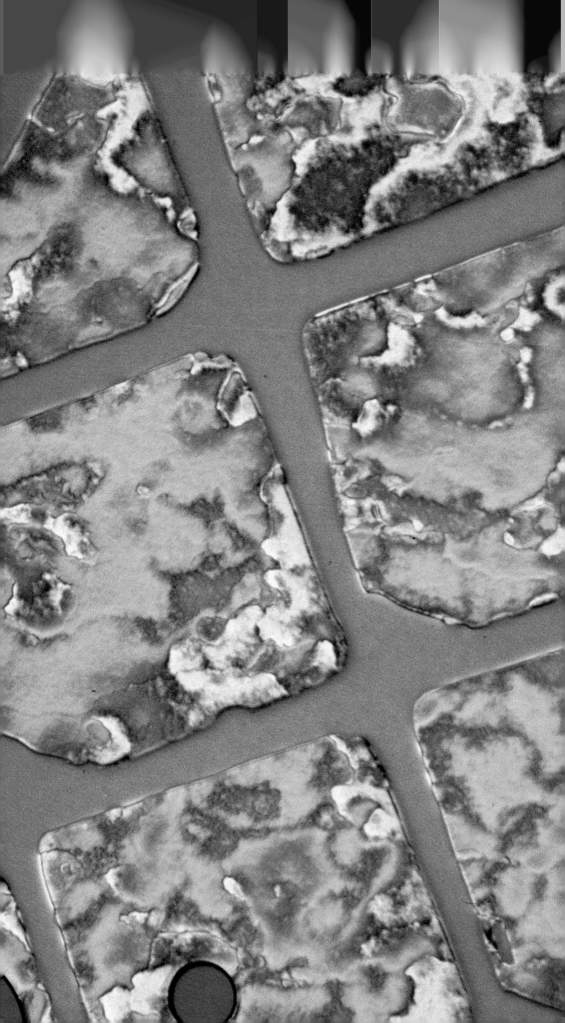

4 / Basics of Picture Making

Make Comparisons by Including the "Other"

Allowing the viewer to compare the important component as it relates to something else helps to clarify what is essential and engages the viewer. If possible, include at least two different basic forms in your image. Including more than five elements begins to complicate things.

4.22

4.22 is an example of comparisons in one image. We see different morphologies of yeast colonies. One type of colony has hairy structures, or hyphae, and the other is smooth. If I showed only the hyphaed colony in the image, there would have been no comparison, and we would not see the essential idea of the picture—that there are two types of colonies.

4.23 A micrograph of patterned calcite.

46

When you include another form in the image, let's call it B, the viewer is able to make one of the following comparisons between components A and B:

A looks like B.
A is different from B.
A has some relation to B.
A has nothing to do with B.

4.23

All of these possibilities help to define the essential component or idea and engage the viewer to participate and understand an image. Image 4.23 with a repetitious pattern (I call it my "wallpaper" image) is unsuccessful because it doesn't hold our interest. It does demonstrate the ability to create that pattern, but it is not a compelling photograph. Without some other form in the image, we don't want to stay with it, and the photograph doesn't become memorable.

4.24

Including an error in the pattern above gives the image some interest. In 4.24, the same material as in 4.20, I framed an irregularity in the image, in this case an air bubble.

Adding another component to a repetitive sample helps define what you want the viewer to see and adds interest to an image.

Extend the Imagination

Encourage the viewer to participate by giving him the framework to imagine beyond the image. It is another means of engagement.

4.25/4.26 Look at the difference in composition between 4.25 and 4.26. It's not always necessary to show the entire sample. By placing the glass wafer off to one side of the frame, as in the image on the right, I made a more interesting composition, giving the viewer the opportunity to mentally complete the image.

Suggesting what lies beyond the edge or border of the image is a means of engagement.

4.27/4.28 Compare images 4.27 and 4.28, again from Noguchi's sculpture garden. Composing the second image with a slit of sky (captured by shifting the special architectural lens), the image becomes more interesting, taking the viewer beyond the

4.29 edge of the picture. The same is true for 4.29. Including a hint of the edge of the material suggests what lies beyond the image without becoming invasive.

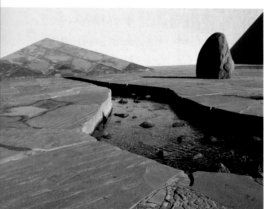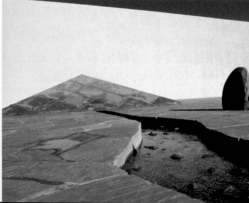

4.27/4.28 Compare these compositions.

4.29 A hint of an edge gives interest to these microcapsules.

Composing your sample on a slant is another means of extending the imagination and achieving the viewer's engagement. You'll find many examples in this book. See if you agree

4.30/4.31 with me that 4.30 is a more interesting photograph than 4.31. I'm not sure why I tend to slant my images, but most people find the pictures successful. Perhaps arranging the elements in the image on an angle directs the viewer's eye beyond the page frame.

The Space Between

Consider the space between the essential components of an image, sometimes incorrectly referred to as negative space. In a flatland, empty space is not "negative" because it becomes

4.32 another form or another component of the image as in 4.32 (see the following pages).

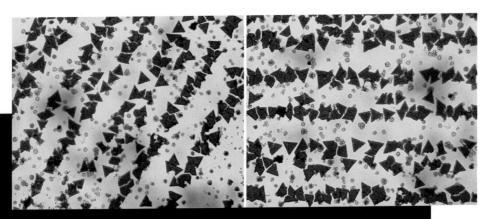

4.30/4.31 50-micron nanocrystals, two compositions.

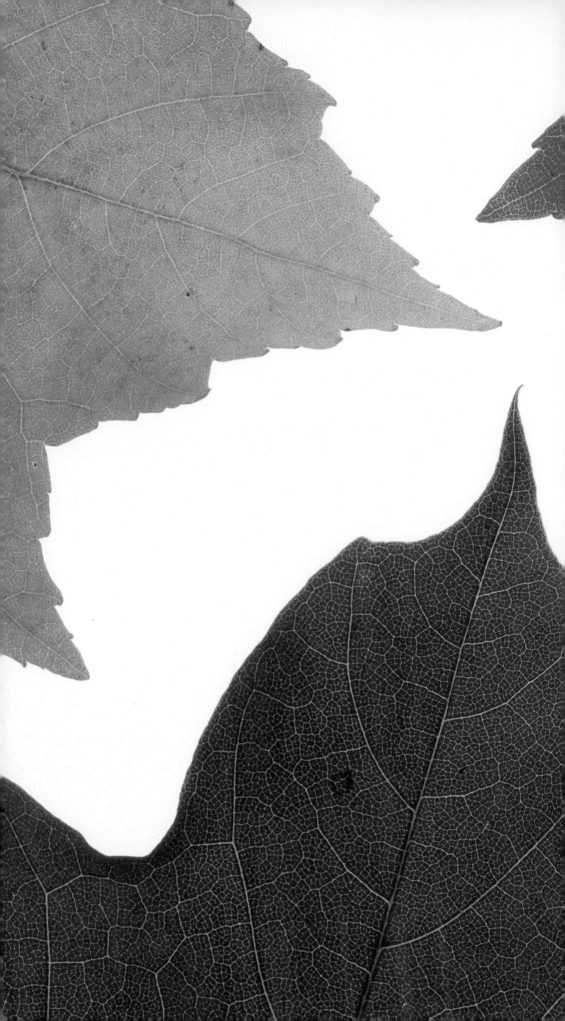

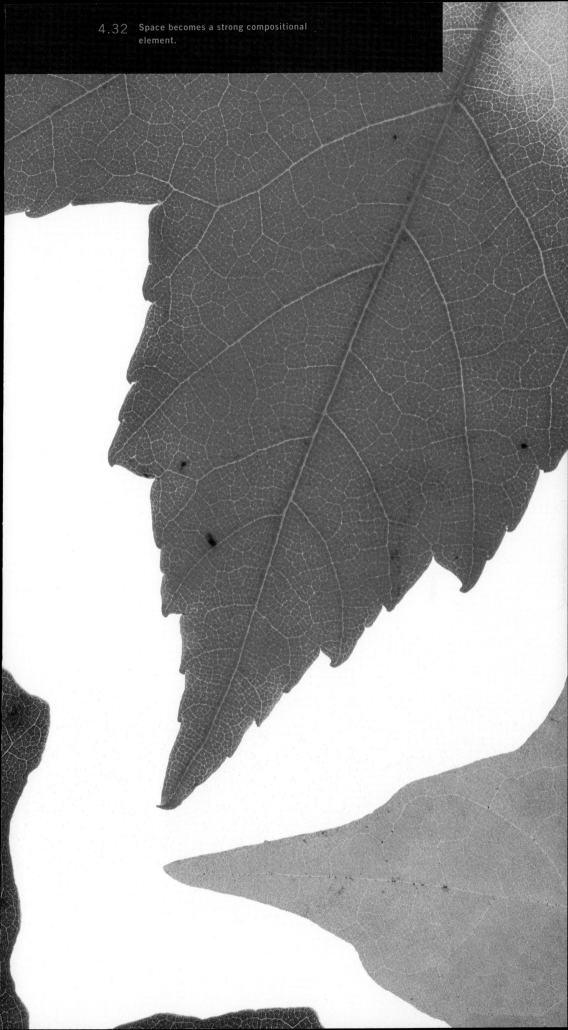

4.34 Compare this opal image, without shadows,
to the one above.

Space helps guide the eye where to look.

Shadows Become Form

Just as space becomes form in an image, shadows become additional components. They are helpful if they add information to emphasize structure (see page 106); however, shadows can also detract. One attempt I made to photograph an opal in image 4.33 was unsuccessful. The shadows are too strong and distract the eye; the image is too complicated. 4.34 is a photograph of another sample without shadows.

4.33
4.34

Watch for Surprises

How many of us have taken a family snapshot and, when the prints come back from the photo shop, we see to our amazement something in the photograph we didn't see in the viewfinder? We paid so much attention to what was, for us, the essential component that we didn't look throughout the entire frame. It's the same when photographing your work.

The problem lies in familiarity.

I paid careful attention to finding the best window reflections and the best pattern, but I never saw my own reflection on the surface of this ferrofluid drop, 4.35 (see the following pages).

4.35

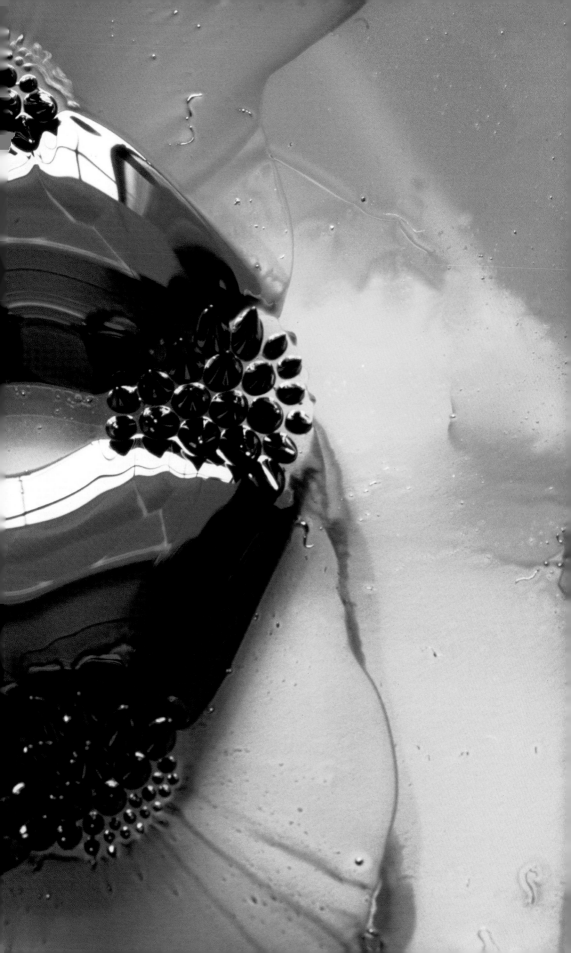

4.36 / 4.37 On the left is an ordinary shot of a wafer
chamber. The simple addition on the right
makes a more interesting image.

4 / Basics of
Picture Making

LIGHTING

LIGHTING

Throughout your career, the nature of the material you investigate
may vary across a broad spectrum—perhaps from silicon to cells
or maybe the other way around. Therefore, just as you should
not stick to one particular point of view, do not limit yourself to
one technique in lighting. The best quality of light for imaging
a petri dish growing bacterial colonies will probably not work for
photographing a combinatorial synthesis chip—but then again,
it could. That will be for you to discover.

There is never only one way to light your sample.

When you look through your viewfinder as you move a lamp
or other light source only a few centimeters, or as you adjust the
light source through the microscope, you will see changes
in how your material appears. The source of light will have a
crucial effect on your final image. Different angles of light
will also produce different pictures. Moreover, the distance of
the light from the sample will also affect how the sample
looks. As you pay careful attention to the differences in lighting,
you will learn to see more precisely. As a bonus, in all likeli-
hood you will learn more about your material and clarify in your
own mind what you are trying to communicate in your image.
In the following chapters you'll see examples of how various
lighting choices affect the image.

Make it a practice to go beyond what you initially believe
is the best lighting. Small changes, as you will see, can make

4.36 wonderful differences. Sensing that image 4.36 was somewhat
drab, I placed a small flashlight in the cavity of the chamber
4.37 and gave image 4.37 the added dimension it needed. In most of
your photography, you will have some control over lighting.
A simple addition of light may make an enormous difference in
your picture.

Investigate the possibilities. The choices you make will make
the pictures yours.

EXPOSURE

In the simplest terms, when you make an exposure, you adjust
the amount of light falling on your film or digital sensor by
controlling three variables:

➤ Film sensitivity (ISO or ASA rating) or chip sensitivity

➤ Lens aperture or f-stop

➤ Shutter speed

I include a short discussion on digital (filmless) photography
at the end of this chapter. For now, I will address the use
of film. Although you might consider the following irrelevant to
your work if you don't use film, the following three issues
are still important.

➤ *ISO* or *ASA* is a measure of how sensitive your film is to the
light that reaches it. The higher the ISO number, the "faster" or
more sensitive the film and, therefore, the less light you
need to make an exposure. For example, film with an ISO of
400 is more sensitive than film with an ISO of 50. But there is
always a trade-off for faster film. As you increase the film's
sensitivity, you increase grain size in your final image, and thus
the quality of the image diminishes when it is enlarged.

Make a test to see what film is best for your work by photo-
graphing a series of images using various film speeds. Image
4.38 4.38 is a microscopic view of the grain structure in an
image (a detail of 5.52) taken on Kodachrome 25 (ISO 25).
4.39 Image 4.39 shows the grain in a similar image, with film
rated at ISO 100.

When I first decided to show this comparison, I never imagined
the results would be as dramatic as they turned out to be.

4.38 Kodachrome 25, under a microscope.

4.39 Ektachrome 100, under a microscope.

4 / Basics of
Picture Making

Notice the difference in clarity between the images; the first
has more detail and is considerably sharper. Imagine how
this exercise might relate to your work, and consider how impor-
tant clarity is in communicating structure in your final image.
Because I am encouraging you to make the best picture possible,
not necessarily the quickest, especially if you intend to enlarge
your images to see various features, I suggest that you use
a slow film if possible.

(An added note: Most photographers agree that no film compares
to Kodachrome 25 for sharpness and detail. Unfortunately,
at the time of this printing, Kodak announced plans to end pro-
duction of Kodachrome 25.)

➤ *Lens aperture* or *f-stop* is a measure of the lens opening.
The designation for f-stop, for example f/22, should be read as
a fraction, that is, "f over 22." That way you will understand
why an f-stop of f/22 has a smaller aperture than f/11. As you
decrease the size of the aperture ("stopping down"), you de-
crease the amount of light falling on the film plane. Conversely,
the wider the aperture (the smaller the number), the more
light you let enter the lens.

You might ask, why not simply use the widest possible aper-
ture, allowing more light to reach the film plane? The complica-
tion when adjusting aperture settings is that you are also
affecting depth of field. As it turns out, the larger the aperture
(the smaller the f-stop number), the more you lose depth of
field. I discuss this in further detail on page 66.

➤ *Shutter speed.* The faster the shutter speed, the shorter the
time your lens is open, allowing less light to reach your
film. Conversely, the slower the shutter speed, the longer your
shutter is open, allowing more light to reach the film plane.

Theoretically, you should be able to make an image with any
shutter speed needed to get the right amount of light on
the film. You will see, for example, some two-minute exposures
in this book. I wanted to get the best depth of field, stopping
down the lens as far as possible. Long exposures work best
with the following conditions:

- Light sources are halogen or fiber-optic light and/or the
 built-in light source in your microscope

- The sample is stationary (not in liquid and without moving
 parts)

- The camera is securely mounted on a vibration-free micro-
 scope or tripod

Before starting, be sure that a long exposure will not damage
the material, such as by bleaching in fluorescent microscopy.

The "Best" Exposure

Many useful books describe the technical details of obtaining
the best exposure. For our purposes, I would like to suggest
an unusual premise that will disturb some of my photographer
colleagues:

Don't waste time getting the perfect exposure.

One may follow a number of rules and systems, using gray
cards and zone systems (for black and white printing, for exam-
ple), to determine the "best" exposure. My experience is
that the best depends on your taste and how the final image will
be used. Sometimes I prefer an image that appears slightly
dark where the colors become highly saturated. Then for some
images I prefer having a softer, more pastel look. So much
depends on the subject (and my mood).

To complicate things further, the "right" exposure depends on the preferences of art directors and the equipment used by the printing companies. Now that most of your image submissions are required to be digital, your final scans (see page 252) will probably be adjusted by the journal. To cover all bases, bracket your exposures, and scan the image you believe comes closest to the best presentation.

Bracketing means taking a series of exposures, underexposing and overexposing beyond what your meter tells you is the best exposure. I prefer to bracket by half stops, as described below.

Making Your Exposure(s)

Read the following while holding the camera and lens in your hand, without necessarily taking a picture.

Set your camera to the ISO of the film you are using. This is important. Your camera has to "know" how to read the light so that the exposure meter will give you the correct readings for you to then set the appropriate shutter speed and aperture. This should be the first thing you do especially if you are sharing your equipment because your colleagues might be using different film.

Let's say your meter tells you the ideal exposure is f/8 at 1/4 second. Release the shutter for that setting and make your first exposure.

Then take a series of underexposed frames:

➤ 1/4 sec at the midpoint between f/8 and f/11

➤ 1/4 sec at f/11

➤ 1/4 sec at the midpoint between f/11 and f/16

The logical sequence for going the other way to overexpose would be:

➤ 1/4 sec at the midpoint between f/8 and f/5.6

➤ 1/4 sec at f/5.6

➤ 1/4 sec at the midpoint between f/5.6 and 4

However, because you will be losing depth of field as you open your lens to larger apertures, it's best to adjust the last three brackets by changing the shutter speed as well to keep the smallest aperture possible:

➤ 1/4 sec at the midpoint between f/8 and f/5.6

➤ 1/2 sec at the midpoint between f/8 and f/5.6

➤ 1/2 sec at f/5.6

If you are using a microscope, you will not be able to bracket so precisely because of the absence of a lens. You can still determine a similar sequence of exposures by adjusting the aperture in the scope, along with adjusting shutter speed. The brackets will be more approximate.

Bracketing, of course, can only be used when you have the opportunity to take a series of exposures, but this will not always be the case.

4.40 Image 4.40, fluorescing polymer rods (see the following pages), is a grid of images showing nine brackets. The enlarged "best" exposure is on the left.

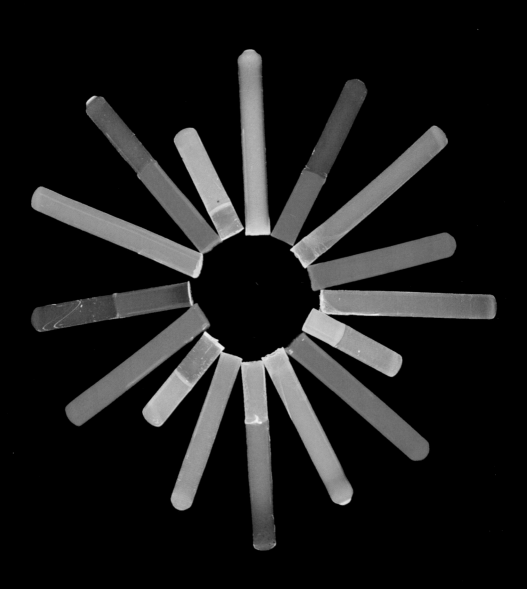

1 SECOND

2 SECONDS

4 SECONDS

8 SECONDS

15 SECONDS

30 SECONDS

60 SECONDS

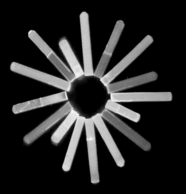

120 SECONDS

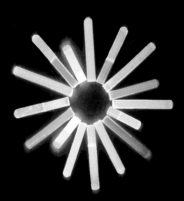

180 SECONDS

DEPTH OF FIELD

The previous reference to f-stop only addresses how aperture
setting relates to exposure. The other very important factor to
remember is that when you change your f-stop, you affect
how much of your image will be in focus, or the depth of field.

As I mentioned before, the designation for f-stop, for example
f/22, should be read as a fraction, that is, "f over 22" to
understand why an f-stop of f/22 has a smaller aperture than
f/11. So therefore, as you close down your lens to what appears
to be a larger number, you are actually decreasing the size
of the aperture at which you will be making your picture (and,
from the discussion on exposure, you will also decrease
the amount of light reaching your film). As the aperture gets
smaller, more of the image will appear in focus, and therefore
you will have greater depth of field. Conversely, taking your
picture with a larger aperture (a smaller f-stop number) decreas-
es depth of field, and less of the image will appear in focus.

4.41

4.42

The following images are examples of how closing or "stopping
down" my lens increased the depth of field. In 4.41, I opened
the lens to f/4. Notice that the hanging nasturtiums in the
background are not sharp. In 4.42, I stopped the lens down to
f/32, the smallest aperture on this particular lens. Everything
appears to be in focus as I increased the depth of field.

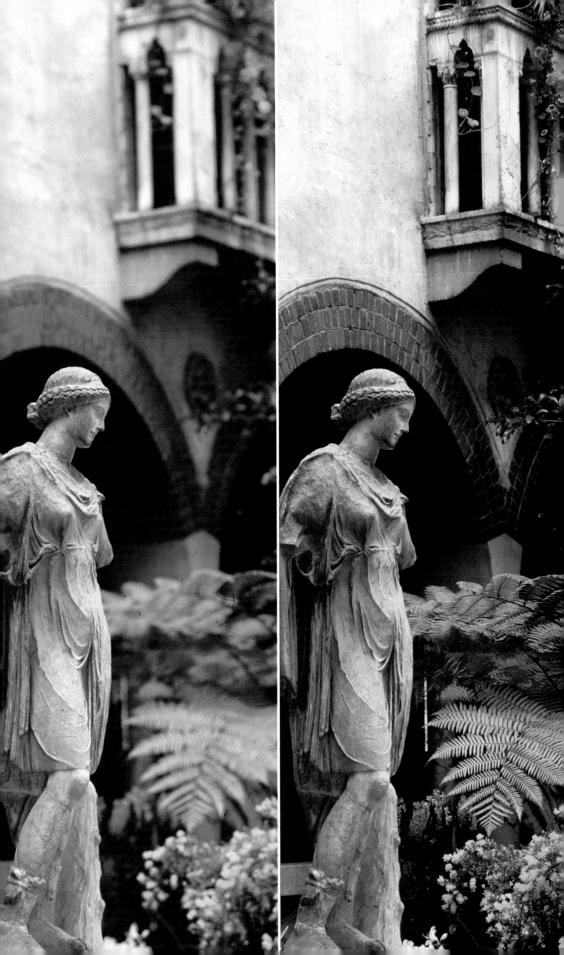

DEPTH OF FIELD

4.43–4.46

The same is true for whatever size object you are shooting. A series of images of an old bookbinders' stamp (4.43–4.46) demonstrates how stopping down the lens affects what appears in focus.

Before you release the shutter, you should know what will be in focus.

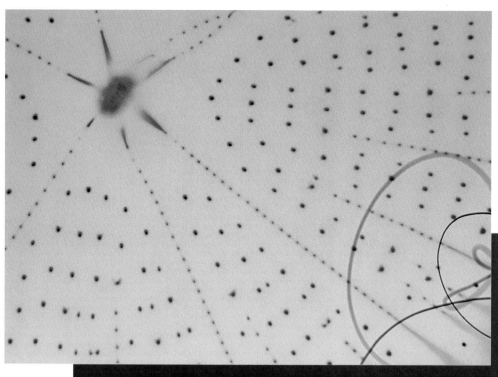

4.47 The "surprise" appeared when I got the film back. I didn't use my depth of field preview button while making the image.

Don't assume that what you see in the viewfinder is the way
the final image will look. Very likely you will be using a camera
that will show you the image in the viewfinder at the widest
lens aperture. When you release the shutter, the lens will
close down to whatever f-stop you previously set on your lens
(adjusted for exposure). For that reason, it is essential that
you depress the preview button (see equipment) or read the
numbers on the lens to determine what will be in focus. (Read

4.47 your manual.) In image 4.47, I forgot to depress the preview
button to see the final focus at f/32. When I looked through the
viewfinder, I didn't notice the hair, which came into focus as
I released the shutter. It was stuck at the back of the lens, but
I have no idea how it got there. At the widest lens aperture,
the hair wasn't in focus.

Use your preview button.

4.48 In 4.48 (see the following pages), I purposefully shot at a
very narrow depth of field, that is, at the widest aperture, focus-
ing only on the drops of water on the leaf. In this case I liked
the effect, but generally I shoot with the maximum depth of
field—the smallest aperture. You have such options when using
a lens and a camera with manual control. Unfortunately, your
options become more limited when you must use a microscope
to capture your images.

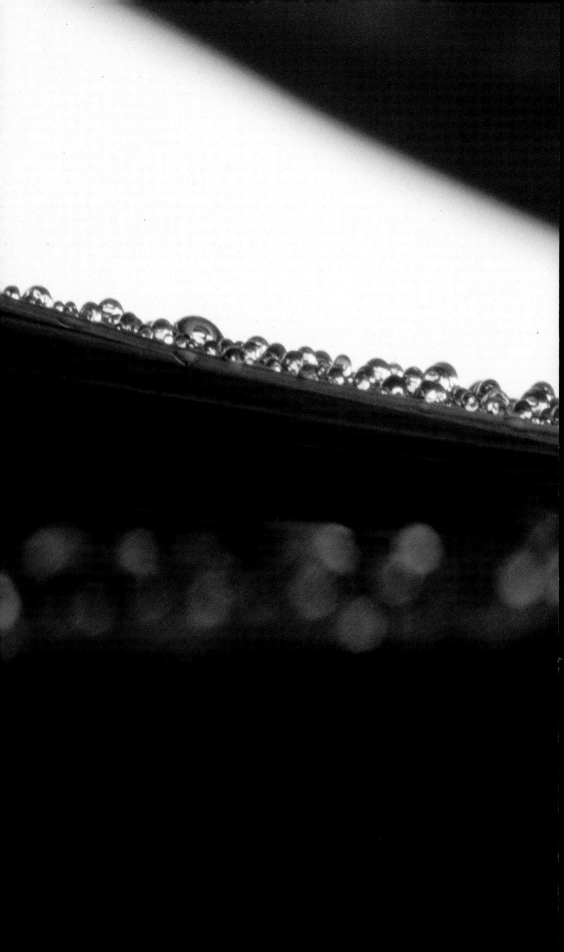

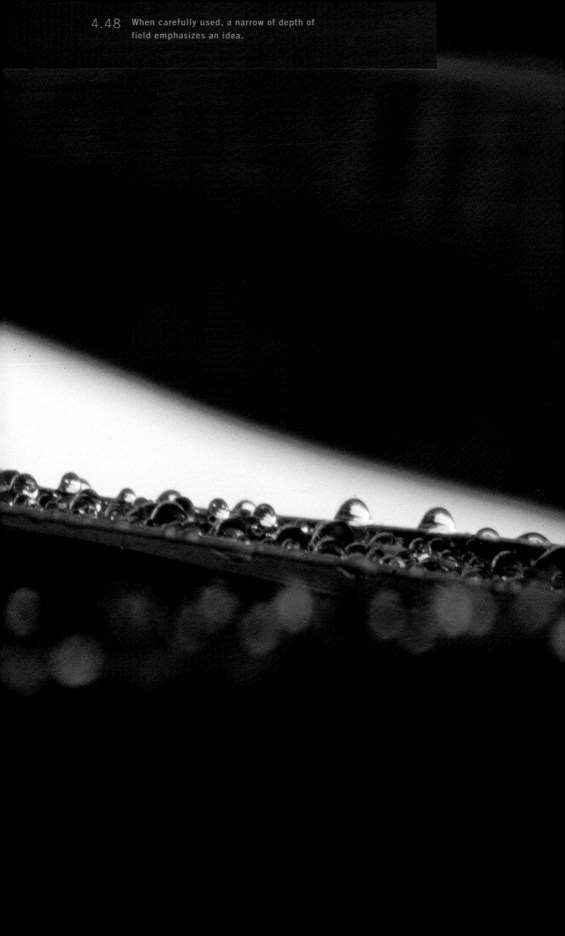

4 / Basics of
 Picture Making

EQUIPMENT

At the beginning of each chapter, you will see a brief list of
equipment appropriate for the scale under discussion. Whatever
equipment you choose, whether a camera or a microscope,
you must be sure it has the best optics, is sturdy, and, most
important, that you understand how to use it. Take the time to
read the manuals.

I am convinced that one of the reasons I became a photographer
was because I started taking pictures using the best equipment
while understanding its limitations. Most of my results were
satisfying from the beginning. Those that weren't were due to
my own limitations, not to those of the equipment.

The 35 mm Camera

I use a Nikon F3. I am not suggesting you must buy this par-
ticular camera, but you should purchase one that has at least
the following essential capabilities:

➤ Through-the-lens metering allowing simple exposure
 determinations

➤ Manual capability for both aperture and shutter control

➤ Removable viewfinder and focusing screen so that you may
 replace the viewfinder when necessary with a special viewfinder
 and focusing screen that compensates for your eyesight when
 making photographs through a microscope. If you're using a digi-
 tal camera, the viewfinder is helpful but no longer essential.
 This special viewfinder will allow you to first adjust the camera
 to your eyesight so that when you focus with the microscope
 knobs, you will be focusing for the film plane or CCD (charge

coupled device). I outline the procedure for using this important attachment in chapter 6 (see page 149).

➤ T and B (time and bulb) shutter settings for long exposures

➤ A mirror lock-up to help prevent camera vibration. It's best to lock up your mirror when using a long lens for 1- to 4-second exposures. First compose your image and determine the exposure. Then lock up your mirror, being careful not to move the camera (refer to your manual). This will take practice.

➤ A preview button. By depressing the preview button for close-up work, you will determine what will be in focus when you release the shutter. Read your manual on how to use it.

Optics

If you are using a lens, use the best available to you. The optics, simply, must be the finest to present your work in the best manner. Don't use a zoom lens; its quality is not comparable to a stationary lens. In chapter 5, I suggest which specific lens you should use for photographing on a small scale. If you are not shooting with a camera lens, your microscope should likewise have the highest quality optics.

Accessories

➤ Cable release. Get into the habit of releasing your shutter with a cable release to prevent vibration.

➤ A high-quality haze filter for your lens. If you share your equipment, protect the lens with a filter in case your colleagues are not as careful as you are. It's preferable not to add another

4 / Basics of Picture Making

layer to the optics, but it is better to scratch a filter than the lens.

Tripod

When you use a camera and lens, it is essential to use a tripod onto which the camera is mounted. Along with the technical issue of preventing vibration in your image, it is good practice to use a tripod for the simple reason that it will slow you down. As you take more time to photograph your work, you are apt to pay more attention to framing your image than if you were hand-holding the camera.

4.49

You must use your tripod correctly. I didn't do so when I photographed the gels in a petri dish, 4.49. Instead of raising the camera by extending all three legs on the tripod, I only raised the center rail (I was in a hurry). I essentially made the tripod into a monopod, a more unstable configuration. The entire image is out of focus because of camera vibration.

4.50

Compare it to the sharper image, 4.50, when I used the tripod correctly.

Quick-Release Mount

A quick-release mount on my tripod and camera enables me to quickly attach and detach the camera and tripod. This comes in handy when you need to photograph in several locations, such as when you are shooting various parts of large set-ups. It's not wise to move your tripod with the camera attached, and

it saves you from the frustration of having to screw and unscrew the camera to the tripod.

Film: Slide Film (Color Reversal) vs. Color Negative

I use slide film for a number of reasons. First, I find the quality of the image for reproduction and scanning is superior to the results with negative films, and it is less expensive to process than color negative film when comparing the single roll of slides to color negative prints. It's also easier to store and retrieve images (see chapter 8). Moreover, you will probably use only one to five images per roll. Getting a bunch of unusable prints is not only expensive but also cumbersome. You can easily scan the one or two slides you will ultimately use to make a quick print for your notebook.

If you need black and white images, you can convert color images to black and white after scanning.

Therefore, to simplify life, I suggest using color slide film. I discuss scanning on page 252 in chapter 8.

In addition, color prints from your local 60-minute photo store will not give you the quality you want. The automatic machine, which reads the lights and darks of the negative as an average, makes unacceptable prints, usually cutting off a considerable amount of the image from the frame. It amazes me how a number of research laboratories that operate under some of the most rigorous standards in science research use quick and

dirty (and I do mean dirty) and expensive photo developing labs. Unfortunately, some so-called professional labs don't change their developing chemistry frequently enough, and the personnel don't pay sufficient attention to quality. Processed slide film is all too frequently embossed with another stamp of sloppiness in the form of smudges and scratches because of poor slide-mounting techniques. I am bothered by film processing labs getting away with bad work simply because they are near universities and are convenient.

Find yourself a photo lab with a staff that takes pride in how they process film. Ask them how often they change their chemistry, and if they don't want to discuss it, walk out the door. You will be happier years from now when you return to your archive and find the same image you remember, not one that faded to yellow because the film was improperly fixed. In addition, don't accept scratched film. If the person at the desk insists the scratch came from your camera (which could be the case), ask for help in investigating the problem.

Film, Color Balance

Color film is balanced for either daylight or tungsten light. Although you will be able to color correct the image after it is scanned, it's a good idea to start with the proper match. If you are shooting in the daylight, you should use daylight-balanced film. If you are using tungsten lamps, you should use tungsten film. I discuss fluorescence in later chapters.

A NOTE ON DIGITAL AND FILM

At the time of this printing the consensus is still unclear
in the world of professional photographers whether digital will
completely take over picture making. There are no simple
answers to the question of which is "better" than the other,
and you must be cautious of reviews that address only the dif-
ferences in resolution. Color, hue, and luminance for both
film and digital, for example, are also important considerations,
and the differences are almost impossible to measure—
something like comparing the proverbial apples and oranges.

The verdict is still out for me. I have been experimenting
with a Nikon D1X, which takes all my Nikon lenses and easily
attaches to my microscopes. The preliminary images seem
fine, but they are small in this book, which is not a rigorous test.
(See the first and third equipment images on pages 146 and
147, in chapter 6). In addition, I am not yet convinced I will be
able to digitally capture certain qualities of light or nuances
of color as I can with film.

Fine-grain film still gives more detail than digital, and that
benefit becomes more apparent in large-format prints. However,
if you are only preparing your pictures for journal publica-
tion, without enlarging a detail, then digital capture might be
enough. All depends on the final use of the images.

You may find the speed of digital capture is beneficial. There
is also the distinct advantage that what you see is what
you get. The choice should eventually be yours, but to make
that choice, you must make your own tests.

The basics of photographing your work are the same whether
you use digital or film capture.

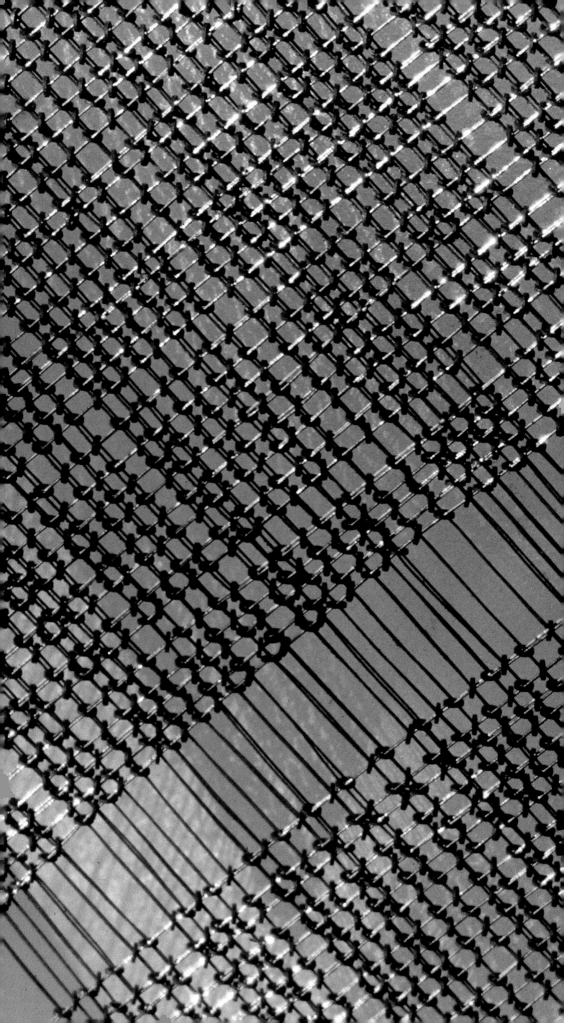

5 / Photographing Small Things

5 / Photographing Small Things

INTRODUCTION

INTRODUCTION

By "small things" we mean objects measuring 4 mm to 10 cm. They require separate discussion both because they are such an important group of objects and, from our perspective here, because they can be photographed without the use of a microscope. Using macro techniques, the basics of lighting, composition, and depth of field, objects of this size can be captured with conventional equipment. You, as photographer, retain most of the control and can infuse the image with a point of view while preserving the integrity of the science.

FOR OBJECTS BETWEEN 4 MM AND 10 CM YOU WILL:

➤ Choose the position of your camera

➤ Control depth of field and shutter speed because you continue to use a camera and lens

➤ Control the quality of lighting

➤ Select backgrounds

➤ Make decisions about composition

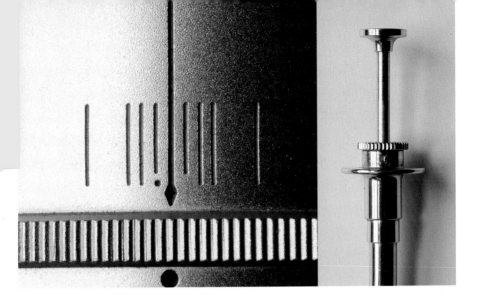

EQUIPMENT

CAMERA 35 mm camera with built-in meter, manual capabilities and pre-view button giving you control of exposure, aperture, and depth of field

ACCESSORIES Interchangeable focusing screen specifically designed for close focusing (see chapter 4, Basics)

Cable release

105 mm or 60 mm macro lens

Extension tubes

Sturdy tripod and copy stand

Quick-release mount

LIGHTS Two or more small lights (fiber-optic or small monolights)

White or colored cards for bouncing or fill

Light table

Handheld UV lamps (optional)

Small standing mirror for fill (optional)

SUGGESTED FILM 64 ISO tungsten slide film (color reversal) for incandescent light source

50 ISO/100 ISO daylight slide film for natural light from window

Never use magnifying filters. Their optical quality is not comparable to that of the lens.

5 / Photographing Small Things

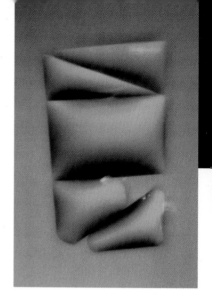

SAMPLE
PREPARATION

SAMPLE PREPARATION

As noted before, the first-time viewer will see your picture as
a whole, imperfections and all (for another discussion of sample
design, see chapter 6, page 152). Although many researchers
photograph actual samples from their experiments, I've found
that samples prepared specifically for the photograph improve
the visual expression of the work, resulting in a simpler, clearer
representation of the science. Moreover, thinking about what
to include in that sample (and what is not necessary) will help
you determine for yourself which components are essential
elements of the experiment and perhaps ultimately clarify your
thinking about the science.

YOUR SAMPLE SHOULD:

➤ *Have as few scratches and as little dust as possible.* Imperfec-
tions distract the viewer's eye. If you're unable to prepare
a clean version of your work, consider digitally "cleaning" the
image after scanning from film to a computer.

If you choose to clean your image after scanning, you must
be careful to protect the integrity of the information your
image represents.

Digital alterations of the image may also change your data.
(See chapter 8 for a detailed discussion of this important issue.)

5.1/5.2 ➤ *Emphasize the point of the work.* Images 5.1 and 5.2 show
two different samples of patterned surfaces. In both images, the
water "drops" wet the hydrophilic surface until the drops

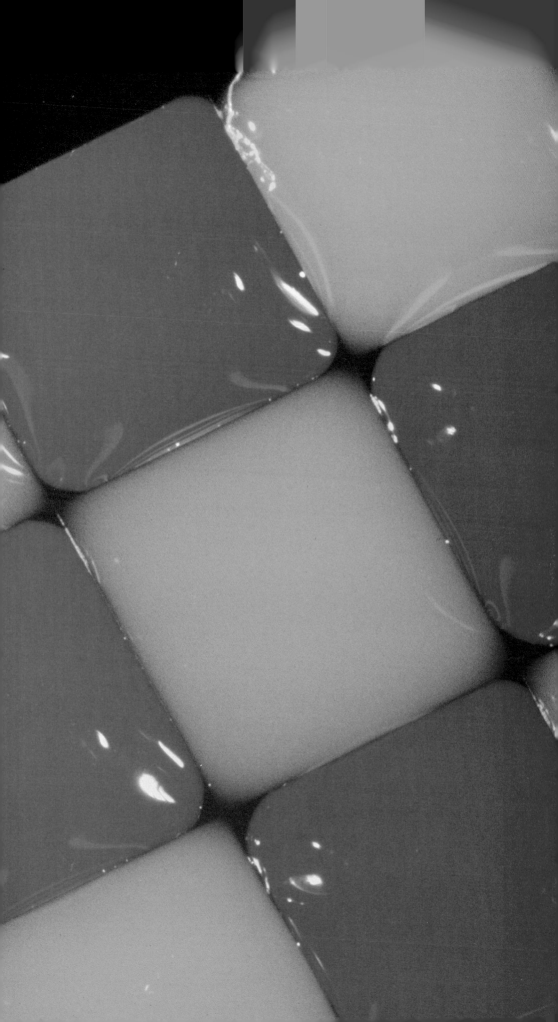

5 / Photographing
Small Things

reach the hydrophobic-etched lines, where they stop spreading. The researchers prepared the sample and photographed 5.1. We redesigned the sample to produce photograph 5.2. The etched lines in 5.2 form a more interesting grid pattern and, by coloring the water with fluorescing dyes, we see no mixing of the water. The photograph succeeds on two levels: it is visually compelling (and not unimportantly, in focus), and it is a clearer representation of the chemistry.

Study the sample you are photographing. Does it clearly demonstrate the point of your experiment? Is there a better way to communicate the idea?

5.4 / 5.5 The 1 cm patterned wafer on the left shows part of the fabrication process of the pyramid on the right.

Using Multiple Samples

5.3

Including more than one sample in a single image is a powerful
technique (see 5.3), increasing the interest and importance
of your picture on more than one level. Additional samples con-
tribute to the aesthetic appeal of your image through repetition
and also imply that your scientific results can be replicated.

Telling a Story

5.4

5.5

5.6

Suggesting how you made your sample can add a valuable
dimension to the picture. Image 5.4 shows a patterned
wafer used to fabricate the three-dimensional pyramid shown
alone in 5.5. These two images tell only part of the story.
With the addition of image 5.6, which contains both elements,
the sequence suggests how the pyramid was made, creating
a more complete story than just one image.

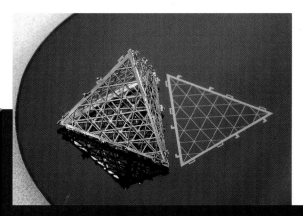

5.6 Placing the pyramid structure on the wafer
results in a third image. The three images
together tell a visual story.

5 / Photographing
 Small Things

SAMPLE
PREPARATION

5.7 Consider image 5.7 as a series of elements combined to create
 a more complete visual representation of the engineering.
 The two small chips resting on the larger wafer were designed
 for drug delivery. By combining three elements in the image,
 I was able to present more information in an appealing way.
 (The background is a large wafer fabricated from the series of
 chips; two chips are resting on it; and the underside of a second
 wafer showing the apertures for drug transmission is on top.)

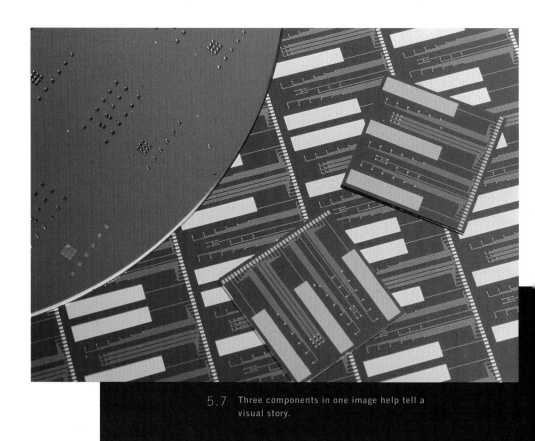

5.7 Three components in one image help tell a
 visual story.

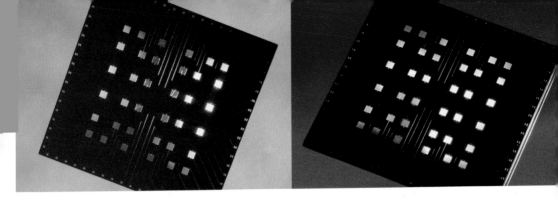

BACKGROUND: MAKING A SELECTION

Despite the importance of background to a successful photo-graph, most researchers don't give a great deal of thought to this essential element. An appropriate background enhances the visual power of your image, and the wrong choice can be distracting. The key to finding an effective background is to select one that complements the sample without drawing attention to itself.

Consider the following when choosing a background for your image:

Texture

As your lens gets closer to the sample, you'll see unnecessary detail in the background. To avoid this problem, choose a background without any texture to ensure that the viewer's eye goes to the primary material, not the secondary backdrop.

Color

Because color has a powerful impact on how your sample will be viewed, color choices need careful consideration. There are few rules to help you make a decision because color preferences are so subjective. Instead of choosing a color based on your personal taste, select one that complements your sample or one that picks up a hue in that sample. Images 5.8 and 5.9 show the same sample with different backgrounds.

5.8/5.9

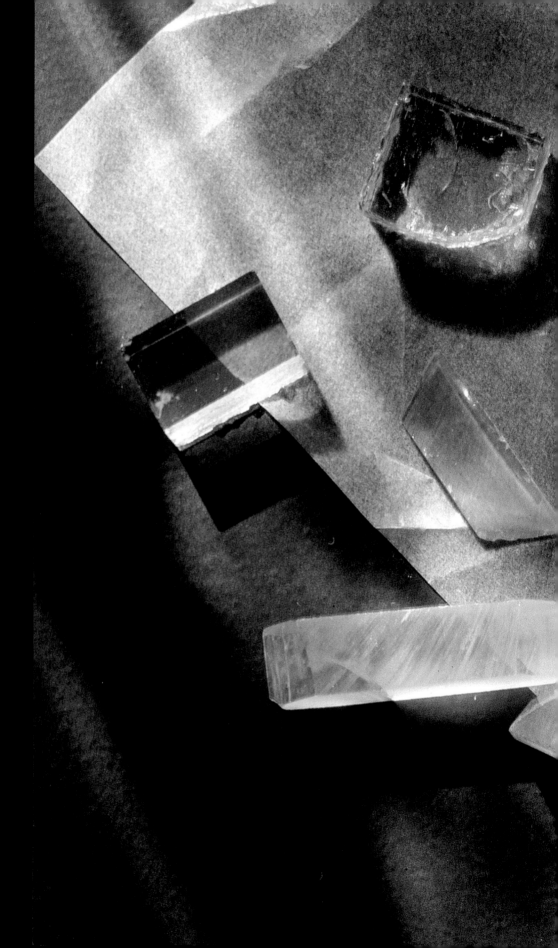

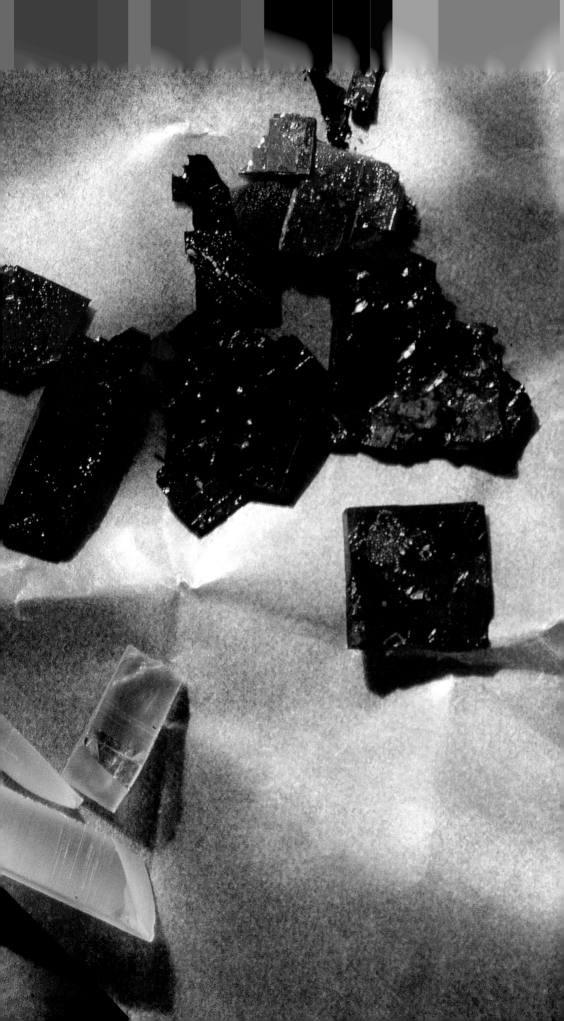

5 / Photographing Small Things

5.10

In 5.10 (see the preceding pages), I used wrinkled weighing paper on my gray desk as a background for the laboratory grown crystals. The weighing paper, familiar to most researchers, also suggests a sense of scale (see pages 130–133 for a discussion of scale).

Broaden Your Background Choices

Ordinary items can serve as subtle and interesting backgrounds. You'll be surprised at how many useful objects you can find

5.11

in your house or in your lab. In 5.11, I used a turquoise glass tray as a background to complement the colors of a more magnified version of the laboratory grown crystals seen before.

Reflections

It is usually best to avoid highly reflective backgrounds, which can be distracting. However, in some instances, reflections

5.12

off your background can be interesting, as in 5.12, and complement the image. The colored reflections off the glass surface on which the sample is resting are appealing, and they reinforce the nature of the polymer's surface by echoing its colors.

More Stories to Tell

A carefully selected background can emphasize a particular

5.13

aspect of your work. In 5.13, I placed the gold chips patterned with water drops on a larger gold wafer, which is used to fabricate the smaller chips.

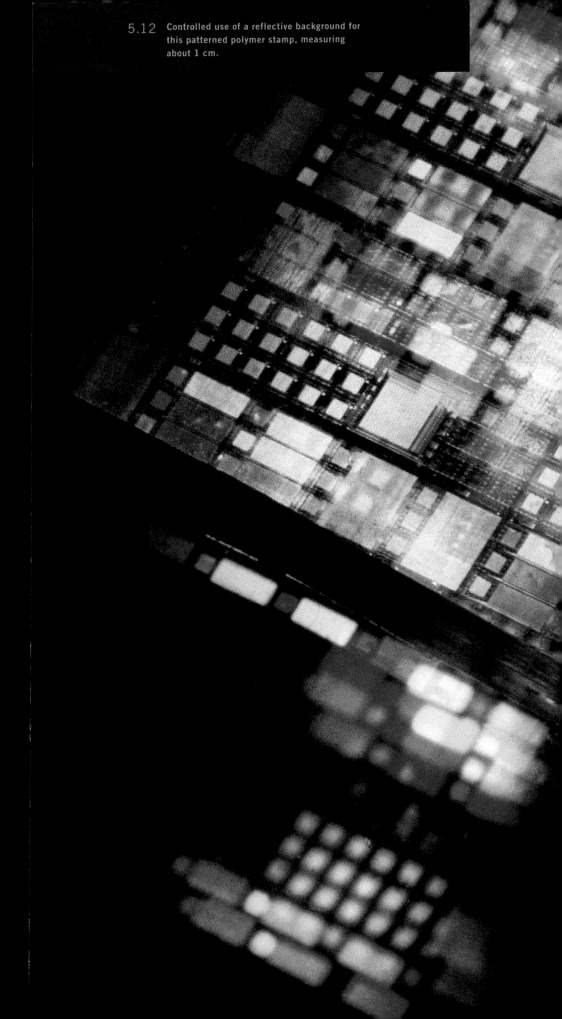

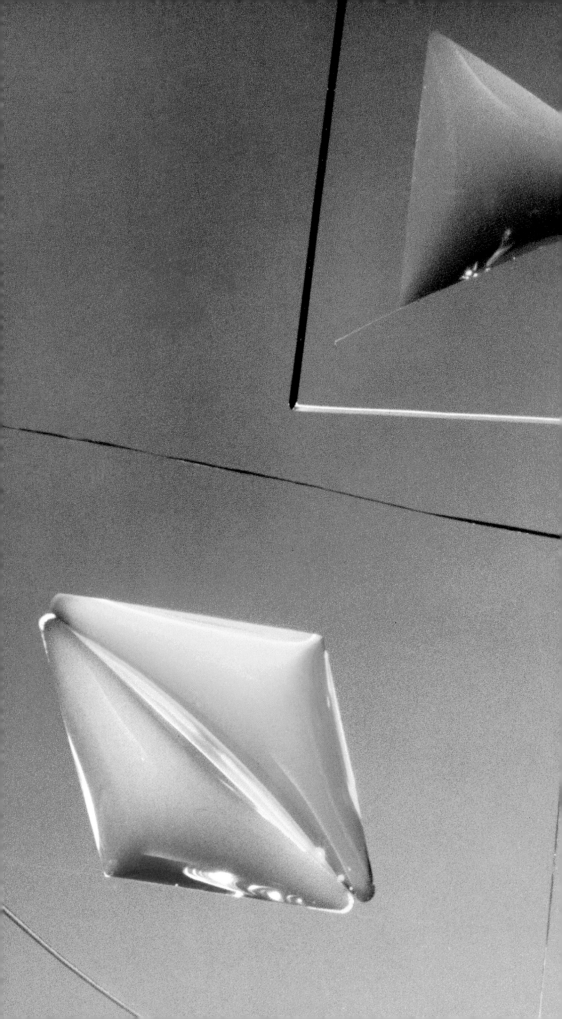

5 / Photographing
Small Things

CAMERA/SAMPLE
ANGLE

CAMERA/SAMPLE ANGLE

Always look through the camera's viewfinder to determine the
best angle for your photograph.

Choose the Angle

Before you set your camera on a tripod or copy stand, you
must choose the angle. To determine the best angle for your shot,
look through the viewfinder while holding the camera in your
hand and move it around your sample. As you will see through
the viewfinder, different camera angles offer different advan-
tages. An overhead shot (5.14) may not be as descriptive as one
taken from another angle (5.15). You may discover that a
series of images taken from a number of points of view is the
best way to communicate your work.

5.14
5.15

Move the Camera

If you decide to shoot from eye level, raise and lower the camera
on the tripod while looking through the viewfinder. Notice the
subtle changes that occurred when I moved the camera. In 5.16,
the tip of the metal structure is too close to the back curve
of the wafer and may be difficult to read. By raising the camera
just slightly in 5.17, you can see each component separately,
which brings clarity to the image.

5.16
5.17

To make sure your image is as unambiguous as possible, avoid
overlapping lines.

5.18

5.19

Small changes in camera position—even changes from the
same perspective—will have significant effects. In 5.18 (see the
following page), I shot the image from above at an angle that
allows the viewer to see reflections of the etched lines dividing
the squares. By moving the camera just a few centimeters in
5.19, I eliminated the reflections. This slight shift also affected
the shape of the grid, turning it from a square to a diamond.

5.16/5.17 Only a slight change in camera angle results in
the easy to understand image on the right. You
have this kind of control when you use a tripod.

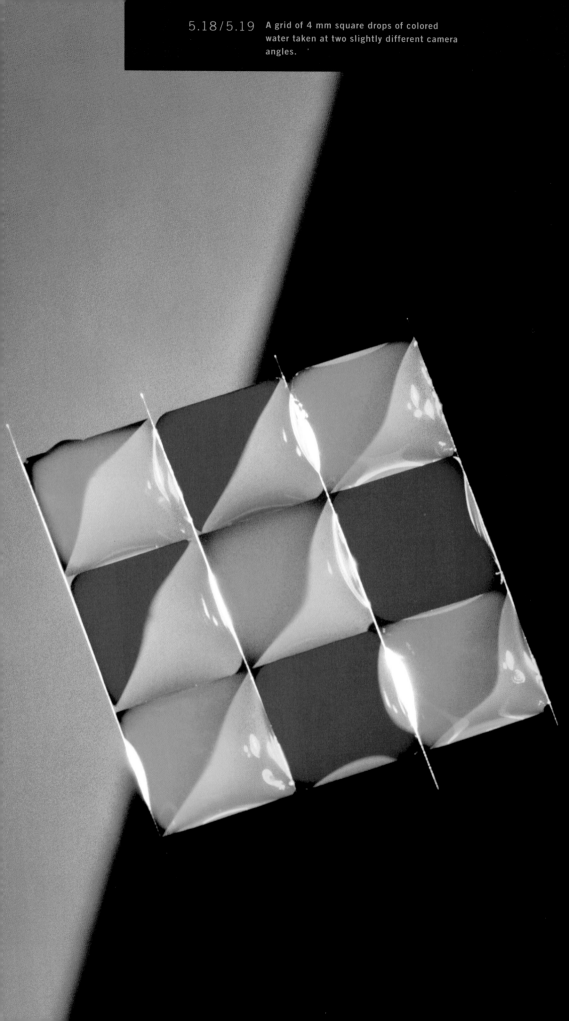

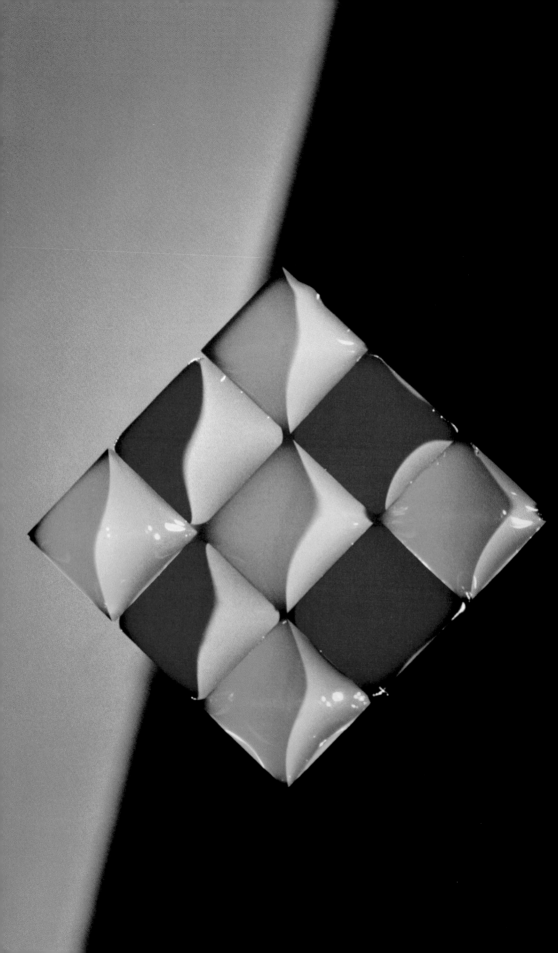

If you decide to shoot from bench level and see a distracting horizontal line from the back edge of your table, you can eliminate the line by hanging a piece of paper from the wall and draping it over the table. (Professional studio photographers use large rolls of seamless paper as background for product shots.) Compare images 5.20 and 5.21.

5.20/5.21

It's well worth the effort to examine all the possibilities by searching for the best angle(s) for your photographs. You'll not only create a better image, but you also will see your own work in ways you never imagined.

5.22–5.25 The identical sample of a 3 cm structure photographed from different angles.

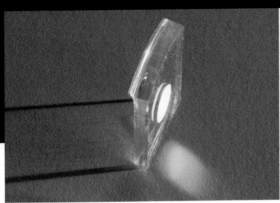

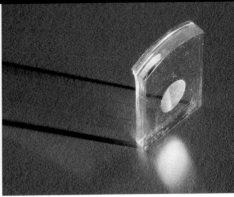

CAMERA/SAMP
ANGLE

Move the Sample

5.22–5.25

Sometimes it's easier to move the sample to achieve different points of view. In 5.22 through 5.25, I placed the three-dimensional self-assembled construction at various angles while the camera remained stationary (with only slight changes to the background). At first glance, it is difficult to believe these four images are of the same sample.

5.26
5.27

Whether you move the camera or move the sample, you can see that even a small change in angle, as seen in 5.26 and 5.27, can make a significant difference in understanding the shape of an object.

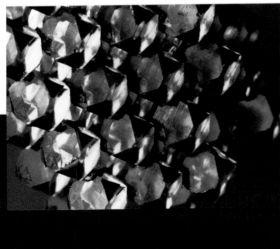

LIGHTING

As you being to experiment with lighting your sample, you will
notice right away how slight adjustments change the way
the sample looks. Learning to adjust the angles and the lighting
together, to get the best possible picture, is fundamental
to the outcome both from the point of view of scientific accuracy
and aesthetic appeal. It is important to be flexible, so although
I recommend a certain order in the process of making pic-
tures, there is no doubt that each decision in the process affects
the others. At times you will find yourself going back and
forth between steps. That is particularly clear as you begin to
use lighting.

The lighting you select will depend on the nature of your sample.
If you're emphasizing a surface, use lighting that reflects
off and defines that surface. This kind of light is referred to as
reflected light or *epi-illumination*.

Reflected Light: Direct vs. Bounced Incandescent Lighting

DIAGRAM 5.1

5.28/5.29

Light that directly illuminates your sample has a different
quality than light directed onto a card and "bounced" back onto
the surface. Notice the difference between 5.28 and 5.29.
In the first image, I pointed a small lamp directly toward the
sample. In the second image, I first directed the lamp onto
a gold card and then bounced or redirected the more diffused
light toward the sample. For highly reflective surfaces, bouncing
light off a white or appropriately colored card helps communi-
cate the nature of the material without adding distracting
reflections. In 5.29, the color from the card (gold in this case
since the material was gold) makes the surface appear uniform.

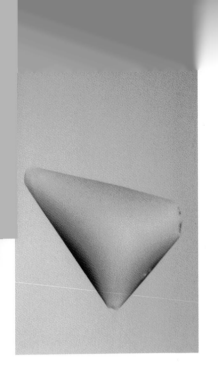

DIRECT LIGHT

BOUNCED LIGHT

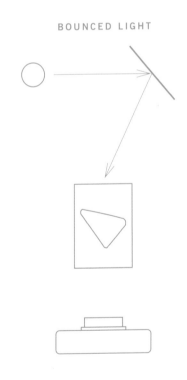

The angle of the reflecting card is important;
for further information, see page 104.

DIAGRAM 5.1 **Direct light on the left, bounced light on the right.**

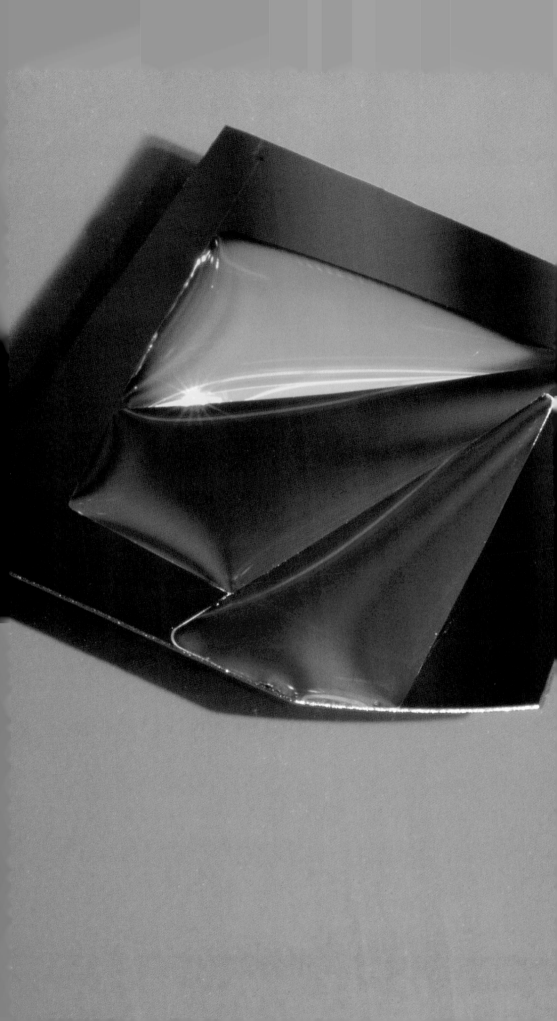

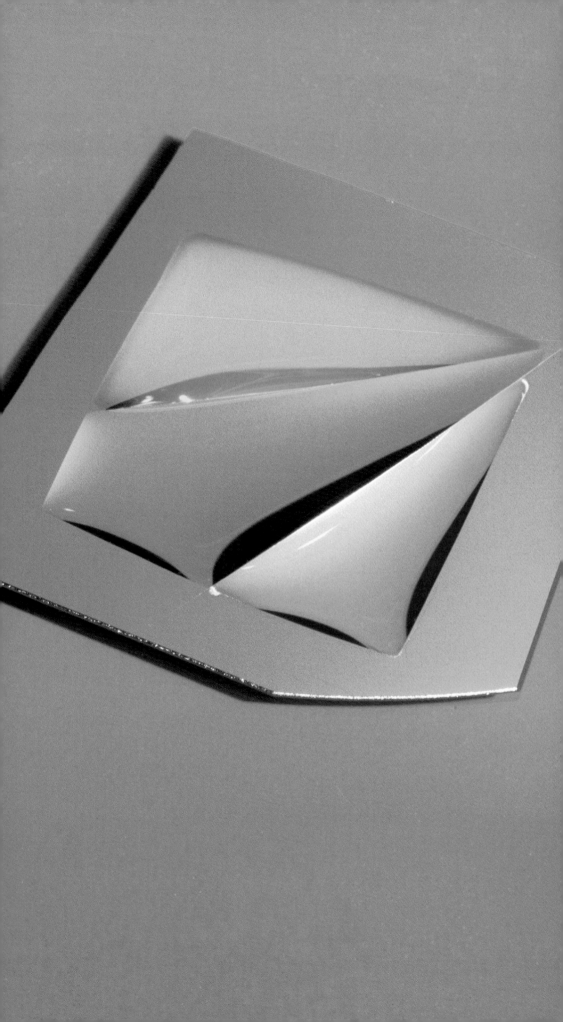

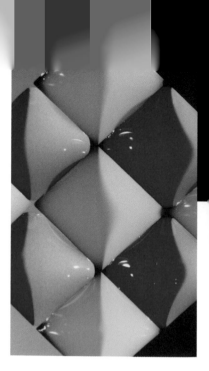

5 / Photographing Small Things

LIGHTING

5.30 / 5.31

Images 5.30 and 5.31 (see the preceding pages) show another comparison between direct light on the left and bounced light on the right. In the first image, the light was far away from the sample so the lamp's reflection is not obvious.

The simple technique of bouncing light off a card must be handled carefully. Slight variations in the card's angle change the final image. In 5.32 the water drops appear to have four different dyes, two tones of green and two tones of purple, although only two dyes were used. When we submitted this image for publication to *Science*, the editors felt the image was ambiguous because it included unintended information in the various colors. In 5.33 there is less ambiguity because

5.32

5.33

5.34 Watch for variations in reflections. You cannot detect them here because of the narrow depth of field.

I held the card at a different angle. However, despite the change, you still see two tones of purple on the right.

Slight changes in your light source will make considerable differences in your photographs.

Reflections
Highly reflective surfaces can be problematic to photograph because you might inadvertently include unwanted reflections in the picture. In 5.34, because the aperture was at its widest f-stop, indiscernible reflections are not distracting. However, because the narrow depth of field didn't give me the focus I usually prefer, I stopped the lens down to produce

5.34

5.35 In this more focused image, however, the reflections become distracting.

5 / Photographing Small Things

5.35 a sharper image, 5.35. Unfortunately, shooting at a smaller aperture brought more unwanted elements in focus, in this case, the window reflection. The image is difficult to understand. (See the section on depth of field in chapter 4.)

5.36 You can sometimes use a sample's reflective quality to your advantage. In 5.36 I held a green card over a 3 cm drop of ferrofluid, giving the black oil suspension of magnetite an interesting reflection without compromising the material's nature. The seven circular magnets beneath the glass on which the ferrofluid sits produced the floral shape.

Shadows

A shadow is a strong component in an image. A viewer's eye is usually drawn to a shadow, so it should be used to help communicate something about the sample. Notice how the

5.37 shadow in 5.37 emphasizes the intricacy of the structure while

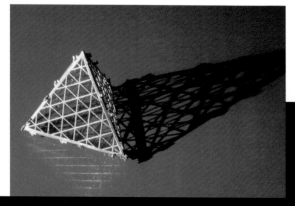

5.37 When used properly, shadows can enhance an image.

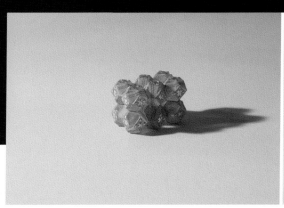 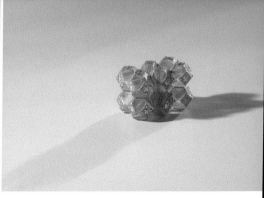

LIGHTING

adding an interesting aesthetic component. Additionally, the
placement of the shadow encourages the viewer's eye to travel,
in this case to the right, giving the eye a place to go. (See
composition, page 41). However, if a shadow isn't adding or
reinforcing an idea, it can complicate your image unnecessarily.

5.38
5.39
DIAGRAM 5.2

The distance and placement of light on your sample will give
different lengths and qualities of shadows. In 5.38 I used one
light from the left side, which adds a useful shadow. In 5.39,
by placing a mirror on the right toward the back, a subtler sec-
ondary shadow contributes to the image by giving it more bal-
ance. Simultaneously, the light reflecting off the mirror clarifies
the right side of the structure, helping to define its surface.

Always look through the camera as you decide where to place
your light source.

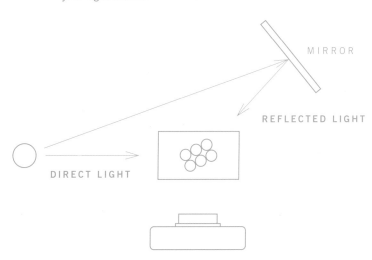

DIAGRAM 5.2 The set-up for image 5.39.

5.40/5.41 Shadows may help emphasize structure.
On the right, the diffraction grating inten-
tionally becomes more obvious.

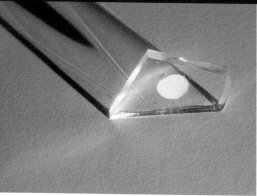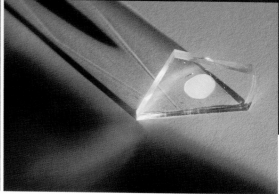

LIGHTING

5.40

5.41

A carefully placed shadow may help make a particular point
about your sample. In 5.40, the visible spectrum reflecting off
the diffraction grating was important, but it appeared only
vaguely on the table surface. Partially covering the light source
with a card (photographers call this "flagging") created a
shadow that made the reflected spectrum more apparent, 5.41.

5.42

5.43

Finally, a shadow alone, without the object casting it, may
sometimes be the best way to demonstrate particular forms or
phenomena. Image 5.42 is one of my many unsuccessful
attempts to photograph the Marangoni effect on the sides of a
wine glass. The best rendition of the phenomenon was pro-
duced by simply photographing the shadow alone, 5.43.

5.42 My first attempt photographing the
Marangoni effect.

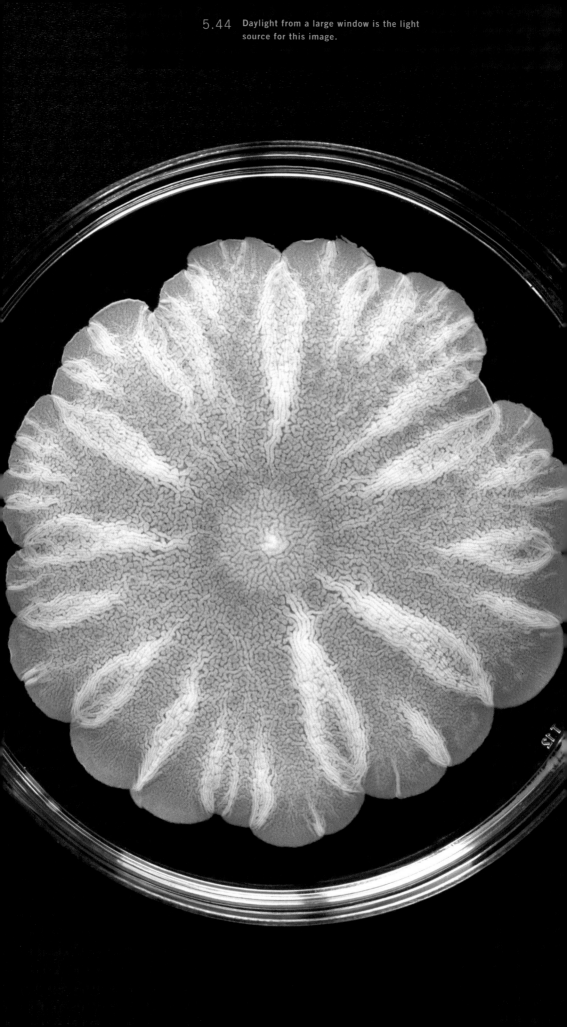

Daylight from a Window

A large window with direct sunlight may be a fine light source.
I shot 5.44 by placing the petri dish with the floral patterned
yeast colony in front of a large window. If I'd taken this picture on
a cloudy day, the resulting image would have had a heavy blue
cast. In 5.45, for example, the sun disappeared behind a
cloud just as I released the shutter. Compare this image to 5.7,
which was taken in front of the same window on a sunny day.
The blue cast in 5.45 can be digitally corrected, but such
corrections are difficult and time consuming to make. Relying
solely on natural—and therefore unpredictable—light for
your photographs can be frustrating and will make it difficult for
you to duplicate your results. To minimize frustration and
unpredictability, it's best to use more reliable light sources
(i.e., lamps).

If you're using a daylight source of light, load your camera
with daylight balanced film.

Fluorescent Lighting

Fluorescent lighting, which is common in laboratories, generally
gives images an unattractive cast. Color correction filters
placed over the camera lens may eliminate the problem, but for
best results, scan the photograph and then correct the color
digitally. (See digital enhancement, page 280.)

5.44

5.45

5 / Photographing Small Things

5.46 In 5.46 I placed the patterned wafer under simple fluorescent laboratory lighting. In this exposure the rod-shaped bulbs from the ceiling fixture make the image appear irregularly lit, and the wafer seems cropped. I find the "partial" wafer more inter-

5.47 esting than that in 5.47, shot in front of a large window.

Ultraviolet Light

At this scale, when you want to show fluorescence in a sample, you will usually need to use an ultraviolet light source. Hand-held UV lamps are convenient because you can easily move them around. Plan to experiment with exposure and find out which film best captures the various emitted wavelengths. You should

5.47 Compare this evenly lit image to the one above. Which do you prefer?

5.48/5.49 On the right, inappropriate film didn't cap-
ture the correct colors. I digitally "fixed" the
color on the right.

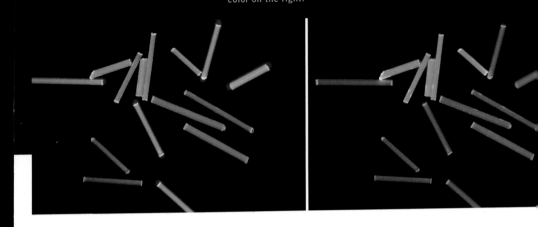

LIGHT

determine both in a preliminary photo session; don't expect to
get it right the first time around.

HERE ARE SOME SUGGESTIONS TO ENSURE THAT YOU
GET GOOD RESULTS:
> I've found that daylight film is best for fluorescence. Test
various films to see which one best captures the particular
wavelengths at which your sample is fluorescing.

5.48 In 5.48 I incorrectly used tungsten-balanced film. The
final image did not appear as I saw it; the film didn't capture
the orange wavelength as shown in the digitally corrected
5.49 version in 5.49. (See page 280 on image enhancement.)

> If you're using a UV lamp as the primary light source, turn off
all other lights since the long exposure will pick up ambient light.

> It's not unusual to have exposures of three minutes or longer.
I use a watch with a loud second hand to count exposure
time in the dark, using the "T" or "B" shutter setting. (For more
information on exposure settings, consult your camera manual.)

> Because you might need a long exposure, make sure your cam-
era is tightly secured on the tripod or copy stand and try to
anticipate and avoid room vibrations in the sample. Be logical.
Don't shoot when the contractors are renovating the floor below.

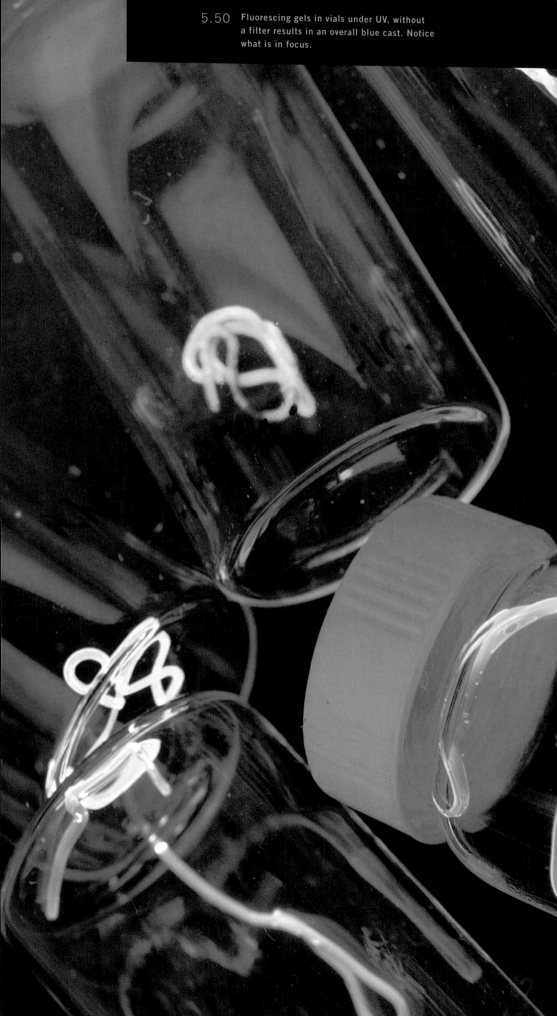

5.51 None of these fluorescing gels are in focus in this three-minute exposure. Think of the possible reasons.

CASE IN POINT

5.50

5.51

Because certain lighting requires long exposures, it is sometimes difficult to tell whether a picture is out of focus because of vibration or narrow depth of field. In 5.50, a few components are in focus. Therefore, we know the problem is depth of field, not vibration, otherwise the entire image would have been fuzzy, as in 5.51. In the latter, assuming I didn't err in focusing for the image, the problem must be from vibration either from the sample or the camera.

Your eye may not see movement, but your camera will.

5.52/5.53

To help ensure the accuracy of colors in your sample, use a filter to absorb the extraneous UV reflectance from your container or sample. In 5.52 I used a strong UV filter; in 5.53 there was no filter. In this case, the difference is subtle and seems to appear only in the caps. Your containers or surrounding material may show UV absorbency, and using a UV filter could help clarify the fluorescing colors.

5.52/5.53 Two images of series of vials containing nanocrystals. Can you see the subtle difference between the two?

115

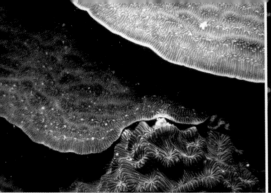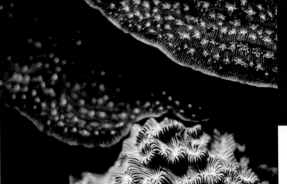

CASE IN POINT

Charles Mazel, an expert in the study and photography of fluorescing corals, took image 5.54 with ambient light and 5.55 with a specially made UV strobe.

5.54/5.55

He used an underwater camera with a 1:2 extension tube and a framer (a framer placed in the viewfinder has markings indicating precise and repeatable composition). These particular specimens were found at the base of a coral head. The photographs were taken using the same film. Mazel took 5.54, then switched light sources and took 5.55. He writes, "I didn't move so I was fairly successful at repeating the framing." (Note: The exposures are different for the two kinds of photos.)

Transmitted Light

If your material is transparent, you'll use light transmitted through the sample. It's important to place your sample on an evenly distributed light source. A well-made slide viewing light box is perfect for photographing small things. The best commercial light boxes provide uniformly distributed fluorescent light that is similar to the temperature (K) of daylight. If your light box has incandescent bulbs, you'll need to use tungsten film. Remember to use film that is appropriate for the temperature of your light source. Light boxes are compact and come in various sizes. The 3 x 2 ft. version is easy to store yet large enough to display most samples.

Turn off all room lights before you make the exposure.

5.56

In 5.56 transparent polymer shapes float at the interface between two liquids. At first, the small crosslike structures were separate from each other, but the nature of their surface

5 / Photographing
Small Things

chemistry caused them to begin self-assembling. I put the
container with the liquid and plastic pieces on a light box and
shot the images from above, cropping the border of the con-
tainer out of the picture frame.

5.57

Image 5.57 shows *E.coli* whose colonies are growing in patterns
in two petri dishes. The photograph was also taken on a

5.58

light box. In 5.58 I placed colored acetate film under the dish
and surrounded it with black fabric, attempting to bring

5.59

attention to the pattern formation. I tried a third idea in 5.59,
using a few dishes with several colors of acetate film.

CASE IN POINT

5.60

Image 5.60 (see the following pages) is a watermark from an
old book at the Folger Shakespeare Library in Washington,
D.C. For my light source, I used a flat paddlelike lamp specifi-
cally designed to view watermarks. I placed the book on a
copy stand, positioned the lamp under the page, and took the

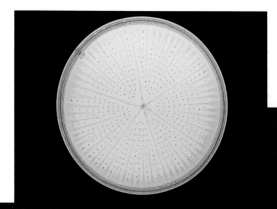

5.58 Adding yellow acetate under the petri dish
and surrounding the dish with black fabric
makes a completely different image.

5.59 A third attempt at capturing *E. coli*, this time
with various acetate colors. Which of these
three images is the most successful, if any?

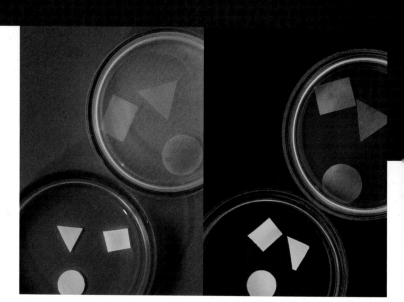

LIGHTING

picture from above. Although the paddle lamp is not necessarily intended for photographing science, it might have some interesting uses since the light source has a low thermal temperature and is safe to use when photographing biological specimens.

Combining Light Sources

5.61

5.62

There are times when combining light sources can produce interesting effects. In 5.61 I used a combination of a UV lamp and a halogen lamp to light the petri dishes containing fluorescing gels. I lit 5.62 with just a UV source.

5.63/5.64

Compare the difference between 5.63 and 5.64. In the smaller image, the two triangular forms in the upper right and lower left corners of the frame are actually the backs of the two hand-held UV lamps. We see them because the overhead fluorescent room light was on. I took 5.64 in the evening with little ambient light from the windows, room lights turned off, and used only two UV lamps. I find the first image more interesting.

5.63/5.64 Fluorescing polymer rods, taken under two different lighting conditions.

5.65

To capture the contours of the bacterial colony patterns in
5.65, I used daylight from a window as my main light source.
I placed a white sheet of paper under the translucent agar-filled
dish as a secondary light source of "transmitted" light. Using
stronger transmitted light would have obliterated the reflected
light that I used to emphasize the contours of the patterns.
I framed the image to eliminate the petri dish.

5.66

Image 5.66 shows a laser source directed through a waveguide
containing rhodamine dye. The fluorescing rhodamine allows
us to see the presence of the laser. I lit the full waveguide with
a simple overhead halogen lamp. If I hadn't used the additional
light, we would have only seen the laser, making an incom-
plete image.

5 / Photographing Small Things

COMPOSITION

COMPOSITION AND FRAMING

I discuss my thoughts on framing and composition in chapter 4. Most of the images in this chapter illustrate my view of composition. Look carefully and notice where the components lie in the frame and how those components relate to one another. Consider which pictures you see in this chapter are the more successfully composed.

The best composition depends upon the purpose of the picture.

5.67–5.69

As with most decisions in photography, there are no absolutes. Images 5.67–5.69 are of cuvettes containing fluorescing material, and each accurately represents the science. Image 5.67 is a highly documentary straight-on view of the cuvettes and shows a particular order in the change of photoluminescence. The eye is immediately drawn to the most important information in the image—the color of the liquid in the containers. Compare this image to the playful arrangement in 5.68 and the third image, 5.69, a more ordered version of the image above it. One could say that all three compositions are successful.

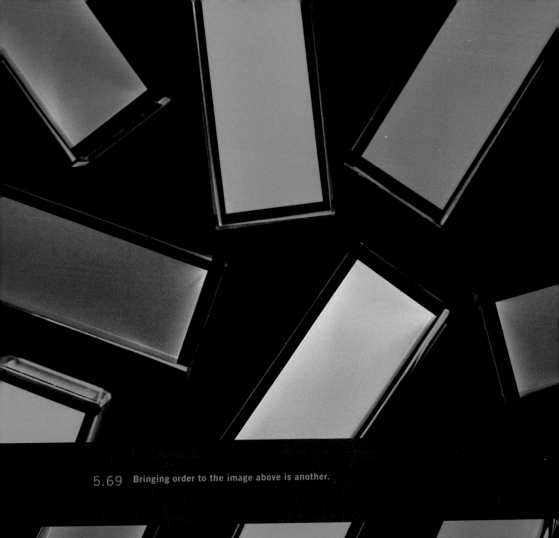

5.69 Bringing order to the image above is another.

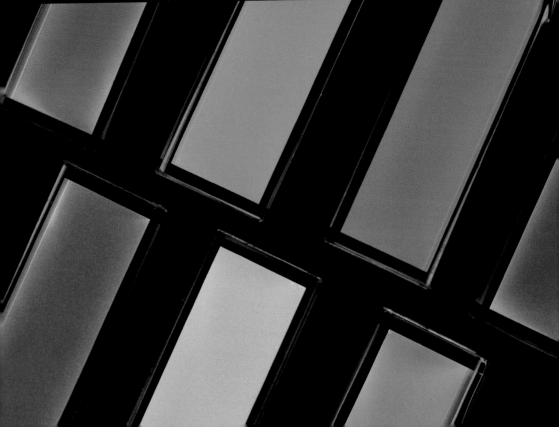

DEPTH OF FIELD

A discussion of depth of field appears on page 66, in chapter 4.
At the scale described in this chapter (4 mm–10 cm), you retain
some control over what is in focus since you are still using
a camera lens with an adjustable aperture. This will not be the
case when you work with samples smaller than 4 mm, as we
will see in chapters 6 and 7. As your lens approaches the object
being photographed, it becomes more difficult to get every-
thing in focus due to the narrowing depth of field. Therefore,
I suggest that you shoot around f/22 to f/32, especially if you
are shooting from an angle.

Use your preview button to get a sense of what will be
in focus, or read the information on your lens. Refer to your
camera manual.

5.70–5.72

Images 5.70–5.72 show how stopping down changes depth
of field. While focusing in the middle of the etched chip, I shot
5.70 at f/8, 5.71 at f/16, and 5.72 at f/32. Even at f/32,
I couldn't get the entire image sharp.

SCALE

One the most difficult and least discussed challenges of envisioning science is how to indicate some sense of scale without compromising on the aesthetics of the picture, that is, how to show scale without relying on the all-too-obvious scale indicator. In many areas of science, such as archeology and geology, it is perfectly acceptable and even considered necessary to place a ruler of some sort in the frame. In image 5.73 Heather Lechtman photographed this rare Peruvian figure carved from a shell. She included a rule to indicate scale.

5.73

5.73 In this archeological image, the researcher was obliged to insert a centimeter rule.

5 / Photographing
Small Things

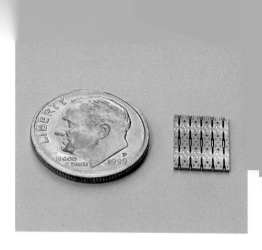

Because one of the most important goals of photographing science is to communicate with the public (and not just our colleagues), we need to find ways to indicate scale that do not distract the eye from the subject of the photograph. Although images without a formal scale usually are not suitable for journal submissions, I believe there is a place for an image with just a *suggestion* of its size.

5.74

5.75

The overused dime-in-the-shot can be effective for showing scale, but usually the dime device results in photographs that are essentially uninteresting, as in 5.74. When making your photographs, try to be less literal in thinking about scale. For example, if you use the dime to show scale, include only part of the dime, as in 5.75.

One effective way of indicating a sense of scale is to include some part of the process of fabrication of your sample, especially

5.76 I included the syringe used to drop the 4 mm square of colored water as a suggestion of scale.

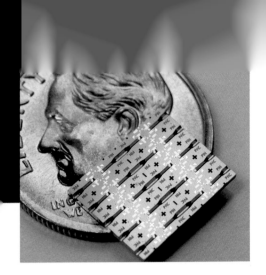

5.76 if you're using a recognizable element. In 5.76, I included
in the image a syringe used to place the colored water on the
surface of the patterned chip.

Incorporating other recognizable elements, even when they're
not necessarily part of the story, helps convey a sense of scale.

5.77 In 5.77, for example, I placed the small triangular chip on a
CD. Another way of showing size is to place your sample(s) on
a grid of known dimensions. I used a grid of 2 mm squares,

5.78 printed on acetate, in 5.78 (see the following pages). The sam-
ples were transparent so I placed them on a light box.

5.77 Here, I placed this etched chip on a CD,
another attempt to show a sense of scale.

SPECIAL CASES

Schlieren Photography

5.79

Kim Vandiver, Director of MIT's Edgerton Center, used Schlieren photography to capture image 5.79, ice melting on the surface of water. The technique reveals gradients in the index of refraction of a medium. The cold water descending from the ice cube has a different index of refraction than the surrounding bath. In the apparatus used for this photograph, the colors indicate the direction of the gradient of the index of refraction.

Stopping a Moment

By their nature, photographs capture a particular moment in time. The picture freezes that moment, but the definition of "moment" changes, depending on the tools you use.

5.80

In 5.80 I captured a particular moment of about 1/4-second as coiling silicone flowed continuously from a source outside the frame. I released the shutter when I thought I saw what I considered a "good" coil. The formation and collapse of the coil happened so quickly, that, unfortunately, I missed many shots because my reaction time was so poor. I took about five rolls of film that day, and only four frames showed clean coiling. A motor drive probably would have helped me get many more usable pictures.

As image technology advances and equipment improves, we are able to capture ever-shorter increments in time. New imaging

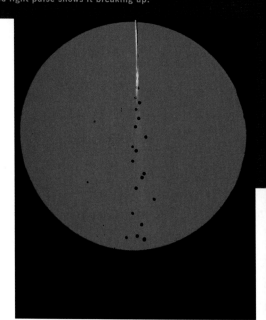

5 / Photographing Small Things

SPECIAL CASES

technologies also enable us to gain new perspectives on scientific phenomena.

Regardless of technological advances, the basic techniques of photography—lighting, framing and composition, background—will always apply.

5.81/5.82

Images 5.81 and 5.82 are examples of how the definition of a moment I captured was reduced from seconds to nanoseconds. I used MIT doctoral candidate Michael Chin's setup. He was studying viscous, electrified water jets. I took both these images at 18 nanoseconds, the length of time of the pulse from a new sophisticated light source. The larger image shows how the jet appears to first whip around and then to break up into droplets. The smaller image shows a less viscous jet. Since my camera shutter speed was set at 1/2 second, you can see the water source along with the very high speed image, creating a double exposure.

Serial Images

When you begin looking at a particular phenomenon over a period of time, you might assume that the best way to capture the phenomenon is with moving images, such as video. Before you resort to video, consider the power of a series of still images, which is essentially what moving pictures are.

5.83

The grouping of images in 5.83 (see the following pages) is an example of how to capture progress in an experiment over time. These images are an edited selection from a series showing a

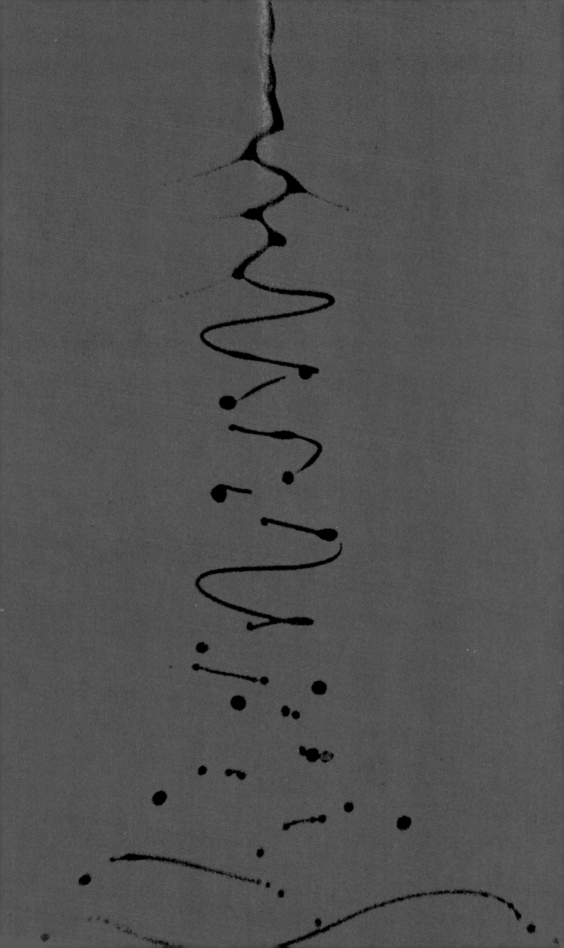

5.83 The Belousav-Zhabotinsky reaction in a petri
 dish over time. Sometimes a series of still
 images can be more useful than a moving video.

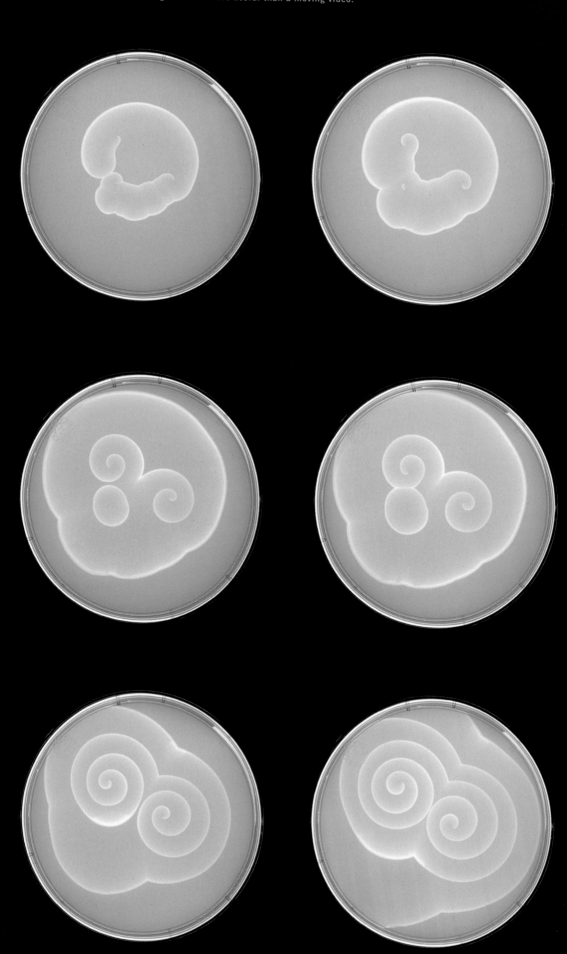

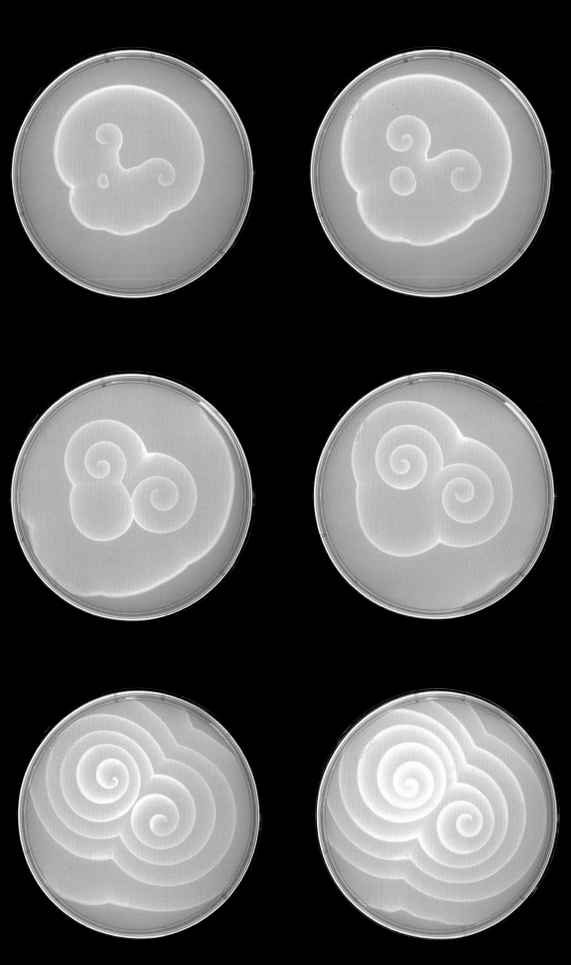

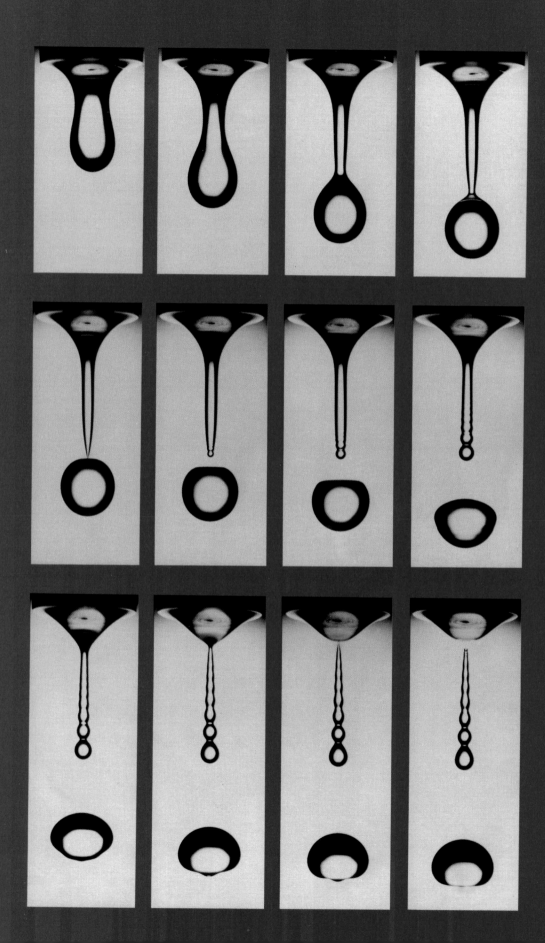

particular reaction taking place in a petri dish. Using a light box, I captured one frame every eleven seconds over a five-minute period.

5.84 In image 5.84, Sidney Nagel took pictures of falling drops of water. He describes his setup as follows:

The nozzle holding the pendant drop was placed between the camera and a strobe light. The room was dark and the camera's shutter was open. As the drop fell, it intersected a signal to start a clock in a time delay circuit. After a preset but adjustable period of time, the circuit fired the strobe in a fast (about a 5-microsecond) pulse. The camera shutter was then closed. Because the drop was transparent, it also acted as a lens and focused the light source in its center leaving a visible dark outline of the surface of the drop.

Movement in a Still Image

To capture movement in a still image, Sidney Nagel photo-graphed an avalanche of mustard seeds in a container, image

5.85 5.85. All motion took place in a thin layer near the surface, with no movement occurring deeper within the container. Nagel used a shutter speed of approximately two seconds.

5.86 The bubbles in 5.86 (see the following pages) were forming and therefore moving between two pieces of glass. Because I shot them at a shutter speed of about one second, we get a sense of movement from the turbulence at the surface of the bubbles while their edges appear to remain still.

5.86 Another example of seeing movement in a still image.

6 / Photographing through a Stereomicroscope

INTRODUCTION

A camera attached to a stereomicroscope (sometimes called a dissecting microscope) will capture details of samples measuring approximately 4 mm to 50 microns. You will not be using the optics of the camera lens because the camera body connects directly to the microscope without the lens.

WHEN SHOOTING OBJECTS BETWEEN 4 MM
AND 50 MICRONS, YOU WILL HAVE:

➤ Little choice over the position of your camera and the object (sample) you are photographing

➤ Minimal control over depth of field

➤ Control over shutter speed

➤ Some control over the quality of lighting

➤ Little need to select backgrounds

➤ Choices about composition

EQUIPMENT

CAMERA 35 mm camera with built-in meter

STEREOMICROSCOPE Stereomicroscope with reflected light, bright-field and dark-field transmitted light, aperture adjustment, and a camera outlet situated on a vibration-free lab bench

ACCESSORIES Special camera focusing attachment for close-up work with special focusing screen, cable release

AUXILLARY LIGHTS Two fiber-optic lights, hand-held UV lights

SUGGESTED FILM 64 ISO tungsten slide film (color reversal) for incandescent light source

50 ISO/100 ISO daylight slide film for fluorescent imaging

OPTIONAL White cards and tape, see page 167

CAPTURED IMAGE/OBSERVED IMAGE

It is essential to understand that using a stereomicroscope to make pictures is different from using one for observation. The same holds true for optical microscopy, discussed in the next chapter.

Single Image

When you use the stereomicroscope to observe your sample, you look through the two eyepieces and see a stereoscopic image. But when you capture a single image on the film plane or CCD, that advantage is lost.

Framing

For the image to cover the full 35 mm frame of the camera, the image transmitted from the sample has to be enlarged with a lens in the camera connection tube. Because of this:

The image you see through the camera is not what you see through the two microscope eyepieces—it appears magnified, and the framing is different. See exercise 21, page 290.

Focus

As you look through the eyepieces in your microscope and adjust the focus with the focusing knobs, you are adjusting the focus for your eyes. That's not the same as adjusting the focus for the camera, that is, for the film plane or CCD. There are differences between how you see (your eyesight) and how the camera sees, and those differences become more problematic as the image becomes more magnified—as you get closer to your sample. Therefore, it is essential to compensate for your own eyesight with the help of a special focusing attachment that replaces the camera's normal viewfinder and a special focusing screen, also replacing what ordinarily

comes with your camera. These devices will ensure that you are focusing for the camera plane. (If you focus on a digital camera monitor, you will not have this problem.)

FOLLOW THESE STEPS TO MAKE THE ADJUSTMENTS:

➤ Place a light-colored paper on the stage and direct the light source to the paper.

➤ Look through the camera's special viewfinder (with the focusing screen in place) and notice the hairlike markings on the focusing screen. Adjust the focusing knob on the attachment until the hairlines become sharp.

➤ Continue turning the knob on the attachment, first in one direction and then the other, to be sure you understand what focused hairlines look like. You will learn what the sharpest setting should be for your eyes.

When you have adjusted the camera to your eyesight, you can then focus the image, this time with the microscope's focusing knob. I encourage you to do this every time you begin photographing with a stereo or other microscope.

Although most microscope manufacturers insist that focusing is *parfocal* (focus is maintained at all magnifications), it's wise to refocus in the camera as you change magnification. In fact, I seldom look through the stereo eyepieces. I use them only to find the sample and get a rough idea of focus. I make all my decisions while looking through the camera viewfinder, just as in the previous chapter.

Always focus through the camera viewfinder, not the microscope eyepieces.

149

6 / Photographing through a Stereomicroscope

LOSING CONTROL

Photographing through a stereomicroscope differs from photographing with a camera and lens in several important ways.

➤ Because you are not using a camera lens when you make images with the stereomicroscope, you won't be able to adjust the lens aperture to control depth of field. You can use the microscope's aperture (see your microscope manual) to have some effect on the depth of field, but not as much as you would with a lens.

➤ You will not be able to control the position or angle of the camera because it is mounted directly above the sample, creating considerable challenges with light. (See page 161.)

➤ Selecting a background, a helpful option in the previous chapter, becomes less useful when capturing the image through the microscope. Most of the image will actually be the sample and not the sample against a background.

However, you will still have choices in the quality of lighting by using auxiliary light along with the built-in light microscope sources. In addition, you retain control over composition and shutter speed.

SAMPLE PREPARATION

Once again, it is important to choose a sample with the least
number of defects that clearly shows the nature of the work.
6.1 Image 6.1, taken with a camera and lens, shows samples
of polymer chips with which I had to work. At first I thought I
could make an interesting arrangement using techniques
described in chapter 5. Later, I decided to use the stereomicro-
6.2 scope, as in image 6.2. Photographing a more magnified image
with the scope gave a better visual description of the work—
it was important to see the channels within the structure.

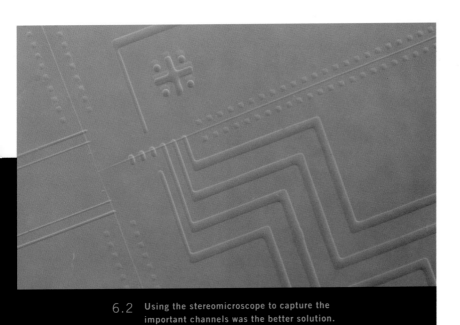

6.2 Using the stereomicroscope to capture the
important channels was the better solution.

6 / Photographing through a Stereomicroscope

Designing Your Sample

6.3

In 6.3, the investigators fabricated and photographed a polymer-enclosed channel through which flowed two fluids. The point of the investigation was to show inlets with different colored liquids, joining into one channel, and maintaining a laminar flow. To emphasize the phenomenon, I suggested fabricating another

6.4

sample, which I photographed in image 6.4. We designed the sample with seven inlets, each flowing with a different color, finally joining into one channel. This photograph is more compelling than the first attempt and dramatically emphasizes the laminar quality of the flow.

6.5

For image 6.5 (see the following pages), also discussed on page 46, I asked for something a bit out of the ordinary. We wanted to show the morphological differences between a mutant yeast colony having hyphae and its wild type with a smooth surface. Normally the lab researchers would have expected two photographs of two petri dishes growing the colonies separately, comparing them side by side. The researchers were surprisingly open to my unusual suggestion of growing both colonies in the same dish. This image contains all the information of two separate images, but it is more interesting.

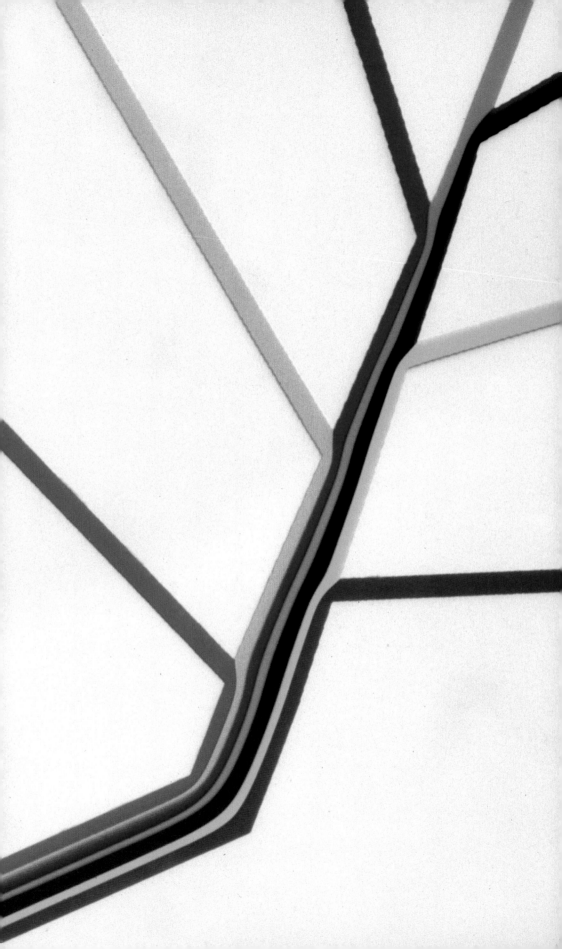

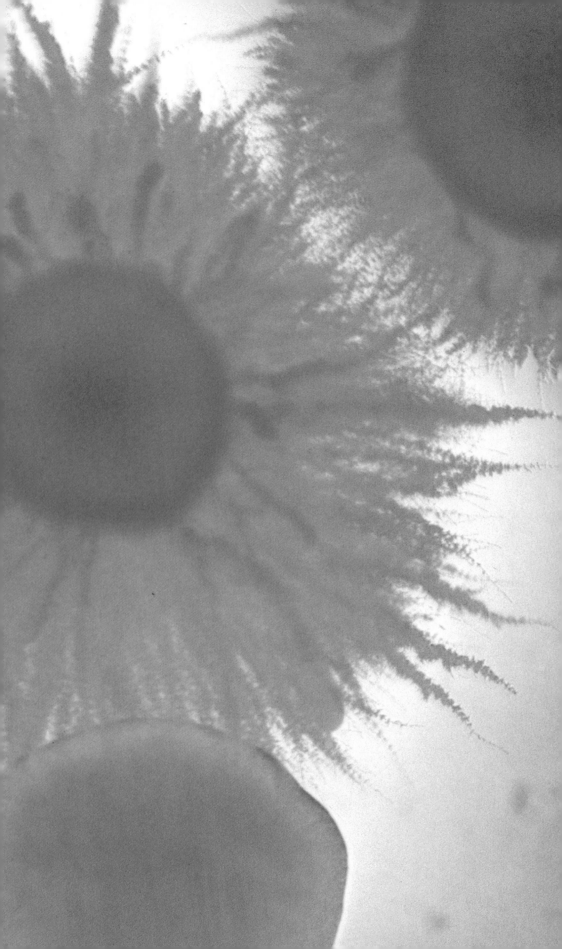

BACKGROUND

In stereomicroscopy, the sample itself usually covers most
of the field of view. It becomes the complete image, obviating
the need for a background. Any background you see in this
chapter is either the glass stage on which the sample is placed
or part of the preparation. Whether you are photographing
with transmitted light or reflected light, the glass stage of the
microscope should be as clean as possible.

6.6

Sometimes the process of preparing the sample will suggest
interesting possibilities. In image 6.6, a piece of transparent
tape at the bottom, holding the square sample of polymer
in place in a petri dish, became an unusual addition to the
image. I found the texture of the tape pleasing, and it didn't
detract from the primary focus of the image, the mercury-
encapsulated grating at the top.

Be open to surprises—they may add interest to your
photograph.

6 / Photographing through a Stereomicroscope

CAMERA/SAMPLE ANGLE

Compared to the flexibility of photographing with a camera and lens, you now have virtually no leeway in altering the relationship between the camera and the sample. Usually the camera is mounted directly above the sample. You cannot move your camera around as you could in the previous chapter. In addition, you have limited choices in moving the sample to various angles because of problems with depth of field. As you get closer to your sample and the image becomes more magnified, it becomes increasingly difficult to get everything in focus

6.7 if your sample is three-dimensional. Image 6.7 is a cross section of a motor measuring one centimeter (an overhead view is in image 6.19). All the layers of the stacked parts are in focus because I mounted the sample upright on a piece of putty with the cross section facing the objective, making sure the sample was level.

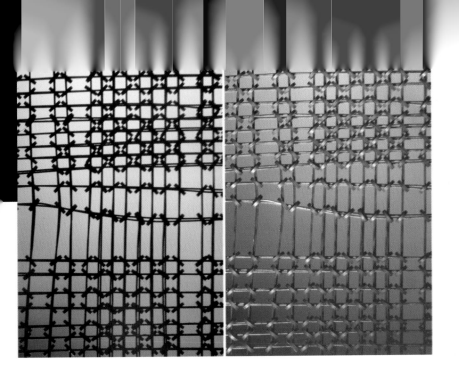

LIGHTING

As suggested, your microscope probably has built-in light sources directly above for reflected light and below for transmitted light. However, you may also want to use auxiliary lighting to enhance your image. Using light in creative ways will make your image considerably more interesting than simply relying on the light source in your microscope. Fiber-optic lamps are excellent light sources for photographing the surface of a sample. As in chapter 5, it is important to experiment with all qualities of light, angles of light, and distances of the light source from the sample.

Don't restrict yourself to using one kind of light—play with various light sources.

Reflected Light vs. Transmitted Light

The stereomicroscope offers the unique advantage of easily switching from *epi-illumination* (reflected light off the surface of the sample) to *transmitted light* (through the transparent sample). You don't have that luxury with a camera and lens setup. Take advantage of that capability with the stereomicroscope.

To photograph the old computer memory at the beginning of this chapter, for example, I first photographed the sample with transmitted light, 6.8, and then easily switched to light from above, resulting in a reflected light version, image 6.9.

6.8
6.9

In another pair of examples (see the following pages), I simply changed from transmitted light, image 6.10, to reflected light, 6.11, when I photographed these origami-like structures,

6.10
6.11

6.13 A similar detail as above, with transmitted light.

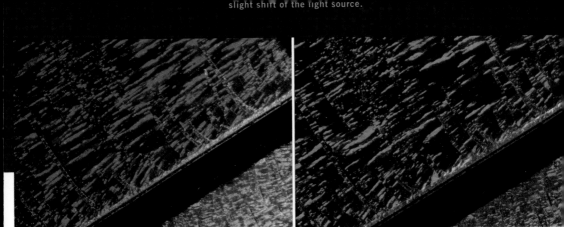

again producing two different results. The first transmitted light version isn't as successful as the second image taken with reflected light. The latter is more appealing and, more important, it emphasizes the three-dimensional quality of the structures.

6.12/6.13 Look at the differences between images 6.12 and 6.13, two stereomicroscopic detail images of a yeast colony "flower." Image 6.12 was taken with reflected light and 6.13 with transmitted light. Each light source enhances different qualities and provides different information about the structure at the interface of the "petals." Both images work.

Reflected Light (Epi-illumination)

If your material is completely opaque, use only light reflected off the surface.

6.14/6.15 Images 6.14 and 6.15 are of the same two glass slides deposited with material similar to a butterfly wing. There is no dye present. The different colors are the result of shifting the lamp a few millimeters, bouncing off the surface of the slides. Both images contribute to understanding the nature of the material. Although this is a dramatic demonstration of the result of small manipulations in the direction of the light source, you will also see interesting changes in your own work when you play with the direction of the light.

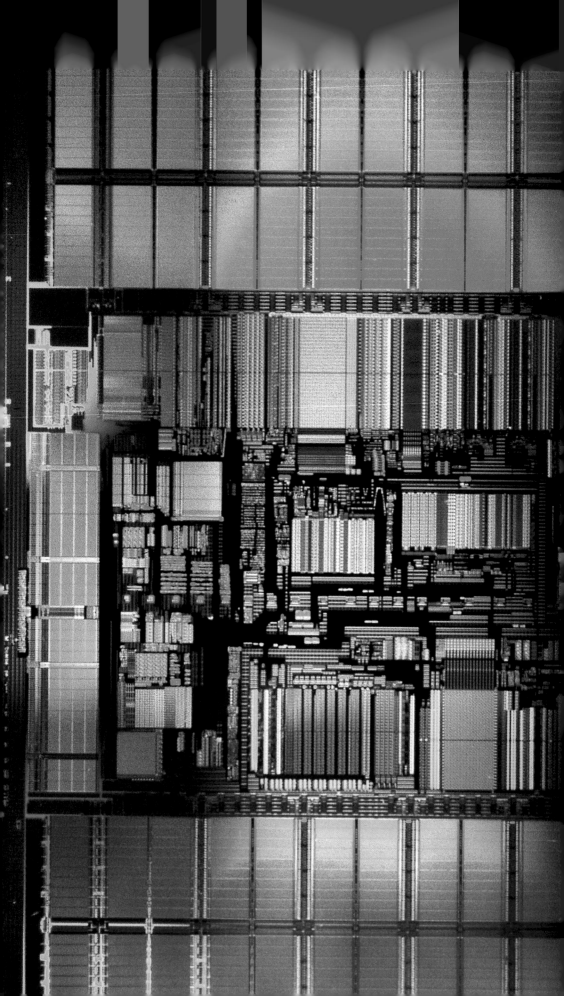

6.16 In image 6.16, the colorful light reflections are due to diffrac-
 tion—the circuit elements on the chip act as diffraction grat-
 ings. In this case, the colors do not necessarily give us infor-
6.17 mation, but they add interest to the image. Image 6.17 is a more
 magnified version of the same chip. Notice how the colors
 are different from the other image. As you change the magnifica-
 tion, you change the range of angles of diffracted light collected
 by the microscope. As a result, different color components
 reach your camera, and the apparent color of the sample changes.

6.18 By including shadows in image 6.18 made with an auxiliary
 fiber-optic light directed from a low angle, I brought attention to
 the charcoal structures within this long channel of a microde-

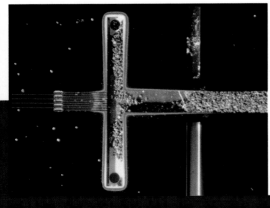

6.18 The low angle of the fiber-optic lamp adds
 shadows to this microdevice. The vertical
 channel measures about 500 microns.

165

6.19/6.20 In this situation, the 1 cm microrotor is
best imaged with the camera and lens, on
the right.

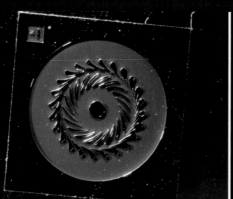 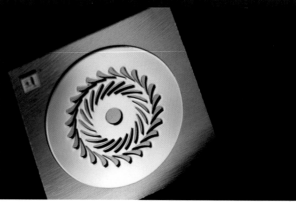

LIGHTING

vice. In chapter 8, you'll see how we address the challenge of communicating the length of a sample.

Challenges When Shooting Reflective Material

The built-in light in your microscope for epi-illumination is directly above your sample. That, combined with the inflexible position of the camera, creates considerable frustration when photographing highly reflective material. In image 6.19, I photographed a 1 cm microrotor with the stereomicroscope's light source from above. We see every speck of dust. Compare it to image 6.20 where I used a camera and lens. The two pictures have about the same magnification, but the more flexible camera permitted me to shoot from an angle to avoid emphasizing imperfections. At times you will be able to choose equipment. In this case, the camera and lens offered the needed magnification while still giving me control of lighting and angle.

6.19

6.20

If you are shooting at a scale that can be captured by either a camera and lens or a stereomicroscope, consider using the camera and lens.

Even if your sample's surface is completely smooth and clean, you still might face another challenge. Notice the halo of light coming from the microscope in image 6.21, a chip etched with square reservoirs. In this case, I needed the magnification and had no choice but to use the stereomicroscope. (I later digitally cleaned the image, see page 275.)

6.21

6.21 An undesired reflection on a patterned chip.
The squares measure about 50 microns.

Using auxiliary lights directed from the sides can help. Never-
theless, any highly reflective surface will show dust. Try
this card trick. If you hold a white card at an angle close to
the microscope lens, its reflection on the surface of the sample
will cover up some of the dust and will generally give an inter-
6.22 esting gradient effect. I did so for image 6.22, which is a
more magnified version of the same sample shown in 6.23 (see
6.23 the following pages).

It is essential to look though the camera while adjusting
the card to be sure you don't block the sample. When you

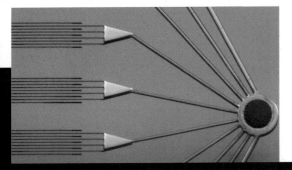

6.22 Using a white card to hide dust on this
microdevice.

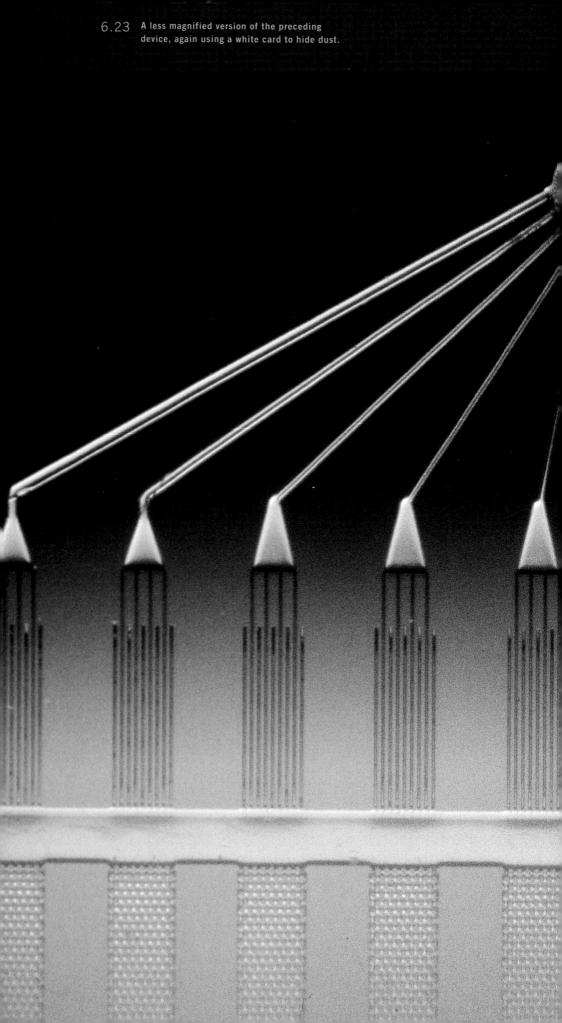

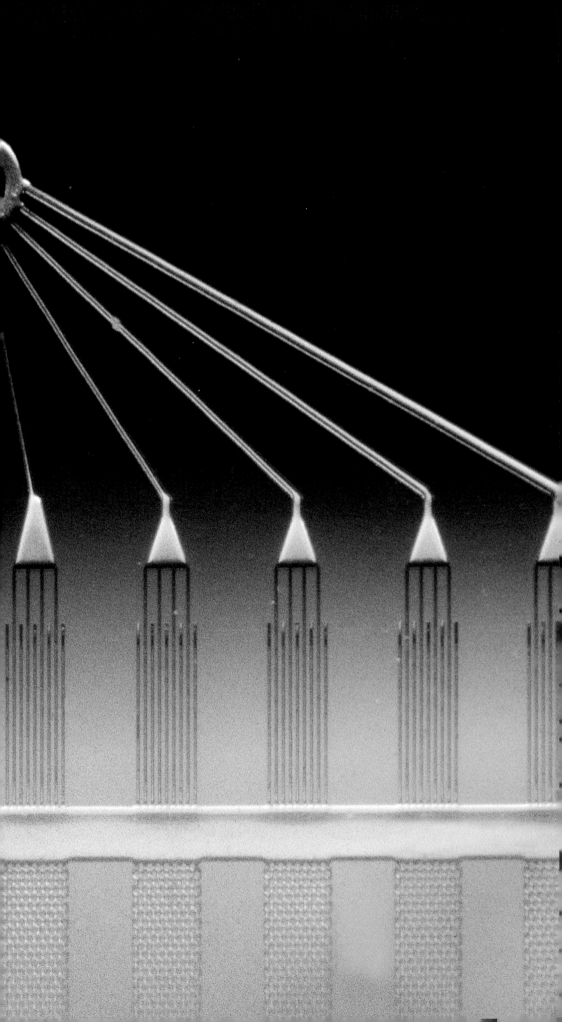

6 / Photographing through a Stereomicroscope

eventually like what you see, while looking through the camera, temporarily attach the card to the outside of the microscope lens with masking tape to hold it in place while you're making your exposures.

6.24/6.25 Compare images 6.24 and 6.25. In the latter, I used the card technique.

Transmitted Light

If your material is transparent, you'll probably use the transmitted light source in your stereomicroscope. If the scope has

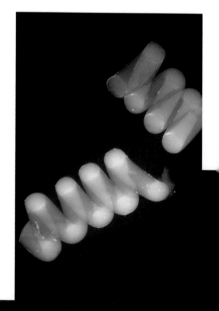

6.26 0.5–1.0 cm coils of gels with bright-field transmitted light.

both bright-field and dark-field transmitted capabilities, you'll have more choices when photographing your image. With bright-field, the light from beneath the stage travels through the condenser, then through the sample, and ultimately to the film or CCD plane. In dark-field, an adjustable patchstop covers the center of the light source and directs most of the light around the sample.

6.26
6.27

Taken with bright-field transmitted light (the patchstop is out of the way), image 6.26 of curled polyacrylimide gels is different from the dark-field version in 6.27, which appears sharper.

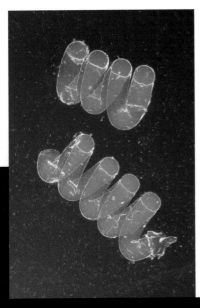

6.27 The same gels as those on the left, this time with the patchstop in place.

6.28 Zebra fish with standard transmitted light.

6.29 The identical sample, with the patchstop covering half the light.

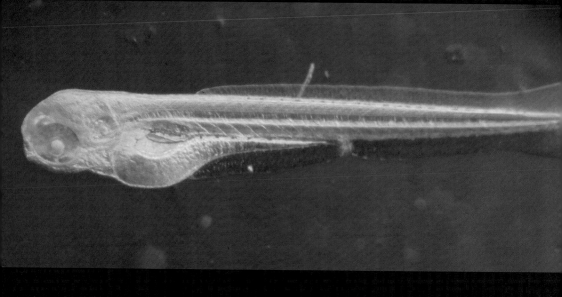

6.30 The sample with the patchstop fully covering the light source.

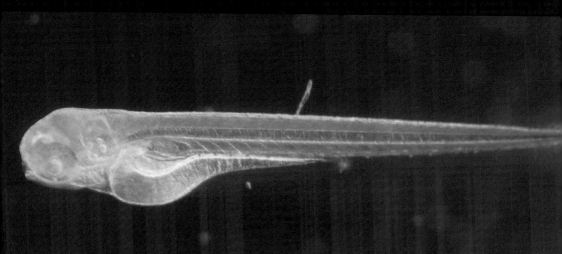

6.28/6.29
6.30
DIAGRAM 6.1

In these images of a four-day-old Zebra fish, 6.28, 6.29, and 6.30, you can see the changes as I adjusted the patchstop in increments. (See diagram 6.1). The first is a completely bright-field image where the patchstop is out of the way. The next is a partially covered light source where the patchstop is halfway covering the light. In the last, the patchstop is completely covering the light source.

TRANSMITTED
LIGHT

MOVABLE
PATCHSTOP

IMAGE 6.28

IMAGE 6.29

IMAGE 6.30

DIAGRAM 6.1 Moving the patchstop over transmitted
light.

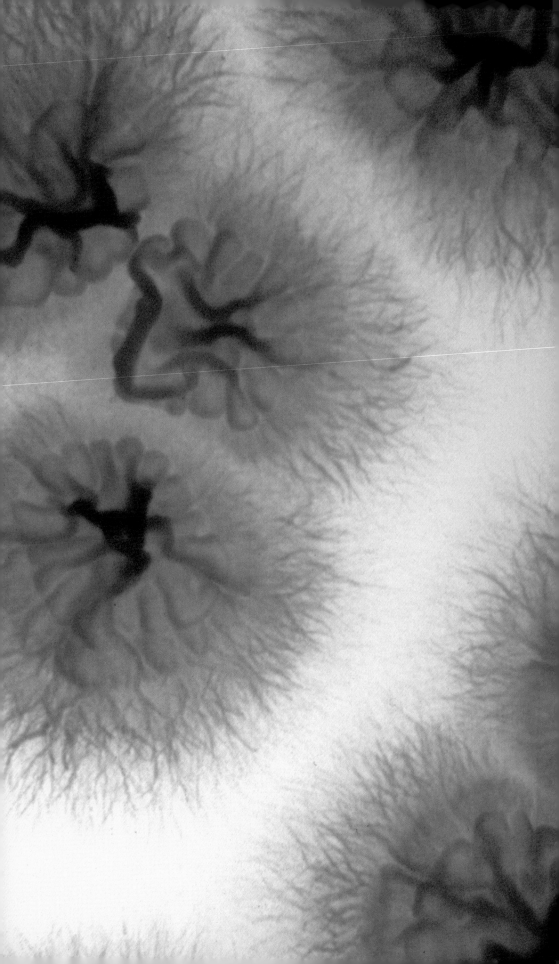

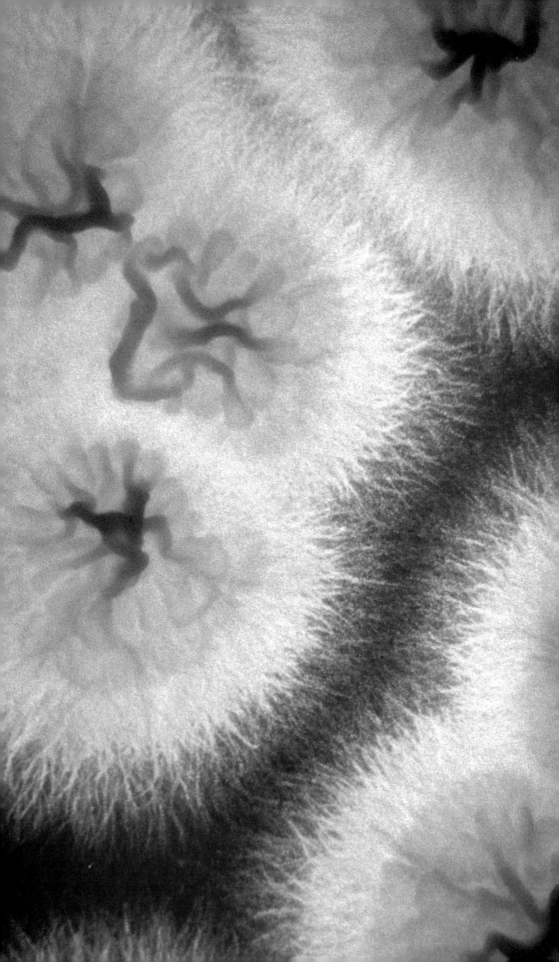

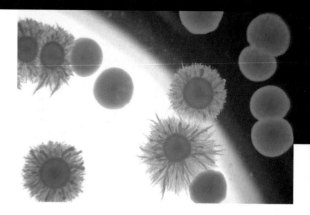

6 / Photographing
through a
Stereomicroscope

LIGHTING

Experimenting with such adjustments gives you more control
over your final image and gives you choices in deciding what is
the best way to portray your sample.

Older stereomicroscopes have an adjustable mirror beneath
the stage to direct the transmitted light at various angles
through the sample. They offer valuable choices in light quality.
In fact, some of the older instruments give you more control
than the newer enclosed and light-inaccessible versions.

Controlling the light controls your image.

6.31/6.32 In images 6.31 and 6.32 (see the preceding pages) I cap-
tured the yeast colonies using an older microscope with trans-
mitted light from under the stage, directed off a movable
mirror. Moving the mirror only slightly resulted in two very dif-
ferent images.

6.34 The cut-out area in this otherwise opaque micro-
reactor is a transparent membrane measuring
about 50 microns seen with transmitted light.

6.35 Using both transmitted and reflected light
sources, we see surface structures and the
200 mm wide transparent central membrane.

LIGHTING

6.33 In image 6.33, the position of the mirror caused the light
to become part of the image—notice the round white structure
in the background. In general, you should avoid bringing
attention to the process of your photography. I am not convinced
this is a successful image.

If your sample is completely opaque but has some transparent
areas, transmitted light can give good results, as in this
6.34 microdevice, image 6.34.

Combining Transmitted and Reflected Light

Sometimes a combination of transmitted light and reflected
6.35 light produces the best outcome. In image 6.35, it was
important to emphasize the transparent channel running through
the middle of this microdevice, but I also needed to show
the structure of the surface. I used transmitted light from the
scope for the channel and reflected light from the sides.

UV Lighting

You can capture fluorescence in your sample by using auxil-
6.36 iary UV lamps. In image 6.36 (see the following pages) I
placed two hand-held UV lights on both sides of the microscope
stage and photographed the polymer capsules embedded
with fluorescing material. As in most fluorescing images, the
exposure was long, about one minute in this case.

6.36 50-micron beads of polymer embedded with nanocrystals, under UV light.

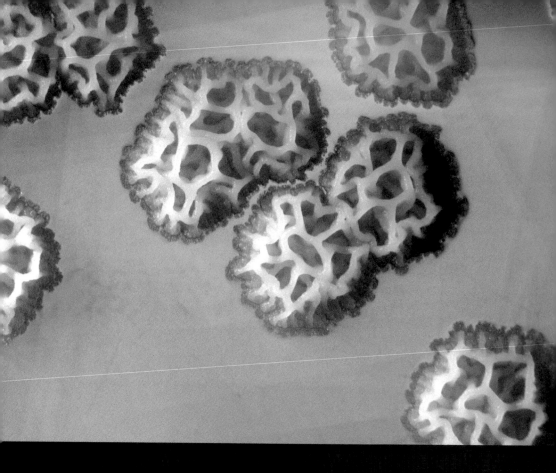

6.38 A more magnified version.

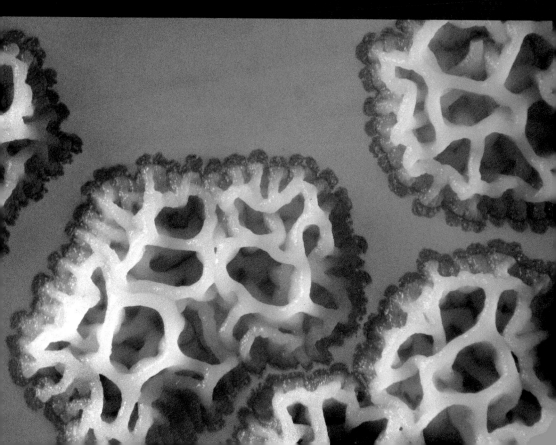

COMPOSITION, FRAMING, AND MAGNIFICATION

Framing, composing, and magnifying are all tightly connected
to each other when creating an image, especially when
using a stereomicroscope. Changing magnification by a simple
turn of the magnification ring is easy with the stereoscope,
so much so that you will probably play a great deal with magni-
fication. I urge you to do so. But it is important to remember
that with that ease you still must pay attention to the changes
in composition and framing as you change magnification.

Always look through the camera viewfinder to see changes
in framing.

6.37
6.38
Image 6.37 is a group of yeast colonies taken with reflected
light. A slight turn of the magnification ring gave image 6.38.
But first, before releasing the shutter, I shifted the stage
to balance the composition.

6.39
6.40
After shooting image 6.39, a chip of cantilevers, in transmitted
light, I then "loosened up" to a less magnified image, 6.40
(see the following pages), where we see two chips on the micro-
scope stage. The second image conveys more information
and is more interesting.

181

COMPOSITION

More magnification doesn't necessarily give more information.

6.41/6.42 Images 6.41 and 6.42 are two more examples of different magnifications in transmitted light. In this case we see two versions of the same sample of salt crystals in a petri dish.

Using transmitted light to photograph a chipped piece of glass for a study in fracture mechanics, I first photographed the
6.43 sample to include the edge of the glass, image 6.43. Increasing magnification and composing without the edge reveals a com-
6.44 pletely different image, 6.44.

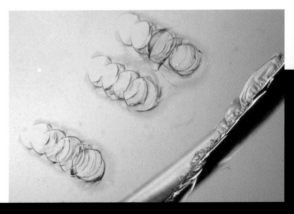

6.43 3 mm circles of fractured glass.

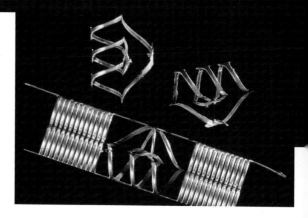

6 / Photographing through a Stereomicroscope

COMPOSITION

6.45 With careful framing, you can suggest how a sample was fabricated. The two examples of "trefoils" at the top of image 6.45 were made by a clever procedure. Each was first patterned onto a larger structure similar to what you see at the bottom of the image. Incorporating the process of fabrication makes the image more interesting than an image with the single trefoil.

6.46 In this image of a microdevice, 6.46, I was quite careful about being precise in capturing its symmetry. As discussed in the previous chapter, an almost perfectly symmetrical picture

6.47 is unsuccessful. But as I increased magnification in 6.47

6.48 and 6.48, to capture part of an edge showing the remarkable precision of the fabrication, I framed the image off center and was careful to compose each image differently.

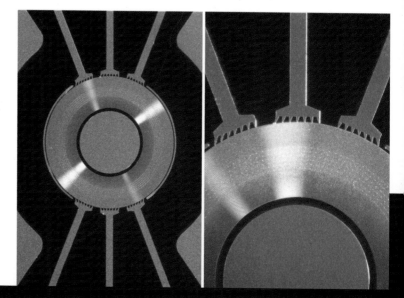

6.46/6.47 On the left, a perfectly symmetrical image. On the right, a more magnified version, off center.

186

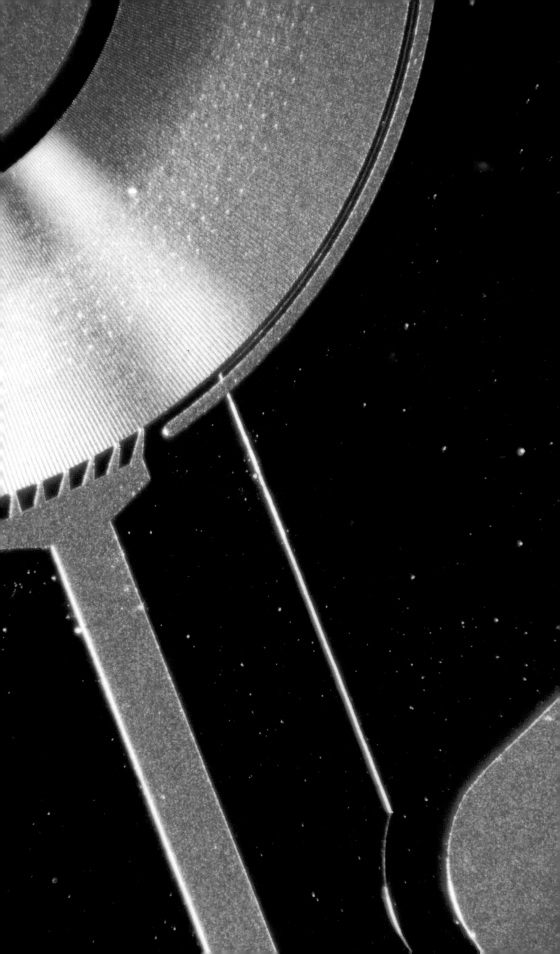

SPECIAL CASES

As with the camera and lens, you may capture still images
over time with the stereomicroscope. Images 6.49 and
6.50 show how these microcapsules respond when they are
addressed with a current. Using both photographs shows
a process.

6.49
6.50

The photographs in the series 6.51 (see the following pages)
show the change in surface patterns on an acrylimide gel
over time. The gel was in a petri dish filled with water, and
I shot the series with transmitted light.

6.51

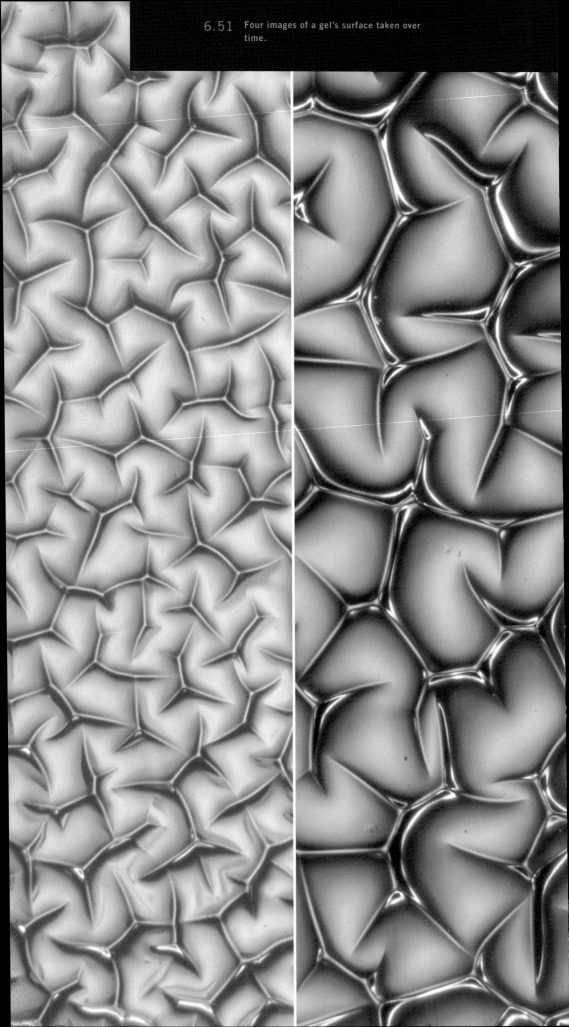

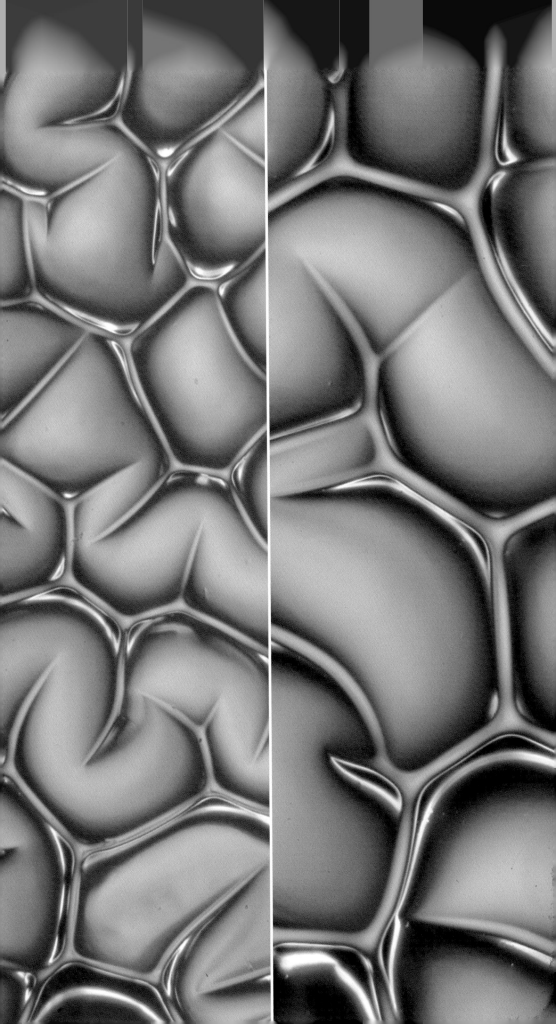

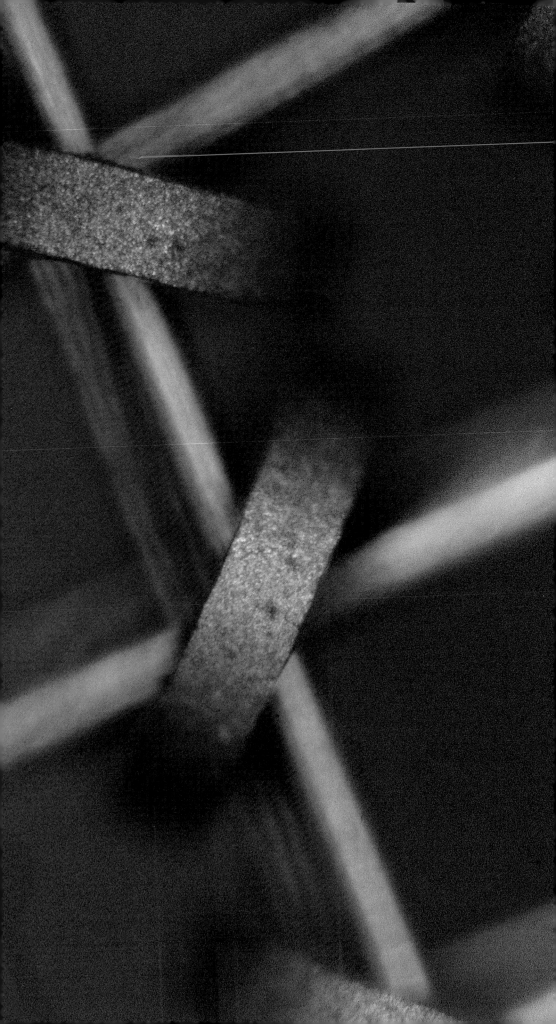

7 / Photographing through a Compound Microscope

INTRODUCTION

INTRODUCTION

The transition to a compound light microscope to image structures as small as a micron will first require you to make a number of decisions—what kind of compound microscope to use, what light source, what objectives, and a host of other considerations. The choices you make will depend on what structures in your sample you will want to image. Trained microscopists spend years studying the optics and characteristics of various instruments and techniques, and you must first research the wealth of literature written by specialists to help you determine what techniques to use. For example, if you are to image your work properly in transmitted light, it is essential that you understand Köhler illumination. For both transmitted and reflected light, you will find that Nomarski differential contrast (also called differential interference contrast, or DIC) will be a valuable tool to show form and structure. I often use the technique, as you will see in this chapter, and refer to it as Nomarski in the text.

Look for books explaining important techniques in microscopy, but keep in mind that using the microscope for making pictures is different from using one for observation. I am not a microscopist, and my intention is to introduce you to a photographer's approach to using the equipment so that you may add that particular point of view to the important technical issues you first must address.

AS YOU MAKE IMAGES OF SMALL STRUCTURES WITH
THIS MICROSCOPE, YOU WILL:

➤ Work with a fixed camera position with respect to your
sample—either above or below, depending on which microscope
your lab uses

➤ Exercise very little control over depth of field (but still control
shutter speed)

➤ Maintain some control over the quality of lighting

➤ Have little need to select various backgrounds

➤ Still have choices about composition and framing

EQUIPMENT

COMPOUND
MICROSCOPE

Compound microscope (inverted or upright) situated on a
vibration-free lab bench or desk with:

Reflected and transmitted light capabilities, both bright-field
and dark-field

Nomarski differential contrast capability

Appropriate objectives depending upon the nature of your
material (see your microscope manual)

Camera outlet

CAMERA

35 mm film camera with built-in meter or digital camera

ACCESSORIES

For film camera, a special camera focusing attachment
(see page 149, chapter 6)

SUGGESTED FILM

64 ISO tungsten slide film (color reversal) for incandescent
light source

50 ISO/100 ISO daylight slide film for fluorescent imaging

CAPTURED IMAGE/OBSERVED IMAGE

Just as when working with the stereomicroscope, what you
see through the compound light microscope eyepieces is not
the same as what you will record on the film or CCD plane.
On page 149 I discuss why this is the case and how to set up
the special viewfinder, which now is even more essential as
you create more magnified images. Once again, if you are using
a digital camera, your computer monitor or camera will display
what your CCD will capture.

LOSING MORE CONTROL

When you photograph with a compound microscope you'll have
little control over depth of field. The challenge here is greater
than with the stereomicroscope. With the latter, you can
still attain focus of the whole field of view. With the compound
microscope, it is virtually impossible to do so as you increase
magnification, especially if your sample is thick. I suggest
you start with the least magnification, for example a 5x objec-
tive, to find a good field of view. I notice that most researchers
go directly to the magnification they think they want, but
if you first look at a broader view (less magnified), it can be
helpful to plan for the next level of magnification, and you might
see something you didn't consider before. Because of the
difficulty of focusing under high magnification, you'll usually
have to choose on which plane to focus. In both images 7.1 and
7.2 of *arabadopsis,* you can see the trouble I had. I simply
couldn't get a completely sharp image.

7.1
7.2

Make a number of pictures, focusing at various planes, and
decide later which is best after you see the possibilities.

7 / Photographing through a Compound Microscope

LOSING MORE
CONTROL

7.3–7.5 For this chapter opener, for example, I made three images from which to select, 7.3, 7.4, and 7.5, choosing the first.

You can use the microscope's aperture iris diaphragm to slightly increase the depth of field, although not as much as you could with a camera lens. As you adjust the diaphragm, you will also be increasing contrast. The image might seem sharper when you increase contrast, but it might not actually be more focused.

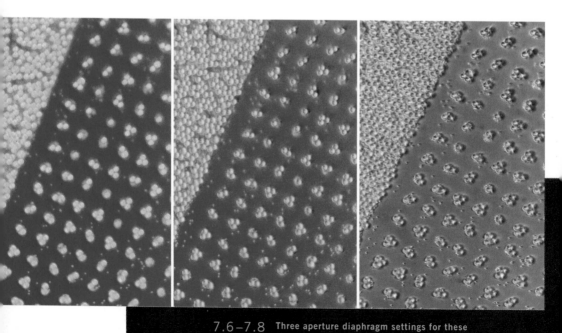

7.6–7.8 Three aperture diaphragm settings for these self-organized colloids, about 4 microns in diameter.

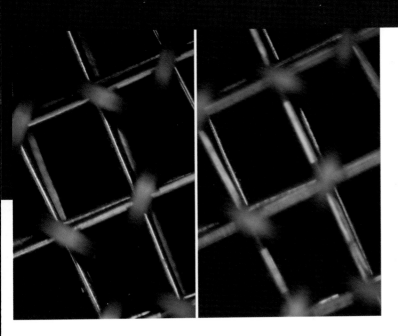

However, your goal at this time is to make images to clearly communicate form, and for that reason I would argue that increasing contrast is valuable.

7.6–7.8 Compare the following images of self-organized colloids on a patterned surface, images 7.6, 7.7, and 7.8. For each, I adjusted the aperture iris diagram. Look carefully. Have I increased the focus or simply increased contrast?

7.9 Incidentally, make sure you understand which knob to adjust. In image 7.9, I accidentally adjusted the field aperture diaphragm, not the aperture diaphragm.

7.9 What error did I make in the photograph?

7 / Photographing through a Compound Microscope

BACKGROUND

The background generally becomes irrelevant at this magnification, but as so often is the case, there is always an exception. In image 7.10, I used a 5x objective to show a syringe embedded with microchips. After placing a piece of a Kodachrome film box under the stage of the microscope, and using a better light source from an auxiliary lamp, I was able to get a more interesting image, 7.11. It's hard to believe these two photographs are of the same sample, yet the combination of adding the background color and using a different light source added interest to the second photograph.

If you are using very low magnification, you can still be creative with light and background.

However, for the most part, when you use a microscope at higher magnification, background and lighting is determined by the sample and built-in light sources.

7.10

7.11

7 / Photographing through a Compound Microscope

SAMPLE PREPARATION

Because you are looking at a more magnified version of your work, you might think you will have less opportunity to make compelling images and that your options for experimentation are more constrained, but this is definitely not the case. In fact, with fewer forms to compose within your frame, you have a better opportunity to communicate a particular idea.

When Kathy Vaeth was a graduate student at MIT, part of her thesis was to demonstrate the controlled gas deposition of a polymer on a patterned surface. She first used parallel lines of varying widths as her pattern, image 7.12. With some encouragement, she later had more fun with her patterns and in the process made more visually interesting samples, still communicating the ideas behind the engineering. Images 7.13 and 7.14 show the second round of patterning. I took both images using Nomarski contrast technique. The first pattern fluoresces under UV light, which we later see on page 230. The second pattern is a combination of two layers.

7.12

7.13
7.14

7.13 A more interesting pattern compared to above.

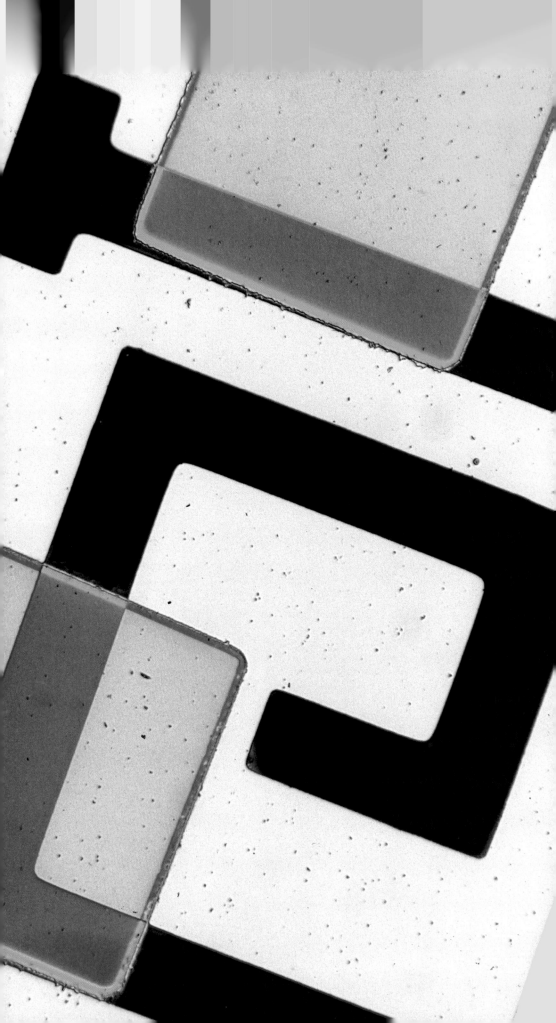

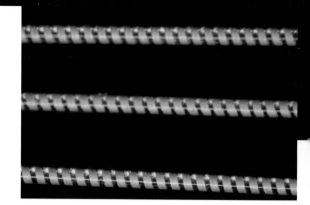

7 / Photographing through a Compound Microscope

SAMPLE PREPARATION

You can bring attention to the essential part of your investigation by creating an interesting sample.

Here's another example of how giving more time to sample preparation can pay off. John Rogers and Rebecca Jackman, while they were at Harvard, took the picture above, 7.15, of metal-patterned glass rods. I asked if they could give me additional samples with different patterns and various metals. The result is image 7.16, which I made with the special focusing attachment previously discussed on page 149. Note the difference in focus between these two images as well as the more interesting variety in sample preparation.

7.15

7.16

As your images become more magnified, sample defects become more obvious. For the most part, it is almost impossible to create an image without defects or scratches, and you may consider digitally "fixing" or cleaning the image. I discuss the appropriateness of this issue in chapter 8.

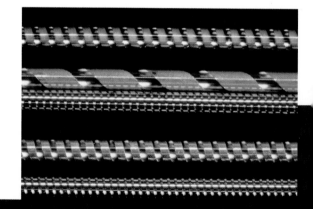

7.16 Additional patterns and proper focus. Compare to the image above.

LIGHTING

7.17

7.18

7.19–7.26

At this scale you will usually know beforehand whether to use transmitted or reflected light, but once again, keep your options open. For image 7.17, when he was at Harvard, Eli Glezer and I photographed a quartz cube patterned with very small holes made by femtosecond laser pulses. Because the material was quartz and therefore transparent, it seemed logical to use transmitted light, but the results were not very satisfying. We then switched to reflected light, using Nomarski differential contrast for image 7.18. In this case, the colors are from interference from the light bouncing off the walls of the holes.

Using the Nomarski technique helps you see forms and adds color to the image. But be careful when dialing in certain wavelengths—the colors can become overwhelming, perhaps even distracting. The following pages, images 7.19–7.26, show various comparisons with only small adjustments using Nomarski.

7.18 With better light quality, the 2–3 micron
 holes are more apparent.

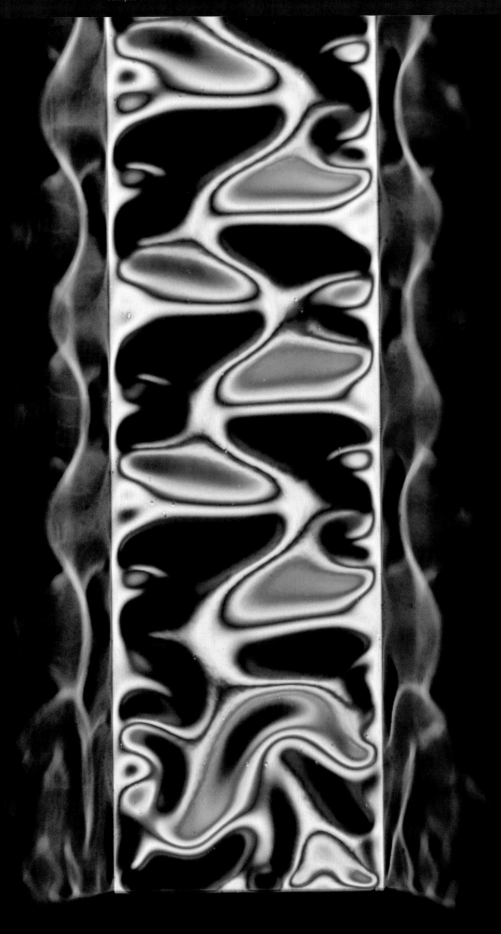

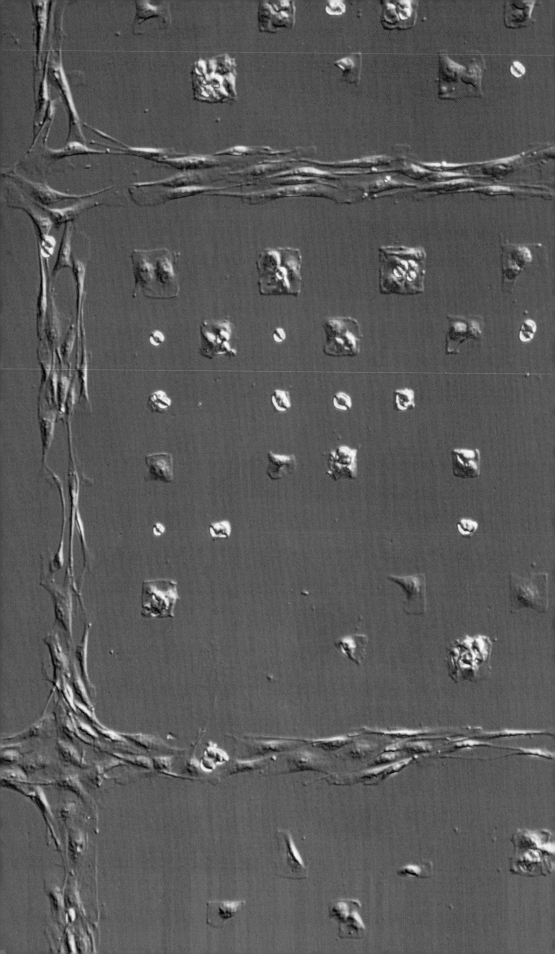

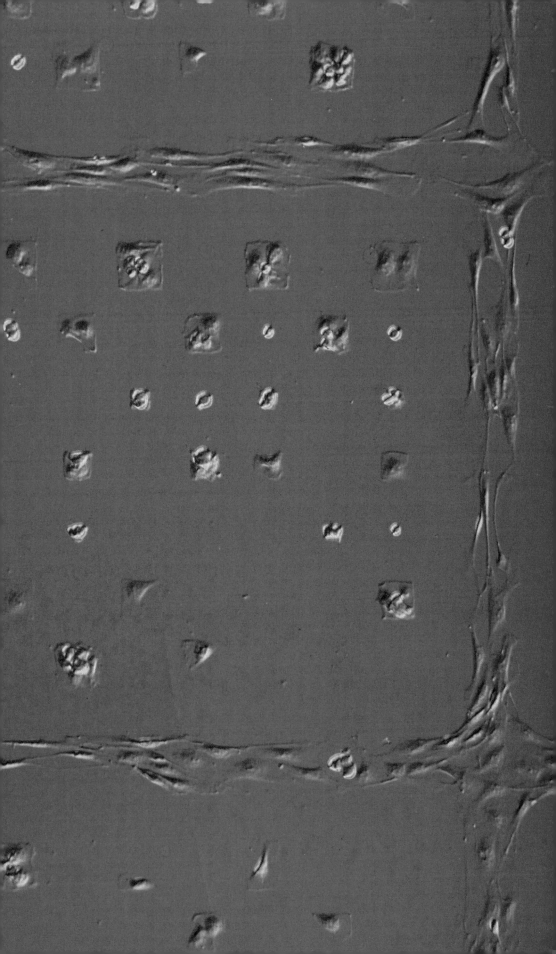

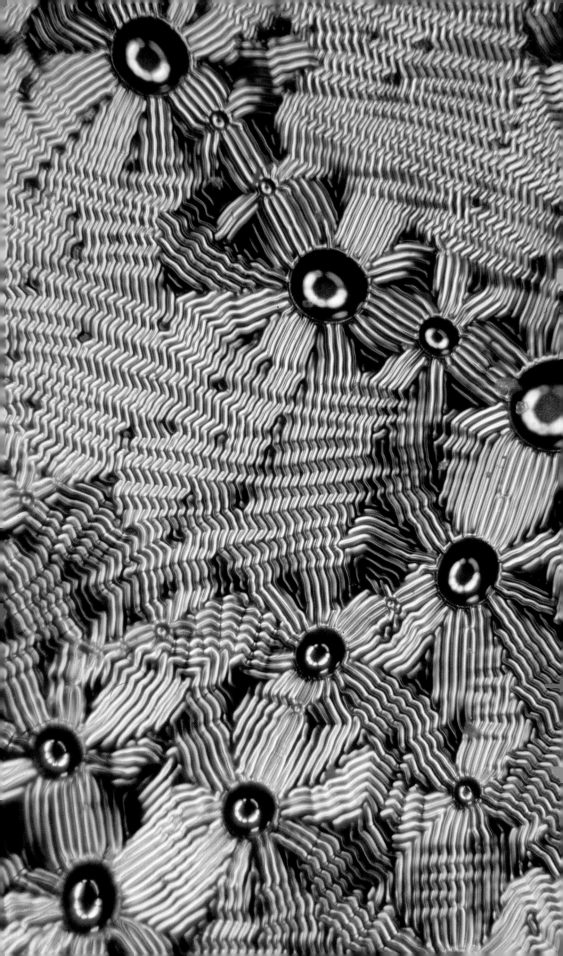

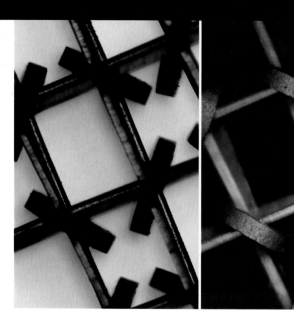

LIGHTING

7.27
7.28

For reflected light, you may find that shooting both a Nomarski image 7.27 (always taken under bright-field), and a dark-field image, 7.28, may have value. In a compound microscope, dark-field, even in reflected light, works similarly to the stereomicroscope, described on pages 172–173.

7.29/7.30
7.31/7.32

I always marvel at how such small manipulatons in light source can completely change a photograph. Images 7.29/7.30 and 7.31/7.32 (see the following pages) are identical pairs of compositions, but look how very different the images in each pair appears. The first of each pair was taken with Nomarski, the second under dark-field. You decide which are the better images.

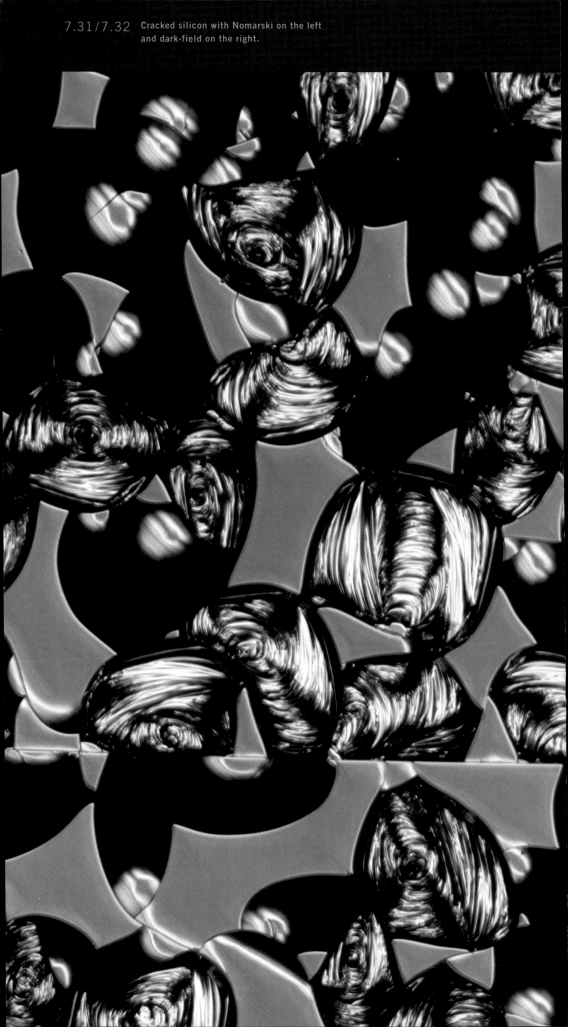

COMPOSITION, FRAMING AND MAGNIFICATION

Creating attractive compositions, as described in chapter 4, can be achieved as simply as by slightly shifting the microscope stage. The material in image 7.33 is made more interesting by including another area of the sample along with the relevant area on the right, image 7.34.

7.33

7.34

As you change magnification, recompose the image.

7.35–7.37

7.38

7.39

Notice how I shifted the composition as I increased magnification in 7.35, 7.36, and 7.37. All images are useful. The same is true in image 7.38 (see the following pages) of cadmium selenide nanocrystals as it becomes a different image in 7.39 with higher magnification.

7.35 A less magnified version of the two images on the right. Compare the framing among the three.

7.36 With increasing magnification, a change in the framing.

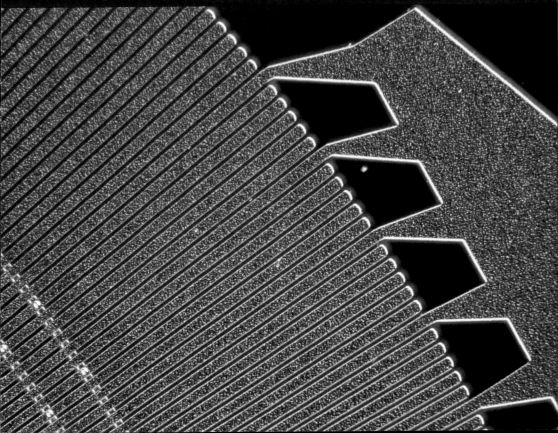

7.37 The most magnified image in a simple composition.

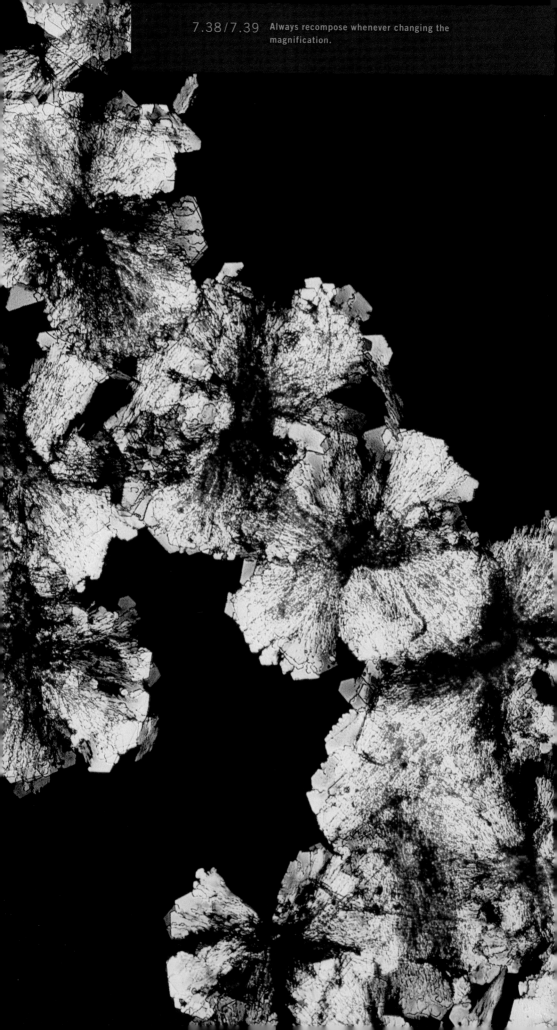

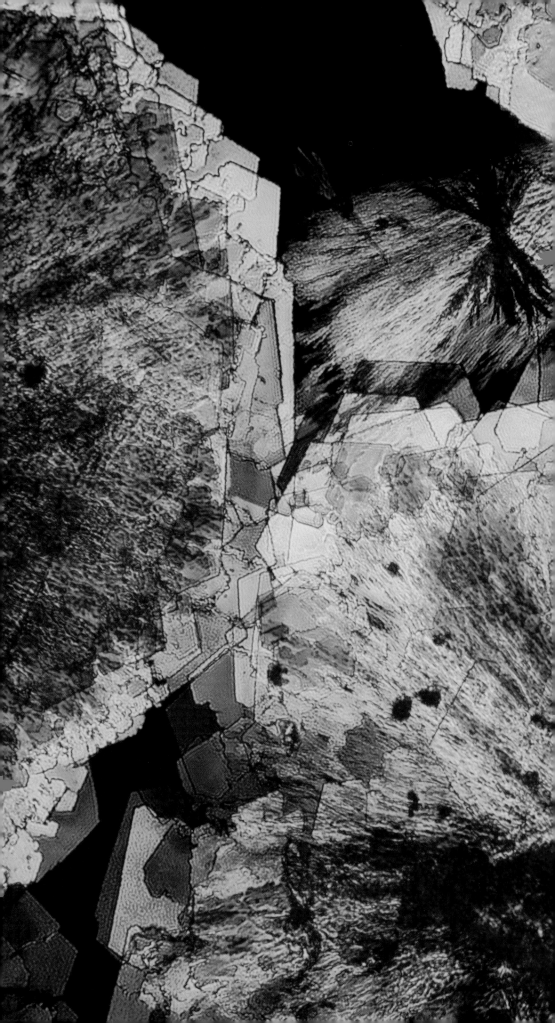

7.40/7.41 Horizontal framing of the channels found in
the device on page 85. The same section shown
vertically. Imagine how I shifted the stage.

7 / Photographing through a Compound Microscope

COMPOSITION

Simply shifting the image from a horizontal shot to a vertical
by rotating the camera on the connection tube and moving the
stage is another way to produce a vastly different image.

7.40/7.41 — Compare 7.40 and 7.41.

Have fun with composition, framing, and magnification. Don't
be satisfied with just one attempt. The possibilities can be

7.42–7.45 — endless as in 7.42–7.45, a series of various photographs of just
one microelectrode.

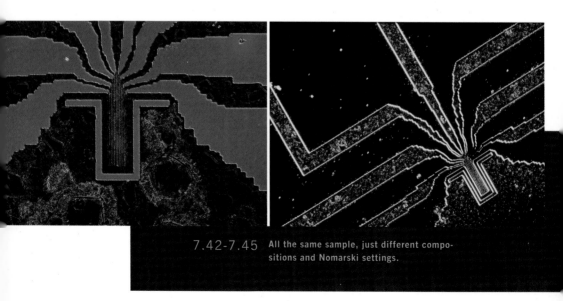

7.42-7.45 All the same sample, just different compo-
sitions and Nomarski settings.

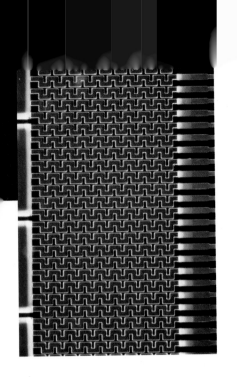

7.46–7.49

When you consider in your framing all the other components over which you still have control—like light quality and magnification—you'll realize that there is never just one way to make a picture. Images 7.46–7.49 (see the following pages), are a series of images I made of two similar samples of patterned crystal growth.

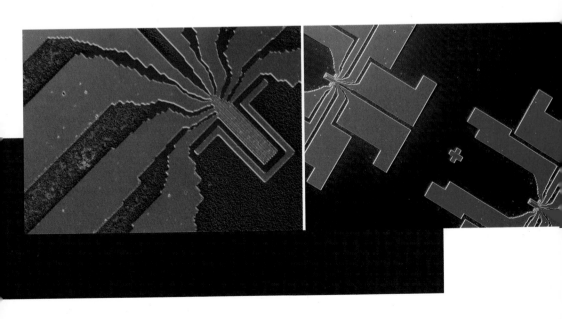

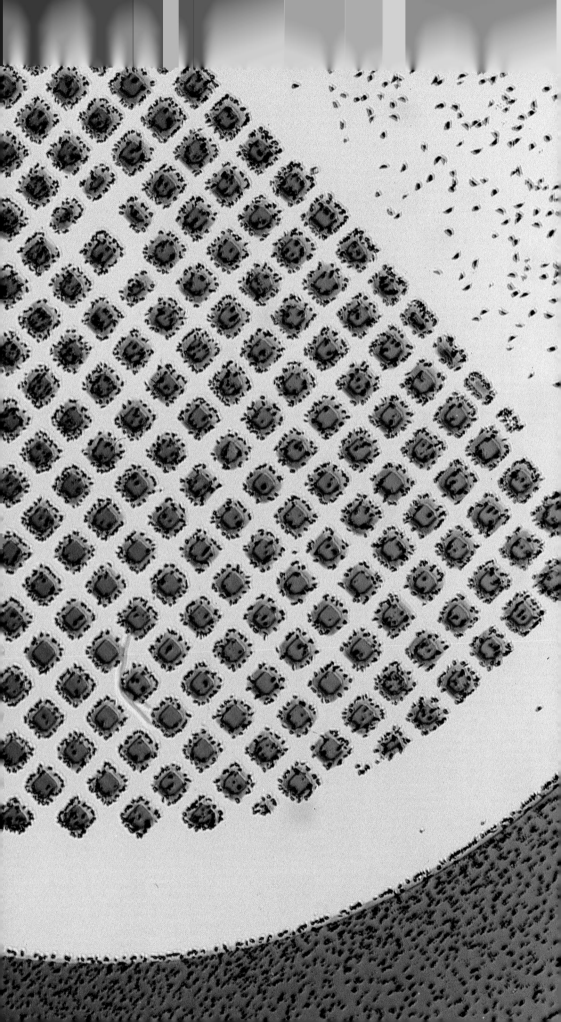

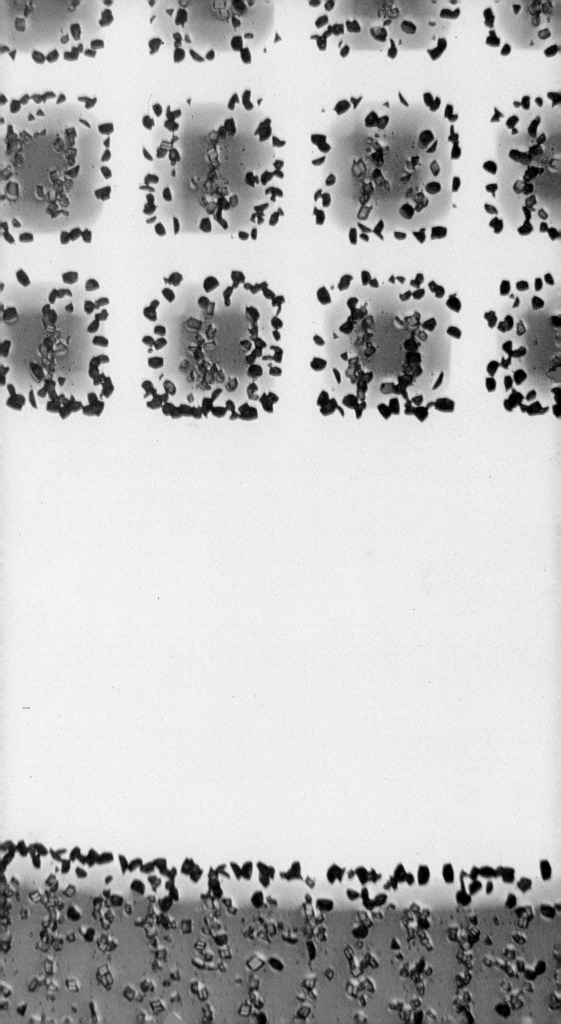

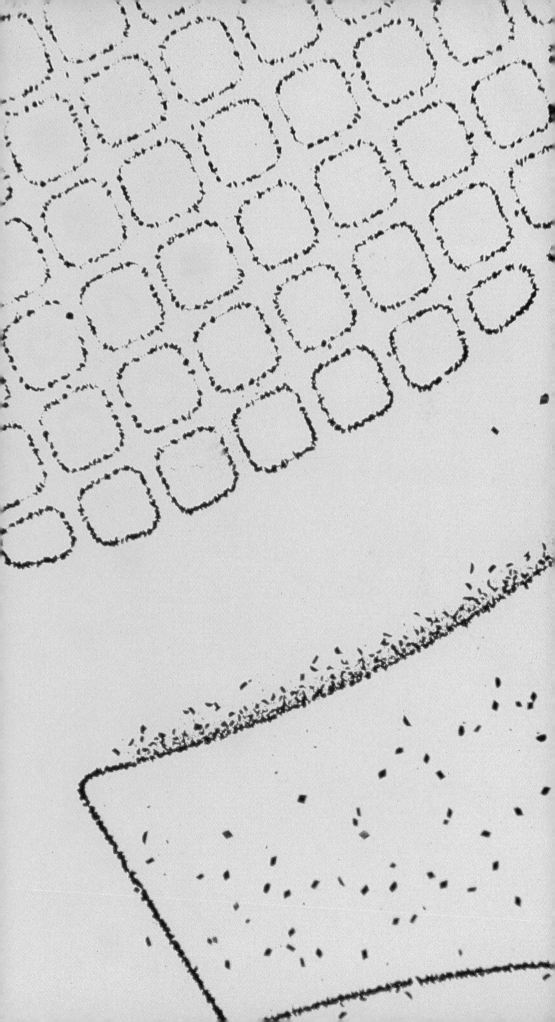

7 / Photographing through a Compound Microscope

SPECIAL CASES

SPECIAL CASES

7.50 My microscope isn't equipped to photograph fluorescent
 materials, but I was still able to make 7.50 by exciting the
 sample (see page 234) with two handheld UV lamps aimed
 close to the surface. Although this technique is not as precise
 as the techniques described in the next section, general UV
 fluorescence is possible even without filter sets.

7.51 In 7.51, I pulled a piece of transparent tape away from
 the surface of silicon. While it was awkward to simultaneously
 pull the tape away from the surface and release the camera
 shutter, and dial in the aesthetically appealing Nomarski
 setting (try to imagine it!), I was able to capture the point of
 the investigation showing the adhesion features at the
 surface of the sample.

7 / Special Section:
Biological Fluorescence
Photography

Matthew Footer

INTRODUCTION

INTRODUCTION

Photographing fluorescence under a microscope opens up a
whole new way of presenting samples. Instead of looking at the
overall structure, you are able to visualize features that might
otherwise be invisible. In this section I focus on fluorescent bio-
logical samples, but the techniques may also be applied to
material science.

By staining a biological sample with fluorescent dyes and
exciting the sample with one wavelength of light and observing
with another wavelength, we are able to see where a specific
type of biomolecule resides within a single cell.

7.52
7.53

Image 7.52, for example, is a simple transmitted light photo-
graph of two mouse embryo lungs at 13 days. Image 7.53 shows
the same lungs visualized with a fluorescent marker for the
airway epithelium. Notice how the labeled structures become
clearer to see.

7.54

In another example, the transmitted light photograph (on
black and white negative film) in 7.54 shows a thick section
of chicken intestine. The intestine lumen appears as the clear
area, but not much else can be observed in this image.

7.55/7.56

Images 7.55 and 7.56 (again on black and white film) show
the localization of two different cytoskeletal proteins not
apparent in the first image. In the former, we see the localiza-
tion of the protein actin, labeled with a rhodamine dye.

The latter image shows an actin-associated protein labeled with an antibody conjugated to fluorescein. Notice that the localization of both proteins is very similar and overlaps virtually 100%. The difference is in the relative amounts of detail we observe, not the location at this magnification and with this preparation.

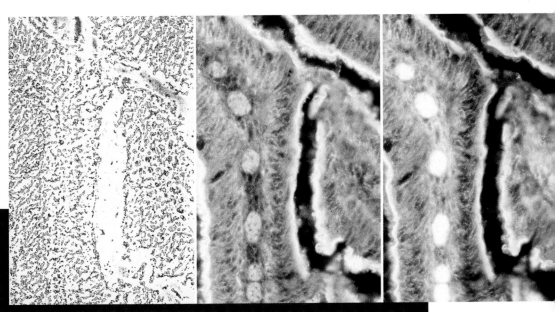

7.54–7.56 Chicken intestine with simple transmitted light followed by two kinds of fluorescing labels. All on black and white film.

HOW FLUORESCENCE WORKS

Our eyes require light to see objects, and light comes to our
eyes by a number of different routes. Fluorescent objects are
unique. To see them we must *excite* them—illuminate them with
light so that they can in turn emit their own light. In fluores-
cence, *fluorophores* are compounds capable of emitting light
when excited with one wavelength of light and in turn emit light
of a longer, lower energy wavelength. The lifetimes of fluores-
cent molecules are very short, on the order of nanoseconds, and
when the excitation light is turned off the fluorescence ceases.
This is unlike phosphorescence, which can persist for many
minutes or even longer.

Fluorophores are designed to emit light of as few wavelengths
or as pure a color as possible. The ideal fluorophore would emit
light of a specific wavelength, for example 580 nanometers,
which is a bright red. In reality, a red-emitting fluorophore like
rhodamine emits light from 540 nm (green) up to 700 nm
(near infrared), with the maximum being in a fairly narrow range

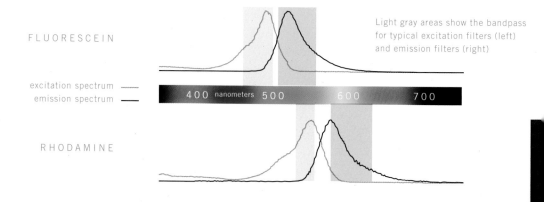

FLUORESCEIN

Light gray areas show the bandpass
for typical excitation filters (left)
and emission filters (right)

excitation spectrum ——
emission spectrum ——

400 nanometers 500 600 700

RHODAMINE

DIAGRAM 7.1 Excitation and emission spectra for fluorescein
and rhodamine.

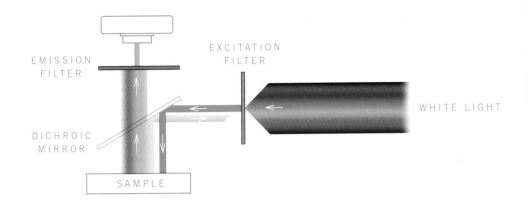

EMISSION
FILTER

EXCITATION
FILTER

WHITE LIGHT

DICHROIC
MIRROR

SAMPLE

centered about 580 nm. Similarly, the ideal fluorophore would
be excited by a single wavelength, but in reality fluorophores
are capable of being excited by a small range of wavelengths.

DIAGRAM 7.1

Diagram 7.1 shows the excitation and emission spectra for
the fluorophores fluorescein and rhodamine. The gray line is the
excitation spectrum, and the black line is the emission spec-
trum. If you look at the spectra shown, it is clear that the
excitation and emission for fluorescein partially overlap those
for rhodamine. This means that a small amount of the fluores-
cein image might end up in the rhodamine image. This is
the case with many fluorophore combinations and is not usually
a problem. Proper controls and an understanding of your exper-
imental system are critical for all image and data analysis.

Fluorescein and rhodamine can be excited, to a small degree,
by ultraviolet light. In fact, most fluorophores can be excited
by ultraviolet light. This is a useful property exploited for macro-
scopic photography, but it is seldom used with fluorescent
photomicroscopy. Instead, preferring a more precise target for
excitation, we use wavelengths near the excitation maximum.
Because these maxima are different from each other, it is then
possible to be more precise and to excite only one fluorophore
when a sample has more than one.

Filter Sets

A filter set consists of two filters and a dichroic mirror. A typical

DIAGRAM 7.2

configuration and result is displayed above in diagram 7.2.
Notice where the filters are placed to remove unwanted colors of
light and how the mirror reflects colors below a given wave-
length. It will then transmit colors above a given wavelength.

The selective excitation and observation of a specific color is
important for seeing where each fluorophore is and its relative
abundance.

EQUIPMENT

Fluorescence microscope

Mercury lamp

Appropriate filter sets

The highest numerical aperture lens you can use

Lenses designed for UV if UV excitable dyes are to be used

Film or digital microscope camera (a dedicated photomicroscope camera is best but not required)

50 to 200 ISO daylight slide film depending on sample brightness. 100 to 400 ISO black and white negative film if color is not possible or appropriate (single-color fluorescence images are monochromatic)

The Camera

Some of the newest microscope cameras dedicated to fluorescence microscopy will analyze your image and make the correct exposure based on reading the bright highlights and a dark background. Because dedicated photomicroscope cameras don't have viewfinders, it is imperative that the camera be *parfocal* (focus will be the same on the film plane and with the microscope's eyepieces) and that you know exactly where the frame lies, either by using a *photoreticle* (a frame in the eyepiece showing where the image lies) or through experience. This is the disadvantage of using a dedicated photomicroscope camera. However, the tremendous advantage of this type of camera is that it can see and meter the low amounts of light sometimes encountered with fluorescence photomicroscopy. These cameras are also set up for taking multiple exposures. Although this type of photography is easier with a camera specifically designed

for photomicroscopy, it is possible to calibrate a conventional 35 mm camera to achieve satisfactory results.

Using a Conventional Camera on the Microscope

If you don't have a dedicated special microscope camera, you might not have enough light to get a meter reading. The way to overcome this problem is simply to have a very consistent way of preparing your sample and to make a test roll to work out exposure conditions.

Make a series of exposures at 1/2, 1, 2, 5, 10, 20, 30, and 45 seconds. Refine your exposure after the first roll. Be sure to keep accurate notes about the film, sample, and exposure data so you'll be able to take more photos without having to worry about whether you've exposed them properly.

WITH FLUORESCENCE PHOTOMICROSCOPY YOU:

➤ May have to compose through the eyepieces and not the camera

➤ Control much of how the image will appear during sample preparation

➤ Generally strive for a clean black background

➤ Compose the image by careful selection of the region of interest

Film

Color slide film has the advantage over black and white film of immediately giving the proper color. It must be used when you want to simultaneously capture several colors in a multiple exposure. (See page 244.)

7 / Special Section:
Biological Fluorescence
Photography

Black and white film is sometimes useful in fluorescence work. The advantage of black and white film is that it can be easily processed in house so you will know what your images look like shortly after taking them. Moreover, some journals require black and white images unless color is needed for interpreting the data. In that case, you can first scan the separate images and then digitally color the image. Of course, digital capture allows you a quick look, but remember that you might be losing resolution when capturing images digitally.

The speed of the film you choose should be determined by the brightness of your sample and how fast the sample photo bleaches. If your sample is bright and doesn't photobleach, then use the finest grain daylight film. If the sample is dim and is prone to fading, you may have to use a film rated ISO 1600, or you can push 400 ISO film (see below).

Processing

Fluorescence photographs present us with a unique problem. Often we photograph a sample and discover that it looked better through the microscope. There are several possible reasons for the disappointing results—improper framing, incorrect exposure, and usually an overestimation of the inherent contrast in the sample. When we look through the microscope, often in a darkened room, we think our sample is brightly labeled on a nice dark background, but what really exists is a dim signal on a not-so-dark background.

The solution to making the highlights brighter and the background darker is to "push process" the film. Push processing

238

does several things. First, it increases the film speed, permitting you to photograph dim structures ordinarily not obtainable on normally rated film. In addition, push processing increases the contrast of the film, thus making the highlights brighter and the dark grays blacker. In general this seems to produce the most appealing fluorescent photomicrograph.

After observing the image and getting a feel for the range of shadows and highlights, I usually shoot one roll of film at the recommended ISO rating and one roll two stops faster. The new ISO rating for a 50 ISO film pushed two stops would be 200 ASA (film speed x 2 for each stop; 50 x 2 x 2 in this case). A 200 ISO film pushed two stops would be rated at 800 ISO. Simply set the camera's light meter to the new pushed ISO and shoot with the compensation you think you'll need; tell the film processor that you want the film pushed two stops. Don't assume you must always push the film. Experience and experimentation eventually help you make the right decision. Your sample should be bright (also referred to as having a good "signal") for every fluorophore you will be using, but without getting so much signal that the sample has too much background fluorescence, the latter of which is also called "noise." We refer to this ratio as signal to noise. If you are making multiple exposures on a single frame, you need not make all the fluorophores equivalent in brightness. The camera will take care of that for you since your exposure times will be different for each label. If you are using a multicolor filter for multiple labeling, then you must make sure the signal for all the colors is appropriately bright to observe the structures you want to see in the picture. For example, if the cell nucleus should be visible

but is not the focus of the story, make sure it is plainly visible
but not so bright that it distracts from important parts of the
image.

Be aware that this "color balancing" can be akin to photomanip-
ulation. It is also important to note that the amount of fluores-
cence you see through the microscope is not necessarily indica-
tive of the actual amount of biomolecule within the sample.

Understand the limits of this technique, and do not misinter-
pret what it represents.

Know Your Sample and Fluorophores
Most people determine what their sample will be before they
set up to photograph, yet many don't realize that they may
have a choice of fluorophores. Although nuclear DNA is usually
visualized with the blue fluorophore DAPI (,6-Diamidino-2-
phenylidole), there are good DNA dyes that fluoresce green and
red as well.

YOUR FIRST IMAGES

Know Your Sample and Exposure Requirements

If your sample is prone to photobleaching, you may get only one chance to capture that great image, so it is imperative that you know exactly what exposure to use before you take the picture. If possible, prepare another sample as a test to learn about how the sample, film, and camera are going to respond before then proceeding to a final image.

With most fluorescence photographs, you should expose the film less than the light meter indicates. For example, with fluorescein and rhodamine, you might have to go one or two stops lower than the camera indicates. With a bright dye like DAPI, you might have to underexpose as many as five stops.

Shoot a test roll of film.

If your sample is stable to fluorescence excitation and you are not concerned with photobleaching, then simply bracket your exposures. However, if your sample is sensitive to excitation, then the information you gain from the test roll will be invaluable.

THE PROCEDURE FOR TAKING YOUR TEST ROLL OF FILM IS AS FOLLOWS:

1 Mount your sample on the microscope and get a feel for its contrast range and how it fades.

2 Set your camera for the proper ISO, taking into account any push processing (see page 238).

3 If the sample seems to fade rapidly, then find a fresh field (move the stage around) and quickly frame your image.

7 / Special Section:
Biological Fluorescence
Photography

Immediately cut off the excitation light. Use bright-field illumination if possible to frame the image.

4 Set the microscope light to transmit 100% of the light to the camera, open the excitation shutter, and take your photograph.

With fluorescein and rhodamine, make your first test exposure three stops under what the camera recommends, then two stops, one stop, and then dead on. Don't waste time taking notes during the exposure series—your sample may not wait for you!

If the sample fades rapidly, you might have to move to a new field for each picture.

Take your first roll of film as single exposures. After you get a feel for how the images will appear on the film, try a roll of double/triple exposures. The ideal test roll has at least one photo that is too bright and one photo that is too dark.

MAKE SURE YOU TAKE GOOD NOTES ON:

➤ Film type

➤ Film's stated ISO

➤ The ISO the film was shot and processed at

➤ Exposure compensation

➤ Frame number and what was photographed

Maximize Your Chances for a Good Photo

It is important to make your photography session as efficient and predictable as possible, especially when dealing with a sample that might fade before your eyes.

Take extra time to prepare yourself and your equipment in advance.

BEFORE EACH SESSION, REVIEW THE FOLLOWING CHECKLIST:

➤ If your apparatus is such that you cannot look through the camera, make doubly sure the light path to the camera is clean. If the camera is on top of the microscope, the chances of something eventually falling off the film and landing on top of the photo eyepiece is virtually 100%. Learn how to keep this light path clean, which will depend on which scope you are using.

➤ Make sure your filter set is properly matched to the fluorophore you are using. Your microscope manufacturer and filter company will supply you with this information.

➤ Use 100% of the light to the camera if your sample is prone to fading, and make sure any polarizers such as Nomarski analyzers are out of the light path.

➤ Be familiar with the microscope you will be using, and keep excitation light to a minimum when not taking photographs.

Finally, don't expect to make a good photo from a bad sample.

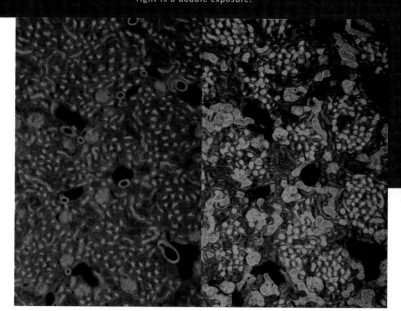

MULTIPLE
EXPOSURES

MULTIPLE EXPOSURES

Making multiple exposures on a single frame can add both beauty and information to an image. The proper exposure for each portion of the exposure will be approximately what it is for the fluorophore on a single exposure, but don't be surprised if you need a bit less exposure. You should make a test roll if your sample fades rapidly. If that's not a concern, then bracket around the exposure you think will give the best results. Be sure to have plenty of film on hand because bracketing for multiple colors means you will need that much more film. (Consider, for example three colors with three bracketed exposures on each frame.) Review the section in your camera manual about multiple exposures.

7.57–7.59 Images 7.57, 7.58, and 7.59 are of a mouse kidney. The red image shows the localization of glycoproteins while the green image shows the localization of the protein actin. I took both as single frames. In image 7.59, I double-exposed the image, on one frame, for both fluorophores.

244

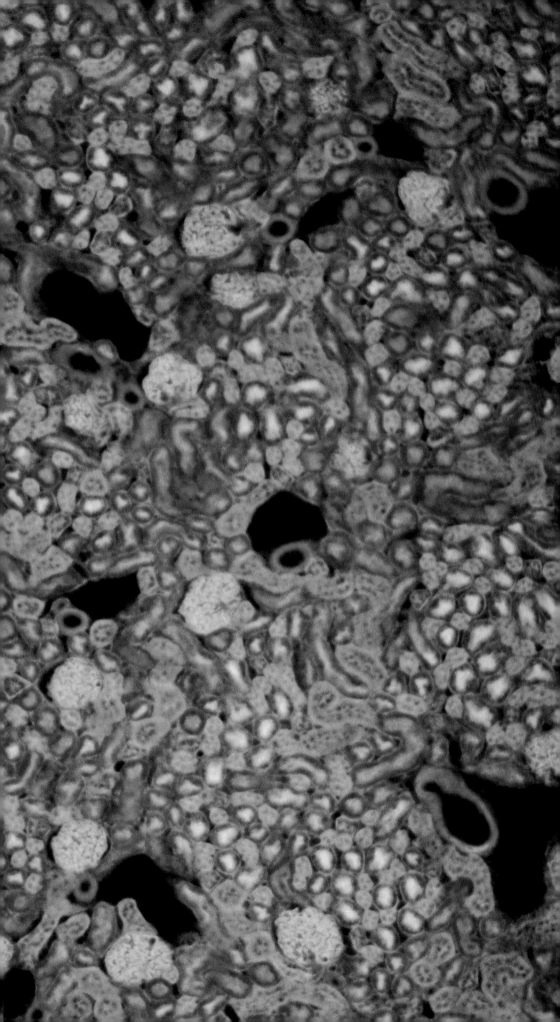

8 / Presenting
Your Pictures

8 / Presenting
Your Pictures

INTRODUCTION

Considering how to present your work should be part of
the process while making your images. Whether standing alone
or combined with other visuals or text, your pictures will
help communicate your research. The possibilities for how to
finally present your images vary. Some options will clarify
information and some will simply be aesthetic. For example,
the opening image for this chapter is a colored SEM (scanning
electron micrograph) of the old computer core memory
that I also photographed with the relevant equipment for the
beginning of the previous three chapters. After I made the
original SEM (8.1) with assistance from Nicki Watson at MIT's
Whitehead Institute, I digitally colored it (see also 8.2);
I wanted the image to work well with the other chapter openers.

8.1
8.2

As you consider the suggestions in this chapter, I encourage
you to think of them only as a starting point for you to then
intelligently expand the ideas to suit your specific needs.

While weighing the possibilities when preparing for a talk
or a journal submission, be selective about the choices various
presentation software packages offer, especially the bells
and whistles of applications like Powerpoint. Those crawling
words and animated colored sentences or striped fuchsia
backgrounds, mostly unnecessary to begin with, will never
replace good solid science and often are a distraction.

**The quality of the scientific investigation will always be
its true measure, not the way it is presented.**

To begin, consider to whom you are presenting and in what
form. Publishing your images in a journal that might ultimately
be displayed on a website will be different from presenting
a talk. A slide talk, either in film or digital format, for example,
gives you the opportunity to tell a story over time. You will
rarely have that opportunity in a journal submission because of
space limitations. For a verbal presentation, think about layering
your story with images appearing one after the other, not
all clumped together on a single screen. Depict a process that
changes over time. Show how your work was fabricated. These
will make interesting stories.

ARCHIVING

ARCHIVING

From the beginning of the imaging process, before putting
your talk together or submitting the images for publication, you
should fashion a system to easily retrieve any image at any
time, even years later. Your system of archiving images, separate
from your laboratory notebook, should reflect the way you
think. For example, my work spans a broad spectrum of sub-
jects and laboratories. For me, the most logical way to organize
my pictures is to categorize them according to the laboratory
and identify them with the investigator's name. In my file
cabinet I have hanging folders for each lab, and in the folders
are the slides and discs of images.

**You have spent a great deal of effort making good pictures.
They deserve to be handled properly.**

Slides and Unmounted Film

When the slides come back from the processing lab, I do an
initial edit and discard any that are absolutely unusable—those
that are too over or underexposed or not sharp enough. I then
store the remaining slides in *archival* slide pages. Don't use
slide pages not designated as such because they will eventually
damage the film. In recent years I have changed my procedure.
I now instruct my processing lab not to mount the slide film
in slide mounts because I scan most of the best images for digi-
tal storage, and my scanner doesn't take mounted slides. I
store the unmounted film in negative holders, also designated
archival.

SEMs

If I make an SEM on an instrument that cannot save the image as a digital file but only records the image on Polaroid film, I use the *negative* of the Polaroid negative/print film (Polaroid 55) to eventually make a scan. Saving the print and then scanning from the print, as I am surprised to see many researchers do, doesn't give you the details (information) that the negative does. Taking the minimal extra step to keep the negative is well worth the effort. (See Polaroid 55 instructions.) The same is true for TEMs (transmitted electron micrographs). Keep the print for reference only.

Store the 4 x 5 Polaroid negatives in archival sleeves.

CDs

After I scan the best images, I burn them on CDs, which I store in the same hanging folders with the slides. I include in the CD holder a printout of large thumbnails of the images. I keep a second copy of the printout of thumbnails in a separate notebook so I can quickly flip through all the files from one source when I want to. Each page is labeled with the appropriate lab so I can then go the folder and find the disc. If I need another variation of the shot (which has happened often for the production of this book), the slides are right there to choose for scanning. There are a number of programs available expressly for making thumbnails of images. I use one called Iview MediaPro. It's simple, inexpensive, and gets the job done. All I do is move the files to the application, and I get a miniature arrangement of the images along with information about the files.

SCANNING

SCANNING

Imaging with film offers control over the final resolution of a
scan, whereas using a digital camera limits the scan to the
resolution of the capture. Your decision about what resolution to
make the scan (usually referred to as ppi, pixels per inch)
will depend on the final use of the picture. As a general guide-
line, if you expect that the images will be printed in a journal
or book, scan the images at 300 ppi at about 6 to 7 inches
long. Even if you are sure the image will only be printed at three
inches, you'll be happier having a larger file for later use in
case the need crops up. You can always reduce the image size,
but it is not a good idea to convert a smaller ppi file to a
larger one (for example, 72 ppi to 300 ppi) because the mathe-
matical calculation used to produce more pixels is an inter-
polation and not real data. The resulting image sometimes
won't look the way you want it to look. No matter what type of
printer you will be using—inkjet, laser, or dye sublimation
printer—use the resolution indicated in your printer's manual.

Making a larger ppi file than your printer requires is a waste
of time and digital space.

In addition to scanning my film at high resolution, I also con-
vert copies of the images to low resolution files, usually around
72 ppi, and store them in a "low res" folder on the CD. For
example, for this book I scanned the images at 300 ppi at the
appropriate dimensions for the layout. A two-page spread of
one 35 mm image became a large file of almost 40 megabytes

and was too large to show my book designer as an attachment
in e-mail, so I converted the file to 72 ppi at about 6 inches
long. Consider that other researchers and journal editors may
want to take a quick look at an image as a small file attachment.
You may also post the image on a private web page for others
to see. For final publication, I later send a larger attachment,
FTP the image to a designated site, or mail the file on a Zip disk
or CD.

I use an Imacon scanner. I have scanned files up to 600 MB for
very large prints and have been pleased with the results. But
my scanner costs about $12,000. For your purposes, a good, less
expensive desktop scanner to scan your work may be all you
need. Check the latest product reviews on the web for the best
scanner manufacturers.

Do not scan from prints.

If you use negative film, scan from the negative, not from a
print. You will lose detail (data) by going through the unneces-
sary second-generation print.

8.3 / 8.4 A visual metaphor: an ink stamp on the left and "soft lithography" on the right, a technique for patterning surfaces.

COMMUNICATING
WITH THE PUBLIC

COMMUNICATING WITH THE PUBLIC

The fundamental premise of this book is that your images are both valuable for demonstrating your work to your colleagues and are powerful tools for communicating to the nonscientific community. Including your carefully crafted photographs in a public talk or a magazine article will make your science accessible to those who would not ordinarily be exposed to it. A few approaches to consider are listed below.

Explain complicated science with visual metaphors.

Because much of your work may be difficult to comprehend by those unaccustomed to thinking as professionals in your field of research do, a simple visual metaphor emphasizing the essence of the work can be enormously helpful. For example, in a talk I gave, I described the similarity of "inking" with a woodcut or this Chinese stamp of my name, in image 8.3, to the chemistry of the patterned areas in 8.4 produced by using a soft-lithography technique.

8.3
8.4

Introducing this image of a piano player roll, 8.5 (suggesting "on and off"), helps the nonscientist understand how a compact disc works, image 8.6.

8.5

8.6

Use your images for multiple purposes—as introductory slides or for report covers.

A detail of the equipment at the Microsystems Technology Laboratories at MIT, 8.7, became the cover image for an annual report.

8.7

2000
ANNUAL REPORT

Microsystems Technology Laboratories
MIT

8.7 Consider using your images for a variety of purposes.

8 / Presenting
Your Pictures

MEMS Technology
for
Micro-Engines

8.8　　Reza Ghodssi used image 8.8 as an introductory slide to one
of his talks. I combined an image from his work and text.

Include props to indicate scale.

In previous chapters we've looked at the challenge of showing
8.9　　scale. Here are some additional possibilities. In 8.9 I included
the containers in which these large crystals were stored along
with a computer memory chip.

One centimeter is comprehendible, the size of the microrotor
8.10/8.11　　in 8.10. Pairing it with the microscopic image, 8.11, of the
same microrotor in the same presentation helps give a relative
sense of scale.

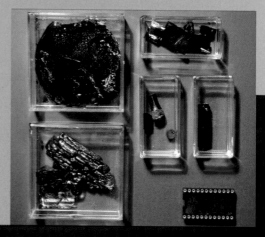

8.9　**One idea for showing scale.**

Consider the historical perspective.

Your reader or audience may be intrigued to know your investigation is part of history. Showing this old drawing by Robert Hooke, 8.12, of a detail of a fly's eye (relating to gathering visual information) could add an interesting component to a presentation showing the structure of similar "eyes," as in the case of this brittlefish, 8.13. Joanna Aisenberg at Bell Labs begins one of her talks about the fascinating structure of this fish by combining a photograph and an SEM of the detail in the shape of eyeglasses, suggesting how the structure helps the larger organism "see."

8.12

8.13

Have fun with the power of humor.

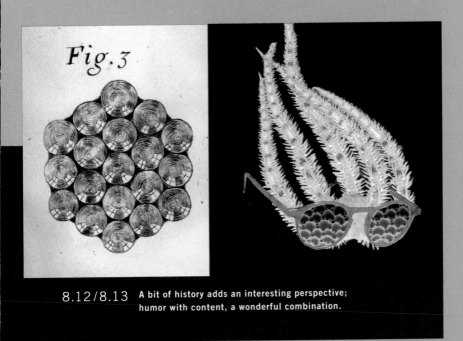

8.12/8.13 A bit of history adds an interesting perspective; humor with content, a wonderful combination.

8 / Presenting
Your Pictures

SPEAKING TO YOUR COLLEAGUES

In journals and in professional presentations, images and text
are often combined. I list just a few ideas and observations
about how to do so effectively.

Combining Photographic Images with Text, Illustrations, and Graphs

It is tricky business to successfully combine your photographs
with text and other graphics such as charts, graphs, and
line drawings. Those trained in graphic design spend years
studying the complexities of visual presentation and practicing
the techniques, so be patient with your own attempts. Pay
attention to how the professionals practice their craft, and think
about why a text and figure layout is or is not successful.

Remember, the first-time viewer takes in everything at once.
It's your job to guide the viewer through all the components in
your image. Consider carefully what is necessary to show,
and eliminate unnecessary elements.

What is the purpose of the composition? Creating a visual for
the printed page where space is limited is different than prepar-
ing an image for projection on a large screen. As you begin
combining type with photographs, drawings, or graphs in one
image, consider these basic questions:

> How many components will make the point? Typically, fewer
 components will result in a clearer message.

> How should these components be arranged relative to each
 other? The size of the component, its placement on the page,

and its placement in relation to the other components will all affect how the viewer reads the message.

> What typeface (e.g., Times Roman, Helvetica) and type style (e.g., bold, italic) should you use?

A note on typeface. I don't recommend using more than two typefaces in one figure, and I would even encourage you to stick to one and simply vary the size for various headings and labels. I prefer a sans serif typeface because I find it more readable, but I've heard many arguments about the matter. You need to make your own choice. Most researchers use too large a point size because they have been advised not to make the type too small. The best way to make these decisions is to run a test. Create a slide with several type sizes and the appropriate graph and image (a test with just text will not be helpful), sit in the audience at various distances, and decide for yourself.

CASE IN POINT

8.14 Image 8.14, from the investigator's lab, is a well-prepared and informative figure of the small reactor we have seen before (see the following page). To begin, he combined two images of each end of the device in one picture and added two hand-drawn lines to indicate the longer omitted section. The important elements are present. However, to improve the figure, I made

8.15 the following changes to produce image 8.15:

> Using Adobe Photoshop, I added more background, thus creating more surrounding space.

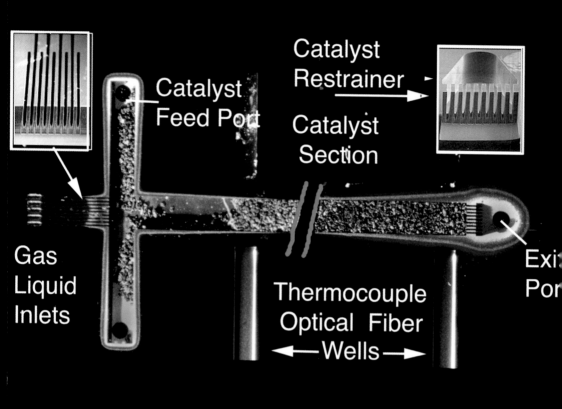

Catalyst
Restrainer

Catalyst
Feed Port

Catalyst
Section

Gas
Liquid
Inlets

Exit
Port

Thermocouple
Optical Fiber
←—Wells—→

8.15 Notice the subtle changes to the above.
Is it improved?

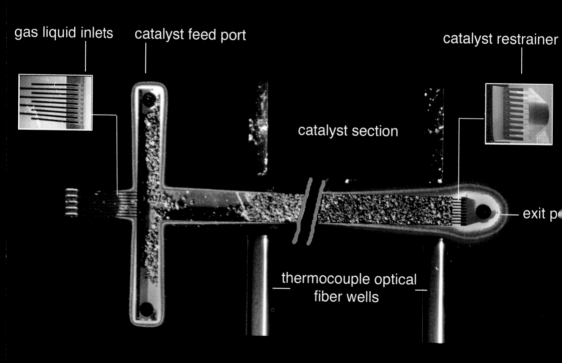

gas liquid inlets catalyst feed port

catalyst restrainer

catalyst section

exit p

thermocouple optical
fiber wells

Two Representations of Quantum Confinement

Two Representations of Quantum Confinement

SPEAKING TO
YOUR COLLEAGUES

> ➤ I changed the insets. If you are going to include an inset or two, make sure the orientation matches the original. Notice how I rotated the insets to correlate with the larger image. This raises the question of whether these particular insets add information, that is, are we seeing more structure in the SEMs?

> ➤ I decreased the type size and eliminated the unnecessary capital letters, resulting in a less crowded figure.

> ➤ I aligned the text, giving a sense of order, which helps the eye to travel through the figure.

> ➤ I deleted the unnecessary arrowheads, simplifying an already complicated figure.

The fewer the graphical elements, the better.

8.16 For 8.16, I combined a photograph of a series of vials containing the fluorescing nanocrystals we saw on page 115 with a graph showing more numerical values of fluorescence. Both components reinforce the information, and the figure becomes more interesting than the graph or photograph alone.

8.17 Note that image 8.17 is the same figure produced for a screen presentation. Generally, darker backgrounds project better on a screen than lighter backgrounds. You might want to experiment with dark backgrounds in your own figures and see the difference.

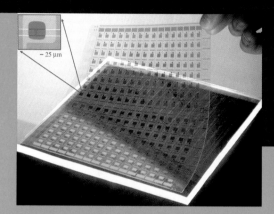

8 / Presenting
Your Pictures

SPEAKING TO
YOUR COLLEAGUES

8.18

In 8.18, the researcher elegantly inserted a microscopic detail
of the stamped electronic circuitry that appears on page 33.
The relative proportion of the two images is good, and the insert
is well placed. Subtleties like framing the insert with the same
weighted lines of the arrows are important. He could have drawn
the arrows from anywhere but chose the middle left portion,
making the final composition feel balanced.

Including Apparatus

Often, it is helpful to show the apparatus in your presentation.

8.19

Including an image of the entire apparatus, image 8.19,

8.19/8.20 **Showing your apparatus at two scales.**

8.20 helps the viewer to make sense of the relevant detail as in
image 8.20.

8.21 In 8.21, I combined the image of the larger apparatus,
photographed by Scott Brittain, with the detail microscopic
image first seen on page 152.

Don't neglect the details that will enhance your photograph

8.22 of the apparatus. The dramatic difference between images 8.22

8.23 and 8.23 results from one small change—I simply placed
a piece of paper behind the apparatus to create a neutral, non-
distracting background.

8.22/8.23 **Remember the small things. Simplify the
image.**

dispersive fiber

dispersed pulse

circulator

λ_{red}

chirped grating

λ_{blue}

electrical
lead

in-fiber grating

tunable dispersion compensator

fiber in/out

to computer control

1 cm

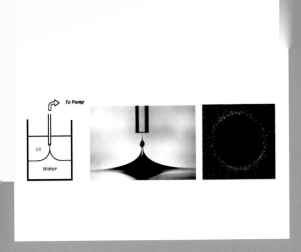

When including the apparatus in a figure with an illustration
or graphs, try to simplify the arrangement of the components.

8.24 In 8.24, John Rogers stacked the components over each other,
making the figure vertical and easy to comprehend.

If a photograph of the apparatus isn't available, a diagram or

8.25 sketch can work when used with other photographs, as in 8.25.

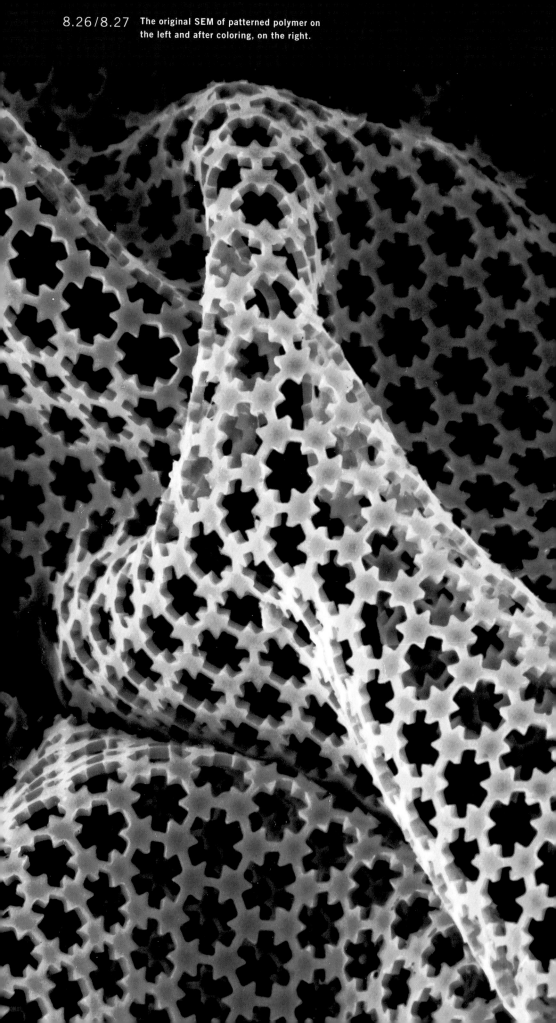

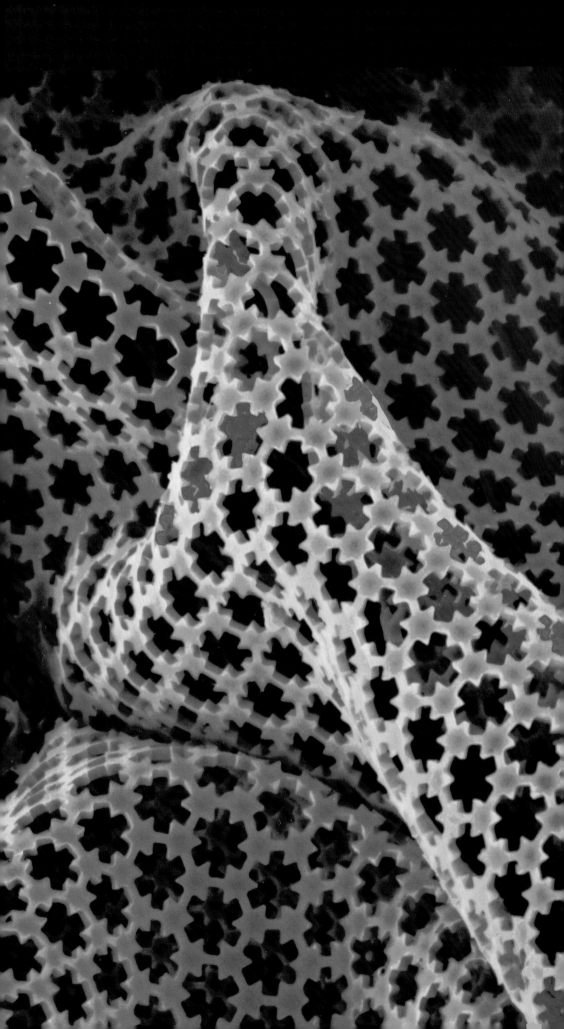

DIGITALLY ALTERING
IMAGES

DIGITALLY ALTERING IMAGES

Because it is so easy to alter images when they are in digital
form, we in the science community must reflect on what we
are ultimately doing to an image when we digitally manipulate
it. Think seriously about whether the change, or "enhance-
ment," you make to an image is appropriate. What might be a
well-intentioned adjustment to clarify structures and forms
could actually create a significant change in the data showing
something new in the image that is not necessarily there.
You must be rigorous when you consider altering pictures in
science. Because this book emphasizes making pictures for the
purpose of communication and not for analyzing data, the
examples included in this chapter address the communicative
nature of the manipulation. However, I urge you to question
every alteration I discuss and its appropriateness when you con-
sider applying the techniques to your own work.

When you digitally alter an image you are changing the data.

Journals' Responsibilities

Scientific journals must become more responsible when publish-
ing images that have been digitally altered. Just as they demand
the rigor of the scientific experimental methodology to be
applied to the text, journals should do the same for the produc-
tion of scientific images. Readers should know exactly how
each picture was made from the first capture to the final repro-
duction in the journal or on the web. I am suggesting an
additional requirement for every article submitted for publica-
tion—a description of the methodology for every submitted
image. Additionally, journals should allocate the space to publish
this information that supports the validity of the research.

**Always inform your reader or audience how you have altered
an image.**

The following are examples of digital alterations I made for this
book. As you read through the descriptions, consider whether
the primary content or idea of the image has changed. In other
words, did I cross the line?

Coloring SEMs

Although many researchers digitally color their SEMs, I am not
convinced that all images benefit from adding color. If
coloring an SEM clarifies the structure in the image or if it helps
to make the image more attractive, thereby making the work
more accessible, then you should consider doing so. Image 8.26

8.26

is an SEM of molded plastic that Younan Xia took when he was
at Harvard (see the preceding pages). I digitally colored the image

8.27

in 8.27. In this case I didn't necessarily clarify the structures,
but it is likely that I helped bring attention to the much-
deserved investigation since the colored image was published
in a broad range of publications.

If your scanning electron microscope comes with coloring
software, don't always use the default color palette. Your images
should not look like those of your colleagues; you should
control the appearance of your image, not the computer scien-
tist who created the algorithms.

CASE IN POINT
There are many ways to color SEMs, some of which you will
discover for yourself. The same coloring techniques or their

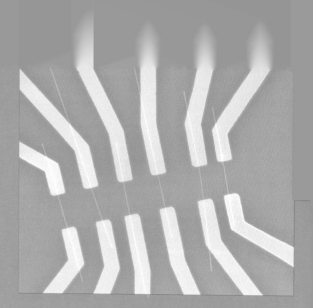

8 / Presenting Your Pictures

DIGITALLY ALTERING
IMAGES

variations may be used for other digital imaging such as TEM
(transmitted electron microscopy) or confocal microscopy.

8.28 Here is how I colored this particular SEM of nanowires, image
8.28. I worked with Yu Huang in Charles Lieber's lab at
Harvard to get the original black and white image at the highest
possible resolution. I used Photoshop for the next steps, but
there are other image-coloring applications that will do the same.

8.29 I converted the image from black and white to RGB and
increased contrast, anticipating the next step when I would use
the selection tool. The tool works best when the selected pixels
differ considerably from the nonselected pixels.

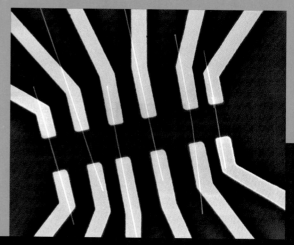

8.29 Conversion to RGB and increasing contrast.

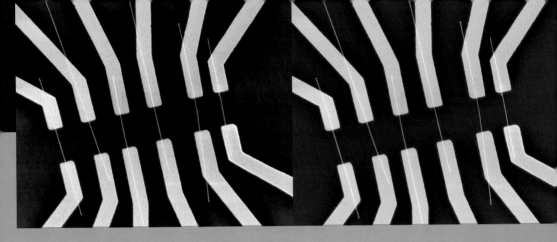

8.30 Using "fill" in the edit menu, I selected and colored the wires.

8.31 I then selected the background, colored it, and then colored
 the rest through a series of steps.

8.32 I selected the background and inverted the selection under
 image =>adjust =>invert.

8.33 Not pleased with the pink background, I kept the background
 selection and changed the "hue" under "adjust" (see the follow-
 ing pages).

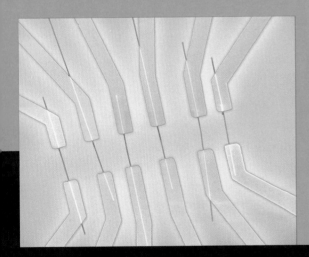

8.32 Inversion.

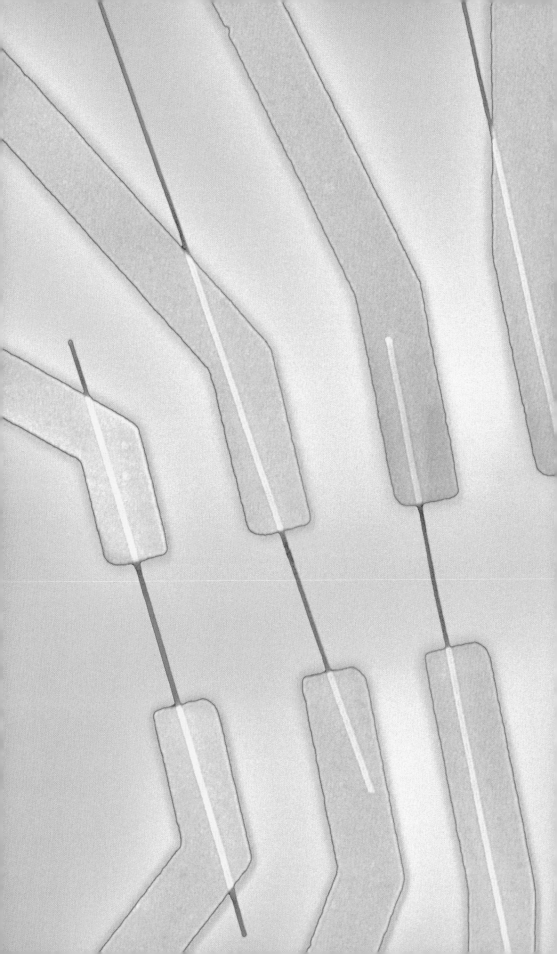

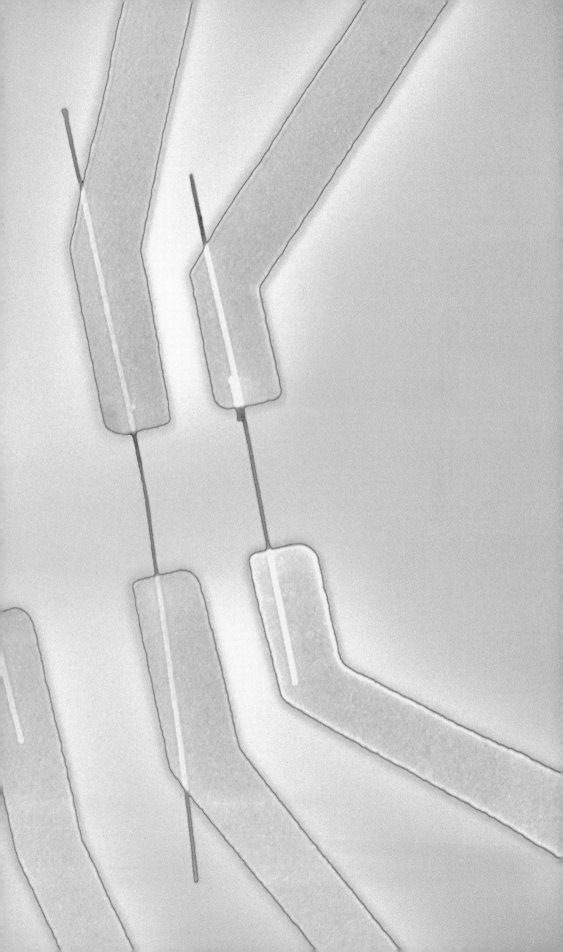

8 / Presenting
Your Pictures

DIGITALLY ALTERING
IMAGES

Digital Subtractions and Additions

On page 167 I described the difficulty in photographing highly
reflective surfaces under a stereomicroscope; the surface
reflected the stereoscope's light source from above, producing
8.34 a halo, repeated here in image 8.34. Digitally removing
8.35 the halo and some dust particles in 8.35 makes the important
structures more readable.

The agar in this petri dish growing *proteus* colonies, first
appearing on page 124, cracked in a number of spots. Image
8.36 8.36 is the original photograph. Because I wanted the viewer to
pay attention to the stunning patterns of growth, I digitally
8.37 "cleaned" the cracks from the agar in 8.37.

8.36 **The original image.**

8.38
8.39

I initially took image 8.38 of this yeast colony, first appearing
on page 110 (see the following pages). In image 8.39, I digitally
removed the petri dish, bringing attention to the structure
and detail of growth. Gerry Fink at the Whitehead Institute, who
with Todd Reynolds published the image, suggested that with
the petri dish gone, viewers might not recognize what they
are seeing. "What is this, a flower or the abstraction of a flower?"
wrote Gerry in a private communication. For him, removing
the petri dish, although "achieving clarity and luminescence that
is missing from the traditional laboratory shot, [it] fails to
give a sense of dimension. With some hint of the petri dish in
the photo, both of those questions are answered."

8.37 After digital alterations.

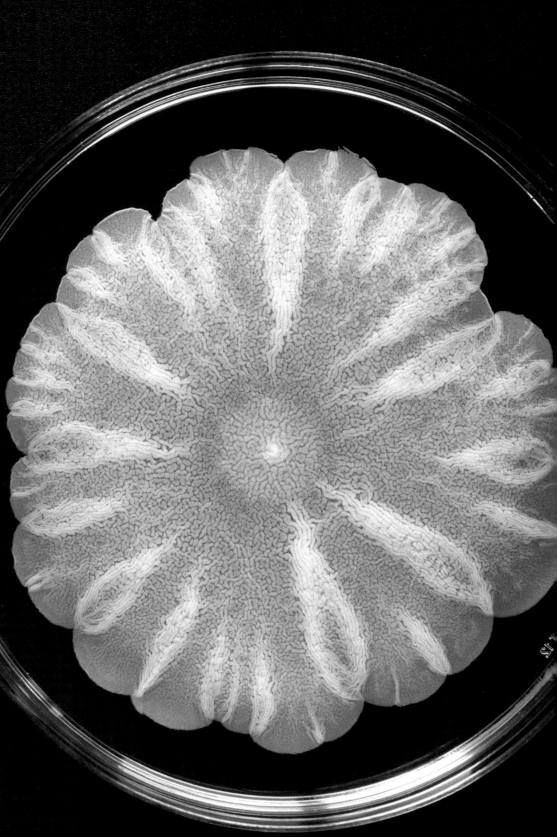

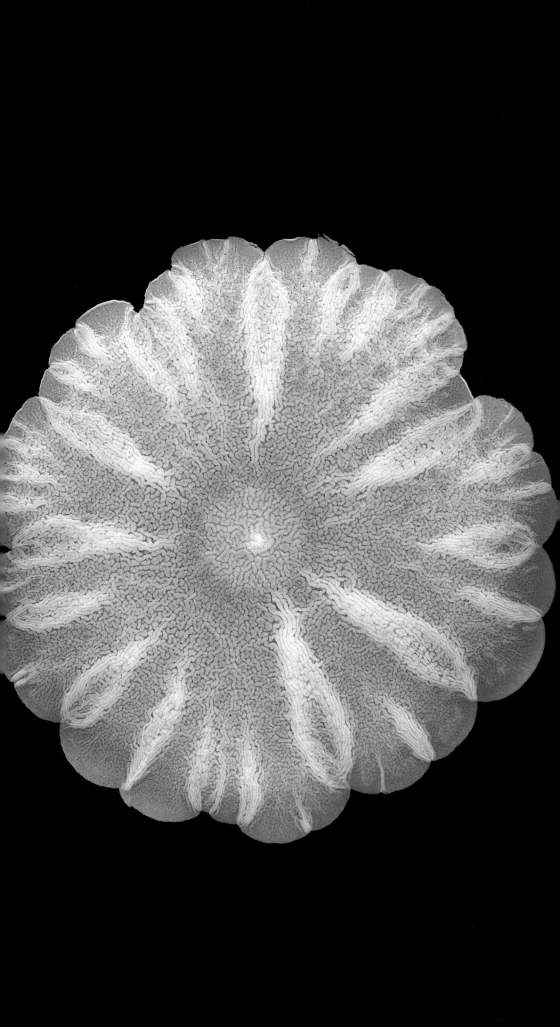

DIGITALLY ALTERING
IMAGES

8.40 Image 8.40 is a detail of an optical system designed to measure
the thicknesses of thin metal films used in microelectronics.
I digitally added the laser beam, an important part of the system.

How appropriate were the previous examples?

Deskewing

8.41 The first image of this pair, 8.41, is a DNA electrophoretic run
captured on film. The run was crooked as was the control.
Is it legitimate to digitally straighten the image to create image
8.42 8.42, using the control as a guide?

8.43/8.44 The original chip image on the left. The
first step in deskewing on the right.

8.43 When I photographed image 8.43, a chip on which there are
a number of small experiments, I liked the way the light
was reflected, but the perspective wasn't interesting. Using
Photoshop, I selected the chip, deskewed the selection

8.44/8.45 in image 8.44, and then cropped the image to produce 8.45.

Have I changed the information?

Fixing Color

On page 113 I changed the color of a group of gel rods because
the film I used didn't capture the orange wavelength. In that

8.45 **Digital correction of the image on the left.**

279

DIGITALLY ALTERING
IMAGES

case, the digital change made the image appear closer to what
my eyes observed.

8.46 In another example, 8.46, while making an image of a device in
Michael Rubner's lab at the Center for Materials Science and
Engineering at MIT, the laboratory fluorescent ceiling lights gave
8.47 a green cast to the image. I digitally corrected the image in 8.47.

Inversions
Taking cues from the architectural community and using a
particular technique of inverting plans and images to produce
a negative sometimes helps to clarify structure.

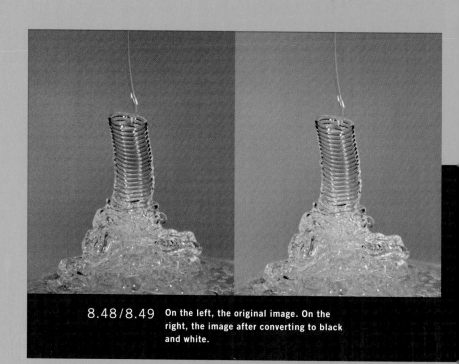

8.48/8.49 On the left, the original image. On the
right, the image after converting to black
and white.

8.48 My original photograph of coiling silicon, image 8.48, was not
as successful as I would have liked. Although, as I described on
page 135, I eventually captured the right moment, I wasn't
happy with the color. I scanned the image and converted the file
8.49 to black and white, making image 8.49. I then selected the
background, deleted it, and inverted the whole image resulting
8.50 in image 8.50.

Be judicious when inverting an image in Photoshop and taking
the idea to an extreme using various digital filters. Although
the scientific community doesn't generally use most of these
filters, it's possible that adding a bit of drama, especially if

8.50 The final image, after inversion.

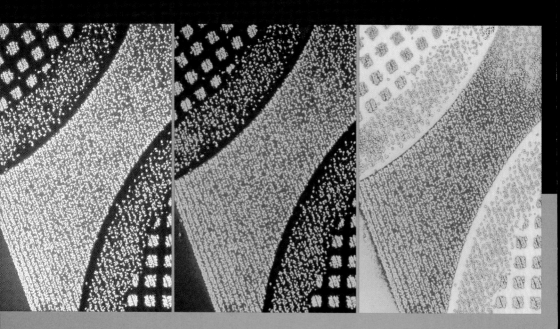

8.51

8.52–8.54

you are presenting the work to the general public, can be helpful. The original SEM, 8.51, was first made by Joanna Aizenberg when she was at Harvard. I made a series of adjustments in 8.52, 8.53, and 8.54. The patterned calcite crystals appear more three-dimensional using the "embossing" filter in the last image of the series.

Do any of these alterations clarify the image?

Remember to indicate exactly what you have done to an image when you present an altered image to your colleagues or to the public.

Combining Images

We have seen in pages 138–140 examples of how combining single images in one series is a powerful way to communicate what happens over time. In fact, single images used this way may be more informative than an animation, especially if one cannot pause the animation to study a particular moment. Combining single images into one larger composite of details is also effective.

8.55 To show the detail in a complicated optical chip from Bell
Labs, I took a series of microscopic images and then digitally
combined them to show the whole structure in 8.55. Notice
the black lines between images, indicating that I photographed
each separately.

8.56 In image 8.56 I combined two photographs, one with five
patterned glass capillaries and one with two. See if you
can determine which image was added to which. (Hint: see
image 7.16)

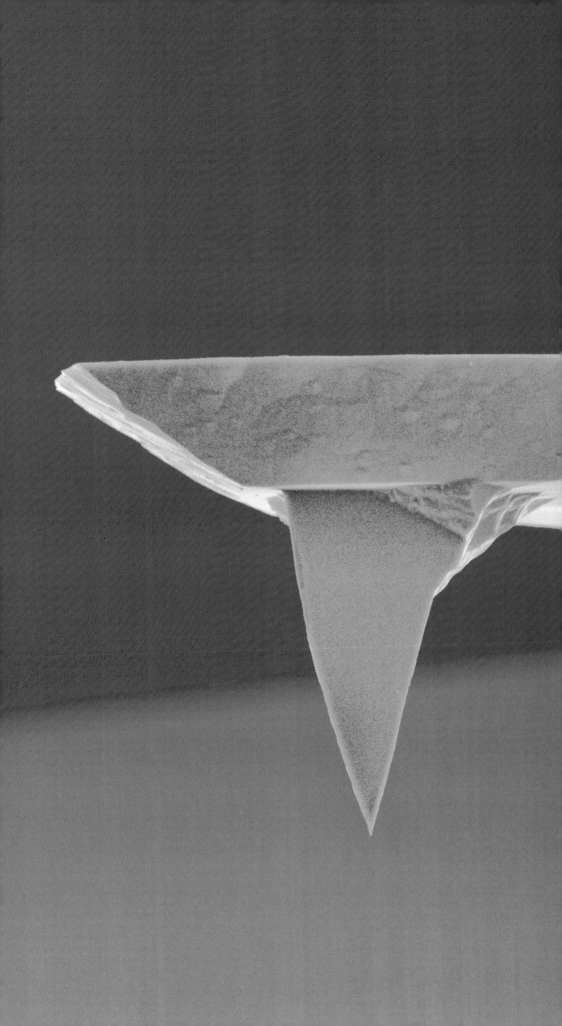

Exercises

The following pertain to chapters 4–8. It is important to respond to the questions after you view the final images and not during the process.

p 30 **Chapter 4**

1 Photograph your sample with a camera and lens, with a stereo-microscope, with a compound microscope, and, if possible, with a scanning electron microscope. Describe the differences.

p 38 **2** Compose an image and purposefully include a distracting element. Take the picture. Recompose by editing the distraction from the frame. Compare the two.

p 40 **3** Make a horizontal image. Now make a vertical image of the same material and adjust for framing. Compare the two.

p 41 **4** Find a symmetrical object and photograph it to purposely make the image crooked. Now rephotograph it symmetrically. Compare the two.

p 48 **5** Photograph a complete sample. Next, photograph only a part of it, still giving sufficient information. Which do you prefer?

p 49 **6** Make two images of your material, one on a slant and one straight. Which is better?

p 62 **7** Bracket an image with four exposures. Describe the differences in the images.

p 66 **8** Make four separate images of an object at four different f-stops. Compare.

Chapter 5

p 82 **9** Sketch three alternative sample designs and determine the reasons why one is better than the rest.

p 85 **10** Make two images, one with one sample and the other with two or more. Observe the difference.

Exercises

29 Make an image using different settings in Nomarksi differential contrast. Describe the differences.

30 Using the same material and framing as in exercise 29, take the image using dark-field. Some material will not be suitable for capturing with dark-field, but if you are able to do so, compare the images to those in 29.

31 Frame an image and take the picture. Now change magnification and take another shot. Compare the two.

Chapter 8

Use this chapter as a foundation for a small discussion and critique seminar on presenting your images/data and figures with the following suggestions:

> Invite no more than ten participants from various disciplines, each posting or projecting two or three examples of presentation material.

> Raise questions of clarity, organization, and communicative potential to colleagues and public.

> Discuss image quality and whether alterations are appropriate.

Each participant has a week to make suggested adjustments and return to the group, showing original and revised material. Discuss improvements.

Visual Index

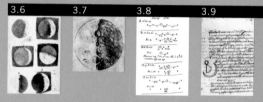
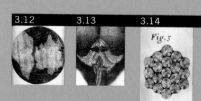

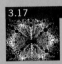
 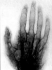
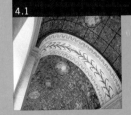

Visual Index

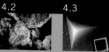
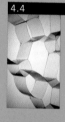
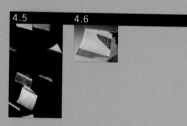

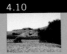

pp 36–37

Point of View

4.9 Codorniu Napa Winery
Carneros region of the Napa Valley,
California. Photographed with a 28 mm
PC lens. Domingo Triay, Landscape
Designer.

4.10 Codorniu Napa Winery
Domingo Triay, Landscape Designer.
See 4.9

pp 38–39

Composition

4.11/4.12 Detail of Wafer Chamber
Photographed with a 55 mm macro lens
at the Microsystems Technology
Laboratories (MTL). MIT, Martin Schmidt,
Director.

4.13/4.14 Magnetic Core Memory
From an IBM 7094 computer of the mid-
sixties. Each donut-shaped magnet
remembers 1 bit; the computer had 32K
of memory arranged in 36-bit words.
Both photographed with a 105 mm lens.

4.15/4.16 Crystals
Robert Birgeneau's Lab, MIT. Laboratory-
made calcium fluoride and manganese
fluoride. Photographed with a 105 mm
lens.
Gilman, J. J. ed., *The Art and Science of
Growing Crystals.* New York: John Wiley &
Sons, 1963.

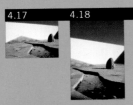

pp 40–41

Composition

4.17/4.18 Sculpture Garden
By Isamu Noguchi. Costa Mesa, California.
Photographed with a 28 mm PC lens.
Landscape Architecture 85 (1995).

4.19 Micropressure Sensor
Microscopic image photographed with
Nomarski Differential Contast. Fabricated
by graduate students at MIT's
Microsystems Technology Labs, Martin
Schmidt, Director.
Stephen D. Senturia, *Microsystem
Design,* Kluwer Academic Publishers,
Boston, 2001.

Visual Index

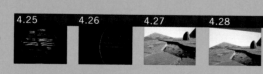

4.29 4.30 4.31

Composition (continued)

4.29 Electronic "Ink" Microcapsules
Joseph Jacobson's lab, MIT. Photographed with a stereomicroscope.
Comiskey, B. et al., "An Electrophoretic Ink for All-Printed Reflective Electron Displays," *Nature* 394 (1998).

4.30/4.31 Nanocrystals
Moungi Bawendi's lab, MIT. Photographed with a stereomicroscope. See 4.2

pp 50–51

4.32

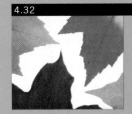

Composition

4.32 Autumn leaves
Placed on a white surface. Photographed with a 55 mm lens.

pp 52–53

4.33 4.34

Composition

4.33 Opal
Photographed with a 105 mm lens.
Murray, C. A., and D. G. Grier, "Colloidal Crystals," *Am. Sci.* 83 (1995).

4.34 Opal See 4.33.
Ohara, P. C. et al., "Crystalization of Opals from Polydisperse Nanoparticles," *Phys. Rev. Lett.* 75 (1995).

pp 54–55

4.35

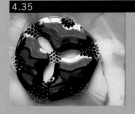

Composition

4.35 Ferrofluid
Suspension of magnetite in oil. The drop was placed on a glass slide, under which is a yellow Post-it and 7 circular magnets. Photographed with a 105 mm lens.
Raj, K. et al., "Commercial Applications of Ferrofluids," *Journal of Magnetic Materials* 85 (1990).

pp 56–57

4.36 4.37

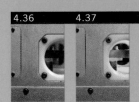

Lighting

4.36/4.37 Wafer Chamber
Photographed at the Microsystems Technology Laboratories (MTL). MIT, Martin Schmidt, Director.

Visual Index

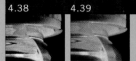
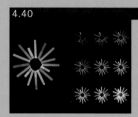
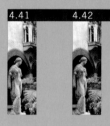
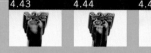

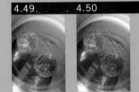

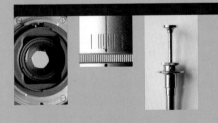
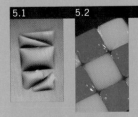

Visual Index

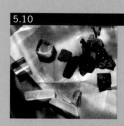

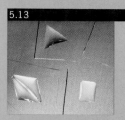

5.14 5.15 5.16 5.17

pp 94–95

Angle

5.14/5.15 Self-Assembled Polyhedra
George Whitesides' lab, Harvard University.
Gracias, D. H. et al., "Forming Electrical
Networks in Three Dimensions by Self-
Assembly," *Science* 289 (2000).

**5.16/5.17 Three-Dimensional Metallic
Tetrahedron Microstructure**
George Whitesides' lab, Harvard University.
See 5.4

5.18 5.19

pp 96–97

Angle

5.18/5.19 Square Drops of Water
George Whitesides' lab, Harvard University.
Abbott, N. L. et al., "Manipulation of the
Wettability of Surfaces on the 0.1-1-
Micrometer Scale Through Micromachining
and Molecular Self-Assembly," *Science*
257 (1992).

5.20 5.21 5.22 5.23

pp 98–99

Angle

5.20/5.21 Self-Assembled Polyhedra
George Whitesides' lab, Harvard University.
Gracias, D. H. et al., "Forming Electrical
Networks in Three Dimensions by Self-
Assembly," *Science* 289 (2000).

5.22–5.25 Self-assembled Structure
See 5.14

5.24 5.25 5.26 5.27

5.26/5.27 Optical Grating
George Whitesides' lab.
"Elastomeric Optics," Wilbur, J. et al.,
Chem. Mater. 8 (1996).

5.28 5.29

pp 100–101

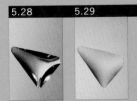

Lighting

5.28/ 5.29 Patterned Drops of Water
George Whitesides' lab, Harvard University.
Abbott, N. L. et al., "Manipulation of the
Wettability of Surfaces on the 0.1-1-
Micrometer Scale Through Micromachining
and Molecular Self-Assembly," *Science*
257 (1992).

5 / Photographing Small Things, pp 78–143

pp 112–113

Lighting

5.46/5.47 Microchemical Systems
Klavs Jensen's lab, MIT.
Jensen, K. F. et al. "Microchemcial
Systems: Status, Challenges, and
Opportunities," *AiChE Journal* 45 (1999).

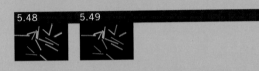

5.48/5.49 Tubular Gels
Toyoichi Tanaka's lab, MIT. Polymerization
of acrylamide monomers. See 5.61

pp 114–115

Lighting

5.50/5.51 Polyacrylamide Tubular Gels
See 5.61

5.52/5.53 Vials of CdSe Nanocrystals
Moungi Bawendi's Lab, MIT.
Bawendi, M. G. et al. "(CdSe)ZnS
Core-Shell Quantum Dots: Synthesis and
Characterization of a Size Series of
Highly Luminescent Nanocrystallites."
J. Phys. Chem. B 101 (1997).

pp 116–117

Lighting

5.54/5.55 Fluorescing Coral
Photographs by Charles Mazel.
Mazel, C. H., "Underwater Fluorescence,"
Sea Frontiers 34 (1988).

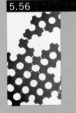

**5.56 Cross-Shaped Self-Assembled
Structures**
George Whitesides' lab, Harvard University.
Bowden, N. et al., "Self-Assembly of
Mesoscale Objects into Ordered Two-
Dimensional Arrays," *Science* 276 (1997).

Visual Index

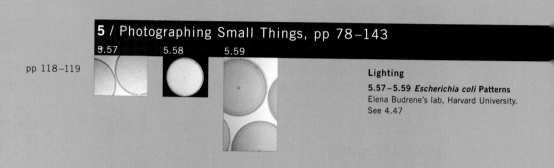

pp 126–127

5.67 5.68 5.69

Composition

5.67–5.69 See 5.52
Moungi Bawendi's lab, MIT.
Alivisatos, A. Paul, "Less is More in
Medicine." *Scientific American* 285
(2001).

pp 128–129

5.70–5.72 5.73

Scale

**5.70–5.72 Cross-Flow Microfabricated
Silicon Chemical Reactor.** See 5.3

5.73 Peruvian Carved Figures
Photograph by Heather Lechtman, MIT.
Spondylus princeps shell (South Coast
Peru, Private collection).
Dorrell, Peter G., *Photography
in Archaeol. and Conserv.*, 2nd Edition.
Cambridge University Press, 1994.

pp 130–131

5.74 5.75

Scale

5.74/5.75 Integrated Optical Components
Alice White's lab, Bell Labs.
White, A. E., "Integrated Optical
Components for WDM Systems,"
Photonics News 11 (2000).

5.76 Patterned Drops of Water
George Whitesides' lab, Harvard University.
Abbott, N. L. et al., "Manipulation of the
Wettability of Surfaces on the 0.1-1-
Micrometer Scale Through Micromachining
and Molecular Self-Assembly," *Science*
257 (1992).

5.76 5.77

5.77 Black Silicon
Eric Mazur's lab, Harvard University.
Wu, C. et al., "Near-Unity Below-Band
Gap Absorption by Microstructured
Silicon," *Appl. Phys. Lett.* 78 (2001).

pp 132–133

5.78

Scale

5.78 Polymer Shapes
George Whitesides' lab.
Kim, E. et al., "Use of Minimal Free
Energy and Self-Assembly to Form
Shapes," *Chem. Mater. 7*, (1995).

Visual Index

Magnetic Core Memory
From an IBM 7094 computer of the
mid-sixties. Each donut-shaped magnet
remembers 1 bit; the computer had
32K of memory arranged in 36-bit words.
Photographed under a stereomicroscope.

Equipment
Focusing knob, focus screen for special
viewfinder, fiber-optic lights.

6.1 6.2

Preparation
**6.1/6.2 Microfabricated Cell Sorter
With Integrated Valves and Pumps.**
Steven Quake's lab, Cal Tech.
Quake, S., Scherer, A., "From Micro-
to Nanofabrication with Soft Materials,"
Science 290 (2000).

6.3 6.4

Preparation
**6.3/6.4 Multiphase Laminar Flow
Patterning**
(6.3: Photograph by Paul Kenis and
Rustem F. Ismagilov.) George Whitesides'
lab, Harvard University.
Kenis, P. J. A. et al., "Microfabrication
Inside Capillaries Using Multiphase
Laminar Flow Patterning," *Science* 285
(1999).

6.5

Preparation
6.5 Yeast Colonies
Gerald Fink's lab, MIT's Whitehead
Institute. Genetically modified and wild-
type strains.
Liu, H. et al., "Suppression of Hyphal
Formation in *Candida albicans* by
Mutation of a STE 12 Homolog," *Science*
266 (1994).

Visual Index

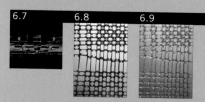
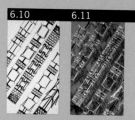
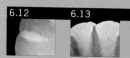

pp 164–165

6.16 6.17

Lighting
6.16/6.17 Microprocessor
Darko Gojanovic's lab, Compaq's Alpha
21164 Microprocessor, 1997.

6.18

6.18 Microchemical Reactor
Klavs Jensen's lab, MIT.
Losey, M. W. et al., "Microfabricated
Multiphase Packed-bed Reactors:
Characterization of Mass Transfer and
Reactions," *Ind. Eng. Chem. Research*,
40 (2001).

pp 166–167

6.19 6.20

Lighting
6.19/6.20 Microrotor Blades
Alan Epstein, Martin Schmidt labs, MIT.
Gabriel, K. J. "Engineering Microscopic
Machines." *Sci. Am.* 273 (1995).

6.21 6.22

6.21 All-Electronic DNA Array Sensor
Daniel Ehrlich's and Paul Matsudaira's
lab, MIT Whitehead Institute

6.22 Gas-Liquid Microreactor
Klavs Jensen's lab, MIT.
Losey, M. W., "Novel Multiphase
Chemical Reaction Systems Enabled by
Microfabrication Technology," Ph.D.
Thesis, MIT (2001).

6.23

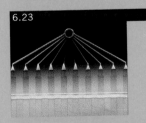

pp 168–169

Lighting
6.23 Gas-Liquid Microreactor
Klavs Jensen's lab, MIT.
Losey, M. W., "Novel Multiphase
Chemical Reaction Systems Enabled by
Microfabrication Technology," Ph.D.
Thesis, MIT (2001).

6 / Photographing through a Stereomicroscope, pp 144–191

6.24 6.25 6.26 6.27

Lighting

6.24/6.25 Cross-Flow Microfabricated Silicon Chemical Reactor See 5.3

6.26/6.27 Polyacrylamide Gels
Toyoichi Tanaka's lab, MIT.
Greytkak, A. B. et al., "Shape Imprinting Due to Variable Disulfide Bonds in Polyacrylamide Gels," *Journal of Chemical Physics* 114 (2001).

6.28 6.29 6.30

Lighting

6.28–6.30 Four-Day-Old Zebra Fish
Nancy Hopkins's lab, MIT; specimen prepared by Maryann Haldi.
Amsterdam, A. et al., "Day 4 Zebra Fish. A Large-Scale Insertional Mutagenosis Screen in Zebra fish," *Gene Dev.* 13 (1999).

6.31 6.32

Lighting

6.31/6.32 *Candida albicans*
Gerald Fink's lab, MIT's Whitehead Institute. Genetically modified and wild-type strains. Photographed with a stereomicroscope.
Liu, H. et al., "Suppression of Hyphal Formation in *Candida albicans* by Mutation of a STE 12 Homolog," *Science* 266 (1994).

6.33 6.34 6.35

Lighting

6.33 *Candida albicans* See 4.22

6.34/6.35 Microfabricated Palladium Membrane Klavs Jensen's lab, MIT.
Franz, A. J. et al., "Palladium Based Micro-membranes for Hydrogen Separation and Hydrogenation/dehydrogenation Reactions," *Technical Digest 12th International Conference on Micro-ElectroMechanical Systems,* IEEE, (1999).

6.36

Lighting

6.36 Microbeads Embedded with Nanocrystals
Moungi Bawendi's lab, MIT.
Alivisatos, A. P., "Less is More in Medicine," *Scientific American* 285 (2001).

pp 180–181

6.37 6.38 6.39

Composition

6.37/6.38 *Candida albicans*
Gerald Fink's lab, MIT with S. Rupp.
Mutant strain growing into crater-pocked
colonies on a petri dish.

6.39 Array of Silicon Microcantilevers
Microsystems Technology Lab, MIT.
Faculty, Staff and Students. Martin
Schmidt, Director.

pp 182–183

6.40

Composition

6.40 Array of Silicon Microcantilevers
Microsystems Technology Lab, MIT.
Faculty, Staff and Students. Martin
Schmidt, Director.

pp 184–185

6.41 6.42

Composition

6.41/6.42 Salt Crystals
Shuguang Zhang's lab, MIT. Sodium chlo-
ride first dissolved in water in the pres-
ence of an ionic self-complementary pep-
tide part of a small fragment of a protein.
When the water evaporates, some of the
salt forms flat crystals. Congo red stains
the peptides.

6.43 6.44

6.43/6.44 Cracked Glass
Subra Suresh's lab, MIT. In aluminosilicate
glass.
Suresh, S. et al., "Engineering the
Resistance to Sliding Contact Damage
Through Controlled Gradients in Elastic
Properties at Contact Surfaces," *Acta
Mater.* 47 (1999).

pp 186–187

6.45

Composition

6.45 Trefoils
George Whitesides' lab, Harvard University.
Jackman, R. J. et al., "Three-Dim. Metallic.
Microstruct. Fab. by Soft Litho. and
Microelectrodep.," *Langmuir* 15 (1999).

continued next page

6 / Photographing through a Stereomicroscope, pp 144–191

6.46 6.47 6.48

Composition (continued)

6.46–6.48 Microfabricated Device
Martin Schmidt, Alan Epstein labs, MIT.
Ghodssi, R. et al. "Thick Buried Oxide in
Silicon (TBOS): An Integrated Fabrication
Technology for Multi-Stack Wafer-Bonded
MEMS Processes," *Proc. 1999 Int'l Conf.
on Solid-State Sensors and Actuators,
Sendai, Japan,* June 7–10, 1999.

pp 188–189

6.49 6.50

Special Cases

6.49/6.50 Electronic "Ink" Microcapsules
Joseph Jacobson's lab, MIT.
Comiskey, B. et al., "An Electrophoretic
Ink for All-Printed Reflective Electron
Displays," *Nature* 394 (1998).

pp 190–191

6.51

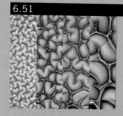

Special Cases

6.51 Expanding Gels
Toyoichi Tanaka's lab, MIT. Surface pat-
terns change as gel absorbs water.

7 / Photographing through a Compound Microscope, pp 192–245

pp 192–193

Magnetic Core Memory
From an IBM 7094 computer of the
mid-sixties. Each donut-shaped magnet
remembers 1 bit; the computer had
32K of memory arranged in 36-bit words.
Photographed under a compound
microscope.

pp 196–197

Equipment
Detail of light indicator, Nomarski differ-
ential contrast filters.

7.1 7.2

pp 198–199

Losing More Control

7.1/7.2 *Arabidopsis* **Plant Pollen**
Gerald Fink's lab, MIT's Whitehead
Institute.

7.3–7.5 7.6–7.8 7.9

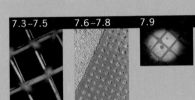

pp 200–201

Losing More Control

7.3–7.5 Magnetic Core Memory See 4.13

7.6–7.8 Self-Organized Colloids
Paula Hammond, Michael Rubner, and
Ilsoon Lee, MIT. On patterned polyelec-
trolyte multilayer. Negatively charged col-
loids on a self-assembled monolayer (SAM).

7.9 Patterned Liquid Crystals See 4.20

7.10 7.11

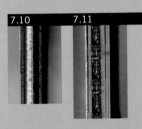

pp 202–203

Background

7.10/7.11 Chip Embedded Syringe
"Hypothermia student project," Kenneth
Szajda; Advisors: Fred Bowman, Charles
Sodini, Microtechnology Laboratory, MIT.

7.12 7.13 7.14

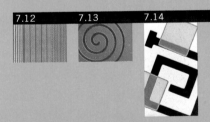

pp 204–205

Preparation

7.12–7.14 Patterned Polymers
Klavs Jensen's lab, MIT.
Vaeth, K. M. et al., "Selective Growth of
Poly (p-phenylene vinylene) Prepared by
Chemical Vapor Deposition," *Adv. Mater.*
11 (1999).

7.15 7.16

p 206

Preparation

7.15/7.16 Metal Patterns on Glass Threads
George Whitesides' lab, MIT. (7.15:
Photograph by John Rogers and Rebecca
Jackman.)
Rogers, J. A. et al., "Using Microcontact
Printing to Generate Amplitude Photo-
masks on the Surface of Optical Fibers:
A Method for Producing In-Fiber Grating,"
Appl. Phys. Lett. 70 (1997).

Visual Index

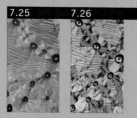

7.27 7.28 7.29 7.30

pp 216–217

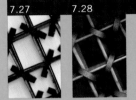

Lighting

7.27/7.28 Magnetic Core Memory
See 4.13

7.29/7.30 Microengine Component
With fuel injection holes. Martin
Schmidt's lab, MIT.
Mehra, A. et al., "A 6-Wafer Combustion
System for a Silicon Micro Gas Turbine
Engine," *Journal of Microelectromechan-
ical Systems,* 9 (2000).

7.31 7.32

pp 218–219

Lighting

7.31/7.32 Fractured Silicon
Arturo Ayon's lab, Microtechnology
Systems Labs, MIT. Plasma enhanced
vapor deposited (PECVD) with cracking.

7.33 7.34

pp 220–221

Composition

7.33/7.34 Self-Organized Colloids
Paula Hammond, Michael Rubner, and
Ilsoon Lee, MIT. On patterned polyelec-
trolyte multilayer. Negatively charged col-
loids on a self-assembled monolayer
(SAM).

7.35 7.36 7.37

7.35–7.37 Microturbine Rotor
Reza Ghodssi's lab, Microtechnology
Systems Laboratory, MIT.
Lin, C. C. et al., "Fabrication and
Characterization of a MicroTurbine/Bearing
Rig," *12th IEEE Intl Conf on MEMS,*
Orlando, FL, January 17-21, 1999.

7.38 7.39

pp 222–223

Composition

7.38/7.39 CdSe Nanocrystals
Moungi Bawendi's lab, MIT. Dark-field
optical micrograph.
Murray, C. B. et al., "Self-Organization of
CdSe Nanocrystals into Three-Dimensional
Quantum Dot Superlattices," *Science
270* (1995).

Visual Index

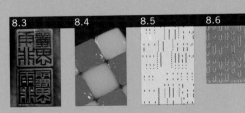
continued

Visual Index

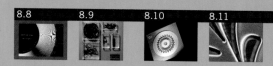

8.19 8.20

Speaking to Your Colleagues (continued)

8.19/8.20 Larger View and Detail
"Computer Microvision System" for measuring motion in Microelectronic Mechanical systems (MEMS). Dennis Freeman's lab, MIT.
Material Science of Microelectro-mechanical Systems (MEMS) Devices II de Boer, M. P. et al., ed. Warrendale, PA: Materials Research Society, 2000.

8.22 8.23

8.22/8.23 Attending to the Details
Light-emitting device. Michael Rubner's lab, MIT.
Handy, E. S., et al. "Solid-State Light-Emitting Devices Based on the Tris-Chelated Ruthenium(II) Complex. 2. Tris(bipyridyl)ruthenium(II) as a High-Brightness Emitter," *Journal of the American Chemical Society* 121 (1999).

8.24 8.25

pp 264–265

Speaking to Your Colleagues

8.24 Combining Photographs and Illustrations
Figure by John Rogers, Bell Labs. See 4.7

8.25 Combining Photographs and Illustrations
Figure by Sidney Nagel, University of Chicago. Selective withdrawal to confine one fluid within a second fluid.

8.26 8.27

pp 266–267

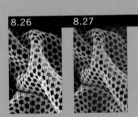

Digitally Altering Images

8.26/8.27 Coloring SEMs
George Whitesides' lab, Harvard University.
Kim, E. et al. "Polymer Formed by Moulding in Capillaries," *Nature* 375 (1995).

8.28–8.33

pp 270–273

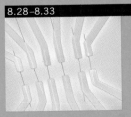

Digitally Altering Images

8.28–8.33 Coloring SEMs
Charles Lieber's lab, Harvard University.
Lieber, C. M., "The Incredible Shrinking Circuit", *Scientific American* 285 (2001).

Visual Index

pp 282–283

8.51 8.52 8.53 8.54

Digitally Altering Images

8.51–8.54 Image Inversion and Embossing
George Whitesides' lab, Harvard University.
Original SEM (8.51) by Joanna Aizenberg.
See 4.23

pp 284–285

8.55 8.56

Digitally Altering Images

8.55 Combining Parts
Alice White, Bell Labs, Planar Lightguide
Circuit Research Department.

8.56 Combining Images
George Whitesides' lab, Harvard University.
Rogers, J. A. et al., "Using Microcontact
Printing to Generate Amplitude Photo-
masks on the Surface of Optical Fibers:
A Method for Producing In-Fiber Grating,"
Appl. Phys. Lett. 70 (1997).

Front Matter

p ii p v

p ii Etched Silicon
Theodore Bloomstein's lab, MIT.

p v Femtosecond Pulses
Inverted in Photoshop. Eric Mazur's lab,
with Eli Glezer, Harvard University.
See 7.18

Back Matter

pp 286–287

p 286–287 Colored SEM of an AFM Tip
Captured with the help of Christopher
Love, Harvard University.

Suggested Readings

Highly Recommended

I particularly recommend these selections. Some are out of print, but I encourage you to search for them.

Frankel, Felice, and George M. Whitesides. *On the Surface of Things: Images of the Extraordinary in Science.* San Francisco: Chronicle Books, 1997. *An example of how I used some images from* Envisioning Science *in a book for the general public.*

Hooke, Robert. *Micrographia.* London: 1665. Reprint, Science Heritage Ltd., 1987. *Valuable for a sense of history and expanding your vision. It's worth finding a high-quality reproduction to study how this remarkable draftsman saw his world. If you cannot locate a copy of the book, a CD-ROM version is available at www.octavo.com.*

Morrison, Philip and Phylis, and the Office of Charles and Ray Eames. *Powers of Ten, About the Relative Size of Things in the Universe.* New York: Scientific American Library, 1982. *The very best book for getting a grasp on scale.*

Pauling, Linus, and Roger Hayward. *The Architecture of Molecules.* San Francisco: W.H. Freeman and Co., 1964. *For elegant and aesthetically refined visual thinking. With pastels and textured paper, Hayward renders molecules like no one else and magnificently communicates complicated principles of chemistry.*

Time-Life Series: Life Library of Photography. Alexandria, VA: Time-Life Books, 1971 (out of print). *Try to find the complete series. I still go back to mine after thirty years of taking photographs and continue to see something new. A truly remarkable series.*

Photography

Some of these books will be inspirational, some are technical, and some are just for fun.

Abbott, Berenice. *Photographs.* New York: Horizon Press, 1970.

Edgerton, Harold. *Stopping Time, The Photographs of Harold Edgerton.* New York: Harry N. Abrams Publishers, Inc., 1987.

Dalton, Stephen. *Split Second: The World of High-Speed Photography.* Salem, NH: Salem House, 1984.

Darius, Jon. *Beyond Vision.* Oxford: Oxford University Press, 1984.

Delly, John. *Photography through the Microscope.* Eastman Kodak Co., 1988.

Goro, Fritz. *On the Nature of Things: The Scientific Photography of Fritz Goro.* New York: Aperture, 1993.

Hoban, Tana. *Shadow and Reflections.* New York: Greenwillow Books, 1990.

Hunter, Fil, and Paul Fuqua. *Light, Science and Magic: An Introduction to Photographic Lighting.* Boston: Focal Press, 1997.

Murphy, Pat, and William Neill, photographer. *By Nature's Design.* San Francisco: Chronicle Books, 1993.

Reich, Hanns. *The World From Above.* New York: Hill and Wang, 1966.

Schaefer, John P. *Basic Techniques of Photography.* Boston: Little, Brown and Co., 1999.

Stevens, Peter S. *Patterns in Nature.* Boston: Atlantic Monthly Press, 1974.

Thomas, Ann. *Beauty of Another Order: Photography in Science.* New Haven, CT: Yale University Press, 1997.

Van Dyke, Milton. *An Album of Fluid Motion.* Stanford, CA: The Parabolic Press, 1982.

Wick, Walter. *A Drop of Water.* New York: Scholastic Press, 1997.

___. *Optical Tricks.* New York: Scholastic Press, 1998.

Williams, David B., Alan R. Pelton, and Ronald Gronsky, eds. *Images of Materials.* Oxford: Oxford University Press, 1991.

Williams, John B. *Image Clarity: High-Resolution Photography.* Stoneham, MA: Butterworth Publishers, 1990.

Microscopy

Herman, Brian, and John J. Lemasters, eds. *Optical Microscopy: Emerging Methods and Applications.* San Diego, CA: Academic Press,1993.

Holz, H. M. *Worthwhile Facts about Fluorescence Microscopy.* Oberkochen, Germany: Carl Zeiss, 1975.

Rawlins, D. J. *Light Microscopy.* Oxford: Bios Scientific Publishers, 1992.

Rizzuto, Rosario, and Cristina Fasolato, eds. *Imaging Living Cells.* New York: Springer-Verlag, 1999.

Tanke, H. J., and Brian Herman. *Fluorescence Microscopy.* New York: Springer-Verlag, 1998.

Design

Bringhurst, Robert. *The Elements of Typographical Style, Second Edition.* Point Robbers, WA: Harley & Marks Publishers, 1997.

Friedman, Mildred. *Graphic Design in America: A Visual Language History.* New York: Harry N. Abrams, Inc., 1989.

Rand, Paul. *Paul Rand: A Designer's Art.* New Haven, CT: Yale University Press, 1985.

Spiekermann, Eric, and E. M. Ginger. *Stop Stealing Sheep and Find Out How Type Works.* Mountain View, CA: Adobe Press, 1993.

Tschichold, Jan. *Asymmetric Typography.* Translated by Ruauri McLean. New York: Reinhold Publishing, 1967.

Tufte, Edward R. *Envisioning Information.* Cheshire, CT: Graphic Press, 1980.

Miscellaneous

Some favorites that don't fit into any one category but are relevant.

Abbott, Edwin A. *Flatland.* 1884. Reprint, New York: Penguin Books, 1998.

Kepes, Gyorgy. *Structure in Art and in Science.* New York: George Braziller, 1965.

Mitchell, William J. *The Reconfigured Eye: Visual Truth in the Post-Photographic Era.* Cambridge, MA: MIT Press, 1992.

Rossiti, Hazel. *Colour: Why The World Isn't Grey.* Princeton, NJ: Princeton University Press, 1983.

Smith, Cyril Stanley. *From Art to Science: Seventy-Two Objects Illustrating the Nature of Discovery.* Cambridge, MA: MIT Press, 1980.

Index

Index

Index